STAR WARS™
STORMTROOPERS
BEYOND THE ARMOR

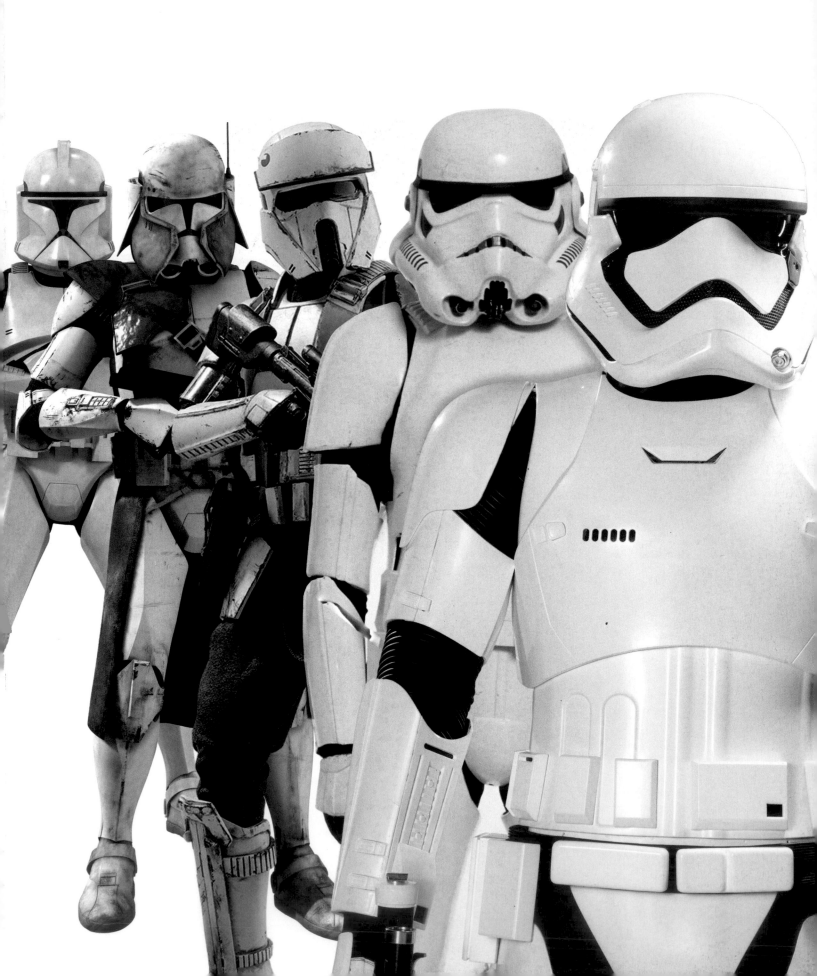

STAR WARS™

STORMTROOPERS
BEYOND THE ARMOR

RYDER WINDHAM & ADAM BRAY
FOREWORD BY JOHN BOYEGA

HARPER
DESIGN

An Imprint of HarperCollins Publishers

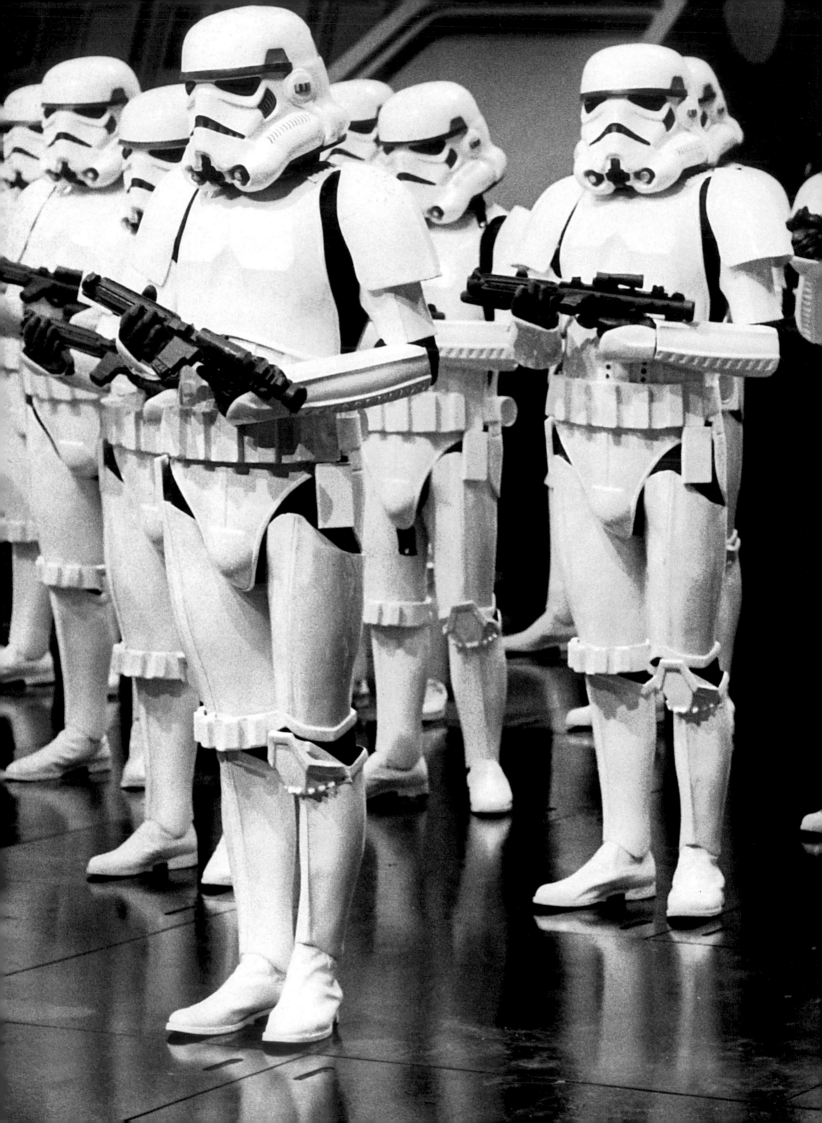

CONTENTS

OPPOSITE: Costumed extras on the set of *Star Wars: Return of the Jedi* (1983) at Elstree Studios, England, 1982.

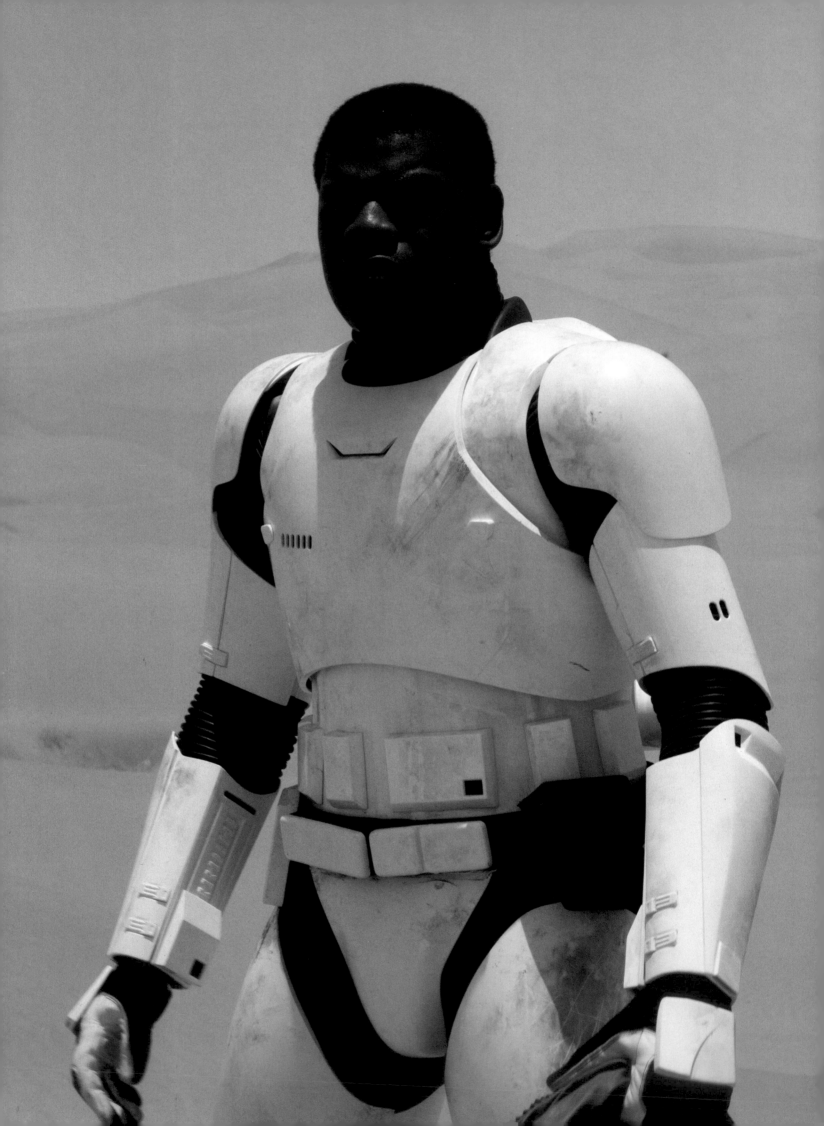

FOREWORD
BY JOHN BOYEGA

The first time I went on set for *Star Wars: The Force Awakens* was in Abu Dhabi to shoot the scenes for Jakku. The sets were real; the archway was there; the creatures moved; the droids rolled by—and I remember thinking this is too much! We're on a planet, a real planet. It was so surreal and amazing.

To be a *Star Wars* fan, getting cast to be part of the galaxy far, far away is an experience like no other. When J. J. called and asked me to meet him and I heard the words "You're going to star in the next *Star Wars*," everything froze. After a lifetime of fandom and seven months of auditions . . . YES! It was real.

My first introduction to *Star Wars* was when *The Phantom Menace* was released (yes, I am a child of the '90s). The characters, the ships, the lightsabers, and the whole galaxy captivated me. As I got older and learned about story and character development, I delved into the original trilogy. I came to appreciate the worlds and truly became a fan. I dug into the comics and video games. In taking on the role of Finn, the first stormtrooper we would get to know as an individual, it was a chance to explore a character in a way that had never been done before in the saga.

Stormtroopers, from the history of the franchise and in comics, all look the same, wear the same armor and helmets. They do the same thing and follow orders. They are just one of many. And here's a character who questions that. It's such an important part of Finn's journey that he questions that uniformity and investigates what that means to him. He has a complicated history of how he came to be a stormtrooper, and as he comes to question how he got to be where he is, it creates an interesting dilemma for Finn.

But he's not the kind of hero who has it all figured out. He doesn't quite know where he fits in the galaxy. It was fantastic that in *The Force Awakens* Finn looks sweaty, out of breath, and confused much of the time. It makes him real and relatable—he's not smooth . . . I mean he's no Han Solo.

The day we shot the scene at Maz's castle, with the rubble all around—the first day I got to hold the lightsaber and still one of my favorite moments ever—Finn had to face his former brothers in armor. It was such an impactful day for the character as well as myself. Finn had been betrayed by the lies he was raised to believe, but he knew he had to fight. He's a character who is obviously trying to do what he thinks is right, to put himself on a purposeful path, which can become quite complicated. But that is what makes Finn's journey his own.

It's been a few years since fans met Finn and his story is far from complete, but the reception he received has been exceptional. There's not much that can prepare you for the massive engine that is *Star Wars*. The action figures. The costumes. The media events. The fans. I mean, I have no shame as a fan myself. I brought merchandise to the set for people to sign. But seeing the fans line up, in costume, to greet us at each event was amazing. The first day I put on my armor was incredible . . . a bit uncomfortable at first, so I applaud those fans in the stormtrooper outfits. You all truly bring the galaxy to life.

The moments you spend with the fans, my fellow geeks, are what make being part of this franchise so fantastic. One of my favorite moments happened as I was standing behind a fan watching *The Force Awakens* trailer. I commented on it. Her reaction, the look on her face, when she turned around was something I will never forget. When *The Force Awakens* was first released, I did several pop-up appearances at various cinemas in New York and in London. Being able to share those moments and experience it with the fans never gets old.

Filming *The Last Jedi* was amazing and special in its own way—it was different than filming *The Force Awakens* because it wasn't the first time. But it should be different. The story and characters are heading in new, perhaps darker directions. As Finn pulls further from his origins as a stormtrooper, he's faced with new challenges, but we might see how that experience as a trooper has shaped him . . . and learn something new about the men beneath the armor.

OPPOSITE: Final frame of the character Finn (John Boyega) on the planet Jakku in *Star Wars: The Force Awakens* (2015). Boyega had to endure 102-degree temperatures clad in the stormtrooper armor while shooting theses scenes in Abu Dhabi, UAE, 2015.

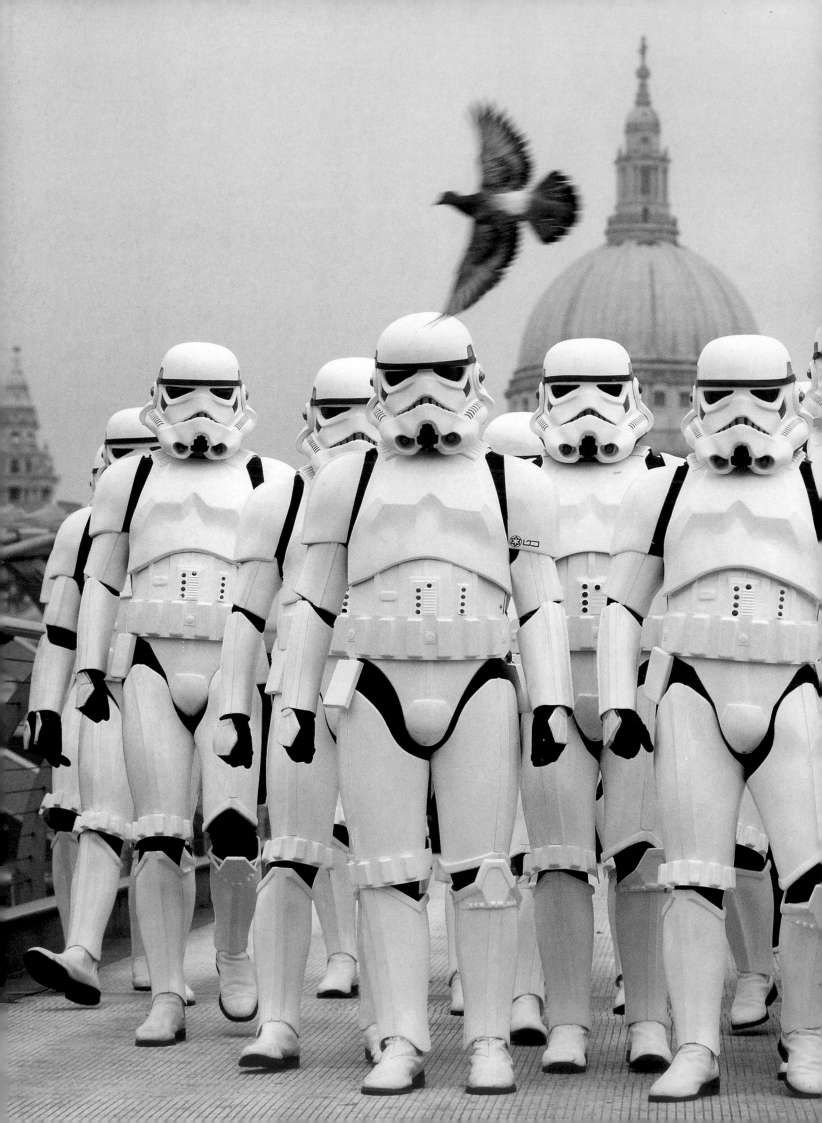

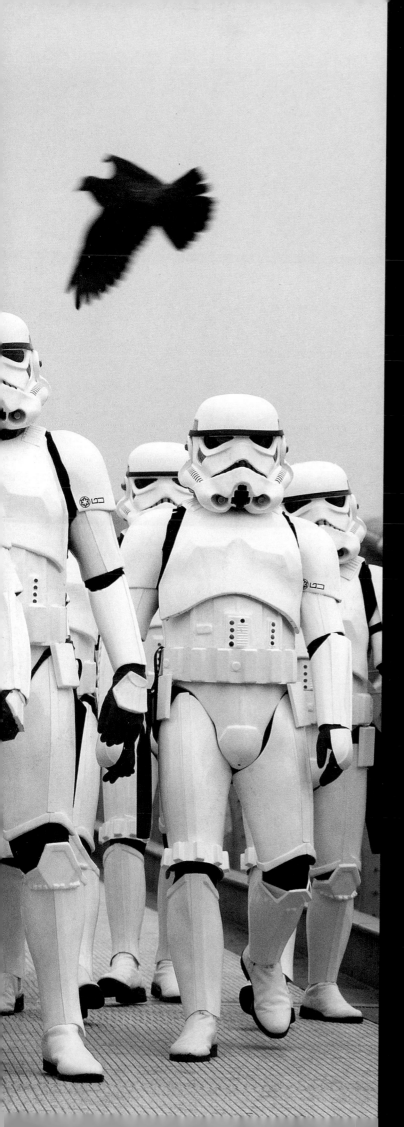

INTRODUCTION

George Lucas' *Star Wars* (1977) introduced us all to a world of Jedi, droids, and scores upon scores of fearless, identical white-armored stormtroopers—the foot soldiers of the evil Galactic Empire commanded by the black-armored Sith Lord Darth Vader. Vader's actions, physical appearance, and limited dialogue helped him become an instant pop-culture icon and a symbol of darkness itself. But behind the ominous figure of Vader was the far more numerous, seemingly and infinitely expendable, and perhaps even more enigmatic Imperial stormtroopers.

Who were the stormtroopers? Where did they come from? How many existed? And why were they so willing to kill and die for the Empire?

On January 1, 2007, thirty years after the world was introduced to them, nearly two hundred Imperial stormtroopers, snowtroopers, and scout troopers marched in the 118th annual Pasadena Tournament of Roses Parade. The following year, when a smaller number of troops joined Lucas on stage as he promoted *Star Wars: The Clone Wars* to the National Association of Theatre Owners at their annual convention in Las Vegas, he said, "I never go anywhere without my army."

This "army" consisted of members of the 501st Legion, an international and all-volunteer organization of *Star Wars* fans who wear movie-quality costumes for charitable causes as well as promotional events. Despite the stormtroopers' reputations as villains in the *Star Wars* universe, the 501st Legion's countless appearances and philanthropic efforts have effectively transformed off-screen stormtroopers into goodwill ambassadors. For many fans, stormtroopers have become the public "face" of *Star Wars*.

LEFT: Members of the 501st U.K. Garrison pose on the Millennium Bridge in London, England, to promote the release of *Rogue One: A Star Wars Story*, December 15, 2016.

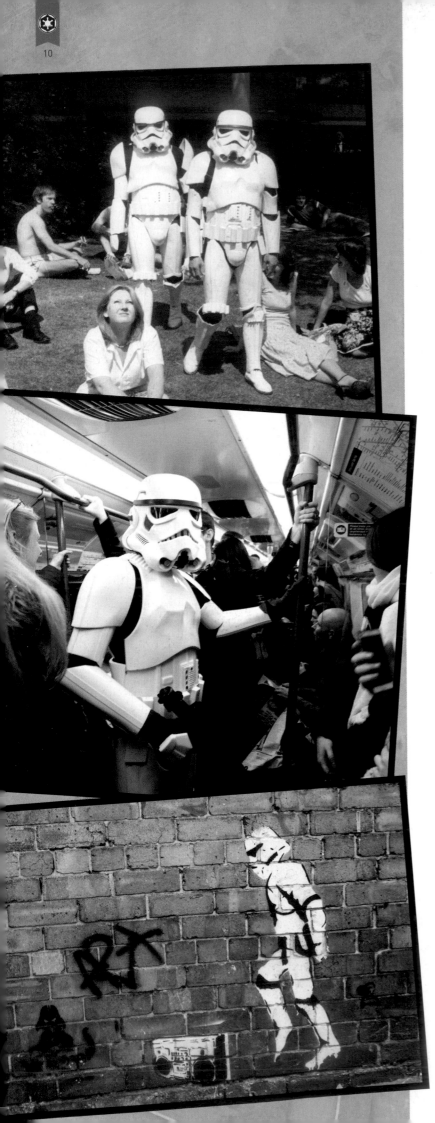

The movies have been an ongoing global phenomenon for decades, but how did stormtroopers become so popular? "The idea of the stormtrooper is that they're anonymous," says Albin Johnson, founder of the 501st Legion. "Anyone could be behind that mask. In some regards, without all the evil Empire stuff, they could be soldiers we know today—dedicated to service, strong, brave. The stormtrooper gives us that archetype we can fill in any way we like."

The good work of the 501st Legion has played a large part in the evolving perception of Imperial stormtroopers. No longer entirely "bad guys," the troopers have come to represent something more than identical soldiers and the limitless power of the Empire. The stormtrooper is the everyman of the *Star Wars* galaxy, one who consistently inspires and fuels the imagination. For all the *Star Wars* movies, toys, and games that ever presented stormtroopers as villains, nothing has ever stopped a *Star Wars* fan from picking up a stormtrooper action figure and thinking: *Maybe this trooper is a rebel spy, or Luke Skywalker in disguise!* The evolution from villain to hero continues with *Star Wars: The Force Awakens*, in which a First Order Imperial stormtrooper defects from the Empire and joins the Resistance.

What does the future hold for stormtroopers? Anything can happen.

Move along.

LEFT TOP: Stormtroopers stroll near the Savoy Hotel in London to promote the premiere of *Star Wars: The Empire Strikes Back* [1980]. LEFT MIDDLE: A stormtrooper on the London Underground en route to the premiere of *The Force Awakens* in Leicester Square, 2015. LEFT BOTTOM: A graffiti mural of a moonwalking stormtrooper by "The Key" in the style of Banksy, painted in Dolphin Lane, Boston, Lincolnshire, England, in 2014. ABOVE: Illustration from a Lucasfilm style guide. OPPOSITE: A young fan examines *Star Wars* merchandise at Toys "R" Us in Alexandria, Virginia, November 27, 2015.

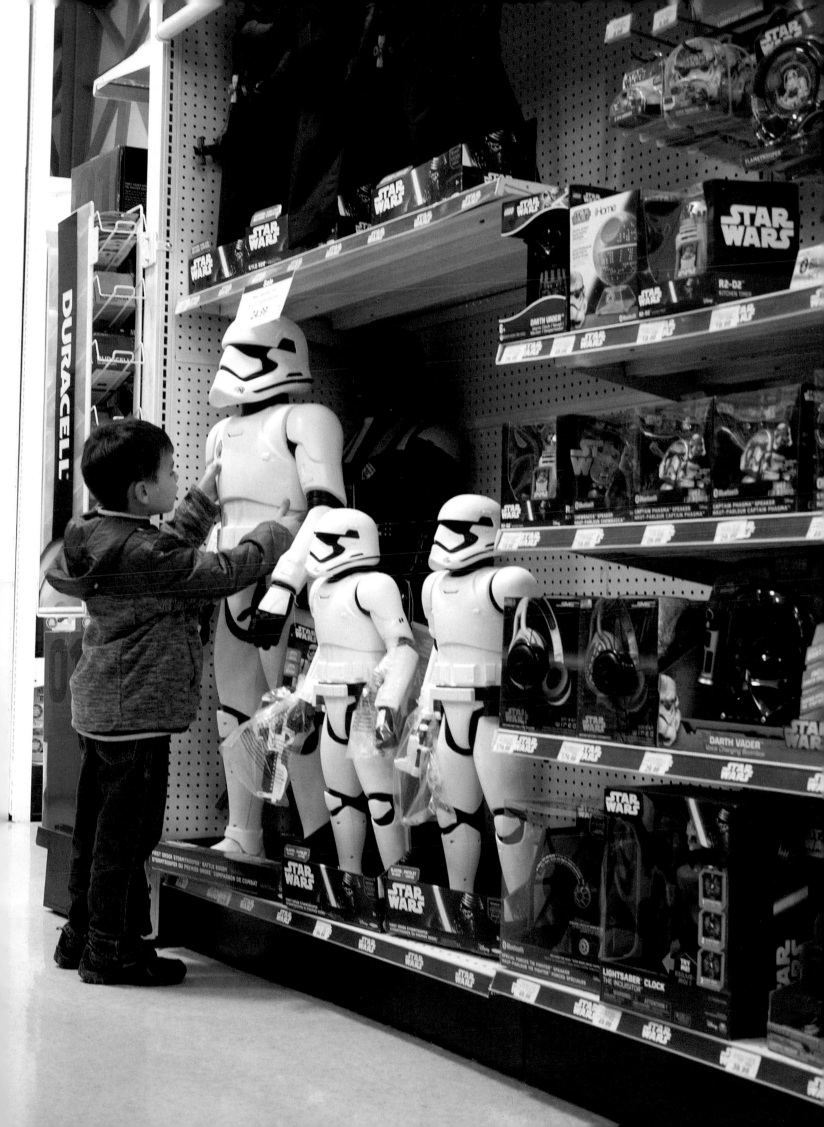

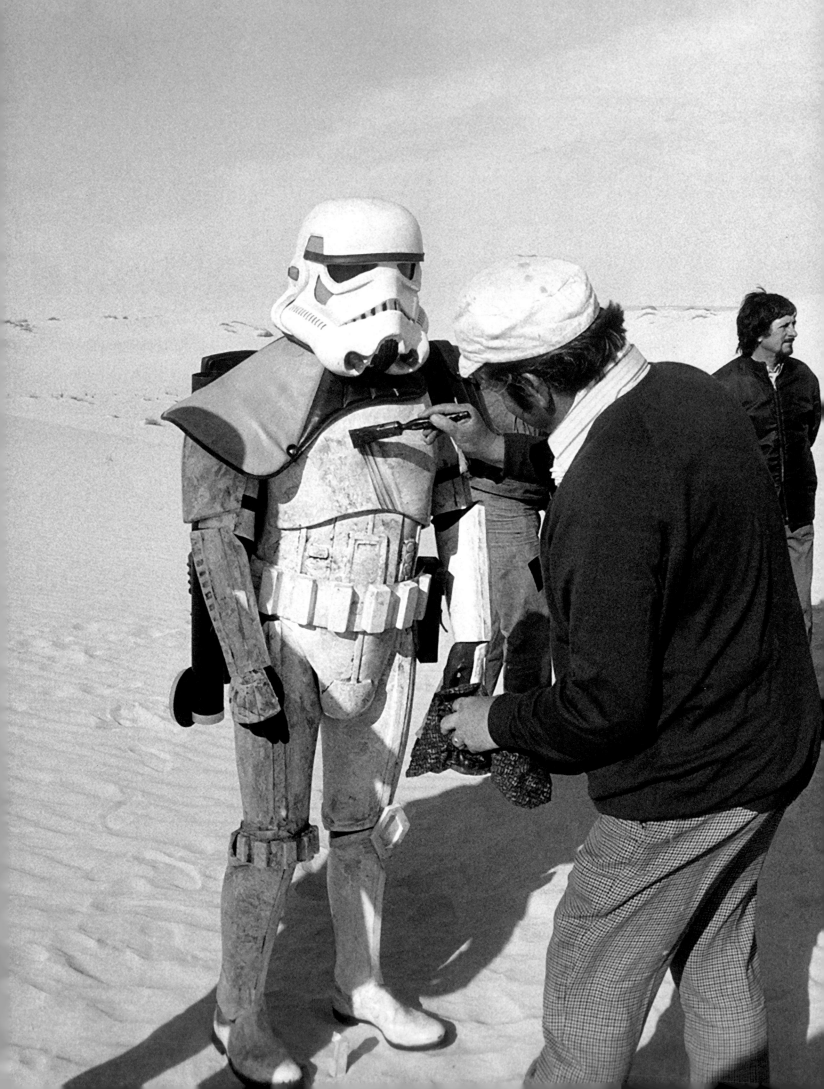

CREATING
AN ARMY

In 1973, twenty-nine-year-old American filmmaker George Lucas had written and directed two features: the dystopian science-fiction film *Electronic Labyrinth:THX-1138 4EB* (1971) and the nostalgic coming-of-age comedy-drama *American Graffiti* (1973). For his next project, he decided to create an interplanetary adventure in the tradition of the *Flash Gordon* serials he'd enjoyed in his youth. Twentieth Century-Fox offered to finance the development of Lucas' proposed movie, which he intended to produce with his newly formed California-based film company, Lucasfilm Ltd.

Two years later, Lucas completed a summary titled *Adventures of the Starkiller, Episode I:The Star Wars.* The summary begins with a battle in outer space, in which four giant Imperial Star Destroyers attack and disable a small rebel freighter. One Star Destroyer maneuvers close to the freighter, and then . . .

> *With fascist precision, ten stormtroopers wearing ominous armored spacesuits drop onto the top of the disabled rebel craft.*

A fight ensues between the rebels and stormtroopers, until . . .

> *The remaining stormtroopers bow low toward the doorway. An awesome, seven-foot BLACK KNIGHT OF THE SITH makes his way into the blinding light of the cockpit area. This is LORD DARTH VADER, right hand to the MASTER OF THE SITH. His sinister face is partially obscured by his flowing black robes and grotesque breath mask, which are in sharp contrast to the fascist white armored suits of the Imperial stormtroopers.*

LEFT: On location in Tunisia, a crew member applies dirt to a storm-trooper costume during the production of *Star Wars* (1977) under the supervision of director George Lucas (far right).

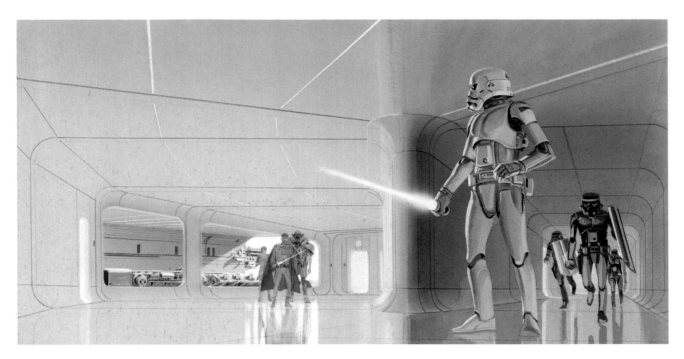

Executives at Twentieth Century-Fox were baffled by Lucas' summary. They couldn't imagine what such a space battle, or his other ideas, might look like on screen. And because the executives couldn't visualize the movie, it was impossible for them or Lucas' chosen producer, Gary Kurtz, to calculate costs for *The Star Wars* (the title was eventually abridged to *Star Wars*). Fortunately, Lucas had already hired an artist to create a series of concept paintings to illustrate key scenes from the movie. The artist was Ralph McQuarrie.

COLLABORATIVE VISION

Lucas met McQuarrie by way of mutual friends, screenwriters and producers Hal Barwood and Matthew Robbins, who had commissioned McQuarrie for a science-fiction film, *Star Dancing* (which ultimately never went into production). A somewhat itinerant artist with extensive experience in industrial design illustration, McQuarrie produced concept paintings for Boeing aircraft and animation sequences for the CBS News coverage of the Apollo space program before he became a freelance illustrator for filmmakers. "Machinery, chemical equipment, the hardware of our lives has always fascinated me," McQuarrie said in a 1979 interview, "and from the age of four or five I got into the habit of making sketches of this type of equipment."

Lucas discussed his ideas for *Star Wars* with McQuarrie, who began sketching characters and scenes from Lucas' summary in late 1974. Lucas subsequently critiqued and corrected the sketches, but also welcomed McQuarrie's design suggestions as they prepared production paintings to present to the Fox executives. McQuarrie recalled Lucas telling him not to "worry about how things are going to get done or how difficult it might be to produce them—just paint them as he would like them to be." Of their collaborative process on the paintings, McQuarrie said, "As much as I designed this, George really designed it too."

McQuarrie's designs for the Imperial stormtroopers and their enemy rebel troops developed from those early concept drawings. Lucas eventually decided the Imperial troops should wear full head-concealing helmets, and McQuarrie explored the idea of distinguishing different Imperial ranks with different helmets. "I had the officers' helmets a somewhat different shape than the standard trooper. The trooper's helmet had a metal-colored top, and a more symmetrical look to it. The officer's helmet was formed more like a skull."

Lucas also asked McQuarrie to draw concepts for equipment-laden field troopers. "George talked about making the stormtroopers really like American soldiers in Vietnam, with things chalked on their jackets. And they would be loaded down with all kinds of equipment:

ABOVE: *Imperial troopers in Death Star corridor*, production painting by Ralph McQuarrie, dated March 28, 1975.

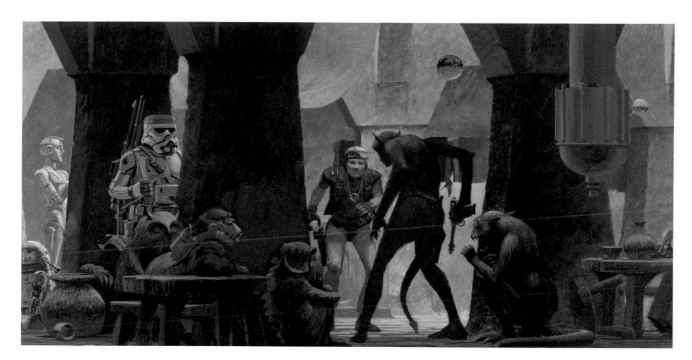

mysterious things that you don't know what they are, [such as] little canisters, like German soldiers wore in World War II." Although McQuarrie acknowledged that Lucas' use of the word "stormtroopers" alluded to a Nazi-esque army, the World War II fascist uniforms did not influence McQuarrie's design of the Empire's foot soldiers. "It was supposed to be a tooled army that was very efficient, in a sense like the German army." He laughed as he added, "They can't hit a damn thing with their laser guns, but they're very efficient."

Of his helmet sketches for the stormtroopers, McQuarrie said, "I really liked the shape of the eyes in my concepts. What looks like a mouth is actually an opening with a serrated heat sink for cooling the troops." One of his production paintings features a bearded Han Solo confronting a stormtrooper in a corridor, both figures wielding lightsabers; this was evidence that Lucas and McQuarrie were still exploring ideas about the characters and their respective weapons. "I developed this painting to feature the stormtrooper costume," McQuarrie said. "I gave Han Solo a lightsaber, and I thought it was reasonable to assume that the opposing forces would have the same weapon."

During the early stages of production for *Star Wars*, Lucas hired two more artists: model-maker Colin J. Cantwell and storyboard artist Alex Tavoularis. Cantwell had previously created models for Stanley Kubrick's *2001: A Space Odyssey*

(1968) and Robert Wise's *The Andromeda Strain* (1971). For *Star Wars*, he created the prototype models for numerous spaceships, including the Imperial Star Destroyer, the Death Star battle station, and a single-pilot Imperial starfighter, better known as a TIE fighter. Tavoularis' storyboards for *Star Wars* initially focused on the opening sequence, with Darth Vader and his stormtroopers assaulting a rebel ship. Like the concept paintings, the models and storyboards would serve to help Gary Kurtz and Twentieth Century-Fox calculate costs for the production, and would ultimately be utilized by others involved with *Star Wars*, including special effects, set design, and costumes departments.

MAKING ARMOR

While concept work and model-making continued at Industrial Light & Magic (ILM)—the fledgling special effects company Lucas had founded in 1975—George Lucas and Gary Kurtz decided to film *Star Wars* in England for various reasons, the major one being money because producing *Star Wars* in the United States would have cost almost twice as much. Lucasfilm rented space at Elstree Studios, a few miles north of London, and hired a largely English crew, including production manager Robert Watts, production designer John Barry, art director Norman Reynolds, and set decorator Roger Christian.

ABOVE: In this production painting by Ralph McQuarrie titled *Cantina*, a stormtrooper stationed inside the Mos Eisley Cantina watches a showdown between Luke Skywalker and an alien.

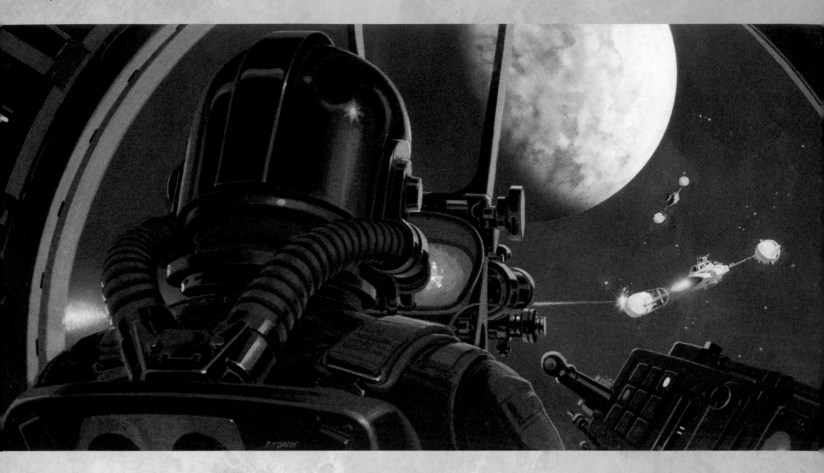

FIRST PUBLISHED IMAGE

Charles Lippincott was a publicist, working on Alfred Hitchcock's *Family Plot* (1976), when he met George Lucas and Gary Kurtz on the Universal lot in 1975. Like Lucas and Kurtz, Lippincott was a fan of science-fiction and comic books. After he read Lucas' script for *Star Wars*, he agreed with Lucas that the movie offered many opportunities for licensing and merchandising. Lucas and Kurtz made a deal with Twentieth Century-Fox to hire Lippincott as the publicist for *Star Wars*, effectively putting him on Fox's payroll, but his actual job was vice president of advertising, publicity, promotion, and merchandising for the *Star Wars* Corporation. One of Lippincott's first tasks was to put together a slide presentation for the Fox board of directors. The presentation featured Ralph McQuarrie's concept art and helped convince the board to increase the budget for *Star Wars* and green-light production.

Because Twentieth Century-Fox executives initially believed *Star Wars* would be one of twenty-six films that they would release in 1976, they decided to include the title in a campaign booklet, "Twenty-Six for Seventy-Six." For the booklet, Lippincott selected McQuarrie's revised painting of a TIE fighter pilot engaged in a space battle. Lippincott also learned *Newsweek* magazine was planning an article about science-fiction movies, novels, and television series, and he submitted the same painting for the article. "Science Fiction: The Great Escape" by Peter S. Prescott appeared in the December 22, 1975, issue of *Newsweek* and was the first-ever published image for *Star Wars*. The following month, "Twenty-Six for Seventy-Six" shipped to movie-theater owners.

ABOVE: Production painting by Ralph McQuarrie, the second of three variations of an Imperial pilot in a cockpit. McQuarrie's first version featured an early design for the Death Star, and his third version incorporated both the *Millennium Falcon* and the Death Star as it appears in *Star Wars* (1977).

Searching for a costume designer, Lucas initially approached Milena Canonero, who had worked with Stanley Kubrick on *A Clockwork Orange* (1971) and *Barry Lyndon* (1975). Canonero was unavailable, but she recommended her assistant on *Barry Lyndon*, John Mollo, who had coauthored several books on military fashion with his brother Andrew. "I met him and he seemed very good," Lucas said. "I wanted somebody that really knew armor, somebody who was more into military hardware, rather than somebody who knew how to design for the stage."

The wardrobe budget for *Star Wars* was approximately £90,000 ($220,000); of that, £7,750 ($18,189) was budgeted for the droid C-3PO, £500 ($1,173) was for Darth Vader, and £40,000 ($93,000) was for the stormtroopers. According to prop man Brian Lofthouse, C-3PO "was first offered to the costume department, but they said, 'That's far too industrial.' So it was handed off to the prop department" to produce the armor and helmets for Vader and the stormtroopers.

Brian Muir was twenty-three years old when he arrived at the art department's sculpting studio in January 1976. As a teenager, he'd apprenticed with Arthur Healey, the resident sculptor at Associated British Picture Corporation, a film studio in Borehamwood. In the late 1960s, while attending art school, Muir assisted Healey with sculptures for various films and television series, including *Captain Nemo and the Underwater City* (1969), *On the Buses* (1969), and *The Avengers* (1968–1969). After college, Muir's work ranged from producing coats of arms and heraldic shields to the restoration of a church's fire-damaged wood sculptures. In late 1975, Healey phoned Muir about an opportunity to work on a science-fiction film at Elstree. "The way he put it," Muir says, "was that there were a lot of strange characters to do."

For *Star Wars*, Muir's first assignment was to sculpt the stormtrooper armor. The film's production required at least fifty stormtrooper suits, and several were needed in Tunisia before March 22, 1976, the first day of filming. Fortunately, Muir had experience with tight deadlines, and the Elstree art department had assigned three plasterers—Jack Arnott, George Gillard, and Tom Wallace—with the specific task of molding and casting the pieces sculpted by Muir and Liz Moore, another Kubrick alum. Moore had also worked on *A Clockwork Orange*, for which she sculpted

the erotic female figures in the Milk Bar, as well as the ape masks and the Star Child for *2001: A Space Odyssey* and statues for *Barry Lyndon*. Moore was working on sculpting C-3PO when Muir began work on the stormtrooper armor. Although John Mollo produced several costume sketches for the stormtroopers, John Barry didn't present Mollo's sketches to Muir. "Ralph McQuarrie's paintings

ABOVE: Art department members Brian Muir (top) and Liz Moore (bottom), circa 1976, sculpted the original stormtrooper armor and helmet.

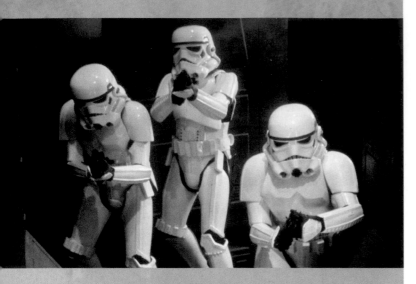

FIREPOWER

Because George Lucas envisioned the worlds and technology in *Star Wars* to look somewhat familiar and "lived in," and because John Barry and set decorator Roger Christian were working with a low budget, Christian bought inexpensive scrap from salvage yards and repurposed the scrap for sets and props. In London, Barry and Christian brought Lucas to Bapty & Co., Europe's largest supplier of weaponry and props for the entertainment industry. In a 1976 interview, Barry said, "Rather than have your slick streamlined ray guns, we took actual World War II machine guns and cannibalized one into another. George likes what he calls the 'visceral quality' that real weapons have, so there are really quite large chunks of real weapons with additional things fixed onto them. It's just so much nicer than anything you can make from scratch. It stops them from having that homemade look."

For the stormtrooper rifle, Christian selected the British-made Sterling Mk IV submachine gun, which was in service with the British Army from 1953 until 1988. Christian collaborated with Bapty & Co. gunsmith Kurt Schmidt to add World War II tank telescopes, plastic T-track draft excluders, and other bits to the gun, and glued a Hengster mechanical industrial counter behind the magazine receiver. Triggers and other mechanisms were removed to disable the guns, effectively rendering them as harmless props so they could be cleared through international customs. To save expenses, Lucasfilm rented the modified guns and returned them to Bapty after filming was completed.

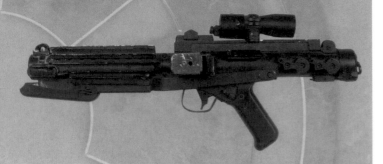

were the only reference I worked from, using artistic license to make slight changes for practical purposes."

The plaster department provided Muir with a full plaster cast of a male figure, made from actor Dennis Plenty, who would work as an extra and appear as a stormtrooper in the movie. Using gray clay, Muir began modeling the armor—starting with the stormtrooper's chest piece—directly onto the plaster-cast figure. After George Lucas and John Barry approved the clay chest piece, the plasterers made molds so they could cast the piece—i.e., replicate Muir's handiwork—in plaster. Muir proceeded to sculpt the remaining pieces of armor in the following order: arms and shoulders, torso (abdomen and crotch), legs, and back. Each piece of the armor went through the same approval process as the chest—first sculpted in clay, then approved by Lucas and Barry prior to creating a plaster cast—before moving on to the next piece. The pieces needed to be fit separately to accommodate actors of different heights. "[The costume] had to fit anyone from 5'10" to 6'0". The only way to make that work was to have a gap between the components, and if someone was bigger, the gap would increase. If they were smaller, it would close up," said Muir.

The back piece posed a creative challenge because none of McQuarrie's paintings showed a rear view of the stormtroopers. Muir and John Barry talked about how to make the back "look aesthetically pleasing" and resolved to decorate the back piece with a rectangular panel that contained a circular shape alongside two vertical shapes. Muir recalls, "I picked out the cog and two oblong pieces of wood from the props department, where [art directors] Roger Christian and Harry Lange had brought in a store of engineered parts, and placed them in my clay panel."

By the end of January 1976, Muir had finished sculpting the armor, and the plasterers had molded and cast most of the pieces. Muir's next job was to clean up and sharpen the details on the plaster casts, which the plasterers would then mold and cast in fiberglass to create positive molds. Muir recalls he was refining the plaster casts when Liz Moore told him she was going to visit her boyfriend, special effects supervisor John Richardson, who was working on the film *A Bridge Too Far* (1977) in Holland. Moore's departure left Muir as the art department's only sculptor on the premises.

LEFT TOP: Stormtroopers in action in a final frame of *Star Wars* (1977). LEFT BOTTOM: A prop blaster rifle used in the production of *Star Wars* (1977).

In early February, Muir finished the plaster casts of the stormtrooper armor and also made a few adjustments to plaster casts for C-3PO's costume. After the plasterers created fiberglass molds for each piece, they affixed the molds to boards in preparation for the vacuum-forming process that would produce the armor in white ABS (acrylonitrile butadiene styrene), a composite plastic. A plasterer named Tashy Baines operated Elstree's vacuum-forming machine and produced a number of sheets of armor before the machine developed a problem, forcing the art department to employ an outside vendor to produce the remaining suits. Muir believes the costume department utilized the initial Elstree-produced armor for filming in Tunisia.

Near the third week of February, Muir noticed a clay sculpture of the stormtrooper helmet on a table outside the sculpting studio. He eventually learned that Liz Moore had sculpted the helmet in a makeshift workshop in Holland before she drove it back to England and delivered it to John Barry. 'John and Liz were friends,' Muir says, "and I'm sure John gave her the helmet as something to do while she was in Holland, for the money, because she was a single mother at the time."

George Lucas and John Barry approved Moore's sculpture, but decided to add caps over the sections that covered the ears; the "ear caps" covered the helmet's seams, and were held in place by uncovered screws. Plasterer Charlie Gomez proceeded to mold and cast the helmet in plaster. After the plaster version's details were sharpened, Gomez made a fiberglass mold, which was then sent to the outside vendor for vacuum-forming. Because the helmets' contours posed challenges for the vacuum-forming process, most of the helmets—fifty in total—were produced in a khaki-colored HDPE (high-density polyethylene) that was more malleable than white-colored plastics; for these helmets, thick latex house paint achieved the desired white finish. Six additional helmets were produced in white ABS for close-up shots featuring actors Mark Hamill and Harrison Ford. The art department's graphic artist Bob Walker painted the details on the helmets.

The armor and helmets went to the costume department. Wardrobe assistant Colin Wilson recalls, "The pieces arrived without any indication of what was what. It was like an Airfix model kit. We had to work out what they were by putting them on our own bodies." Using metal fixing brackets, elastics, and hooks, the costumers devised a rigging system to hold the armor together on an actor.

Working on the helmets, they added flat, dark lenses in the eye holes, foam liners, and chin straps. The final costume featured several additional pieces, including hand plates, an ammunition belt, and kneecaps. Brian Muir says, "The molds for the extra pieces, including the belt, were made in the carpenters' workshop, and were fixed to a board as positive molds to use for the vacuum-forming process." Apprentice plasterer Tony Vice's hands were molded to create the hand plates; Vice's feet were molded for stormtrooper boots, but that plan was abandoned in favor of using black spring-sided Chelsea boots that were painted white with shoe dye.

"I think we had something like four days before shooting; we just played around until we managed to string it all together in such a way that you could get the armor on or off an actor in about five minutes," Mollo recalls. "They had a black all-in-one leotard; the front and back of the body went together, the shoulders fitted onto the body, the top arm and the bottom arm were attached with black elastic and slid on, and a belt around the waist had suspender things which the legs were attached to. The gloves were ordinary domestic rubber gloves with a bit of latex shoved on the front."

Star Wars production call sheets reveal Dennis Plenty — whose body cast had served as a base model for Brian Muir's sculpted armor—was the first to wear the complete stormtrooper costume for a screen test on March 15, 1976. According to Muir, the "bit of latex" that made up the hand plates on Plenty's test costume were simple plastic cutouts that were not used for filming. For the stormtrooper costumes used in Tunisia, the gloves were backed with shaped latex, and only one trooper's gloves were backed by uniquely rectangular pieces.

Although the stormtrooper costume was essentially done, Lucas wanted to see additional gear. "George announced that he was going to take some stormtroopers on location, and he wanted them to be in 'combat order,'" Mollo says. "I said, 'Oh, yes, George, what's combat order for stormtroopers?' and he said, 'Lots of stuff on the back.' So I went into this Boy Scout shop in London and bought one of these metal backpack racks. Then we took plastic seed boxes, stuck two of those together, and put four of those on the rack. Then we put plastic drainpipe on the top, with a laboratory pipe

on the side, and everything was sprayed black. [Laughs.] This was the most amazing kind of film! George asked, 'Can we have something that shows their rank?' So we took a motorcyclist chest protector and put one of them on their shoulders. George said, 'That's great!' We painted one orange and one black, and that was it!"

McQuarrie remained in the United States during the production of *Star Wars*, and was somewhat disappointed when he eventually saw the completed stormtrooper helmet. "The people who made the costumes took my helmet, hyped up certain aspects, and made sort of a cartoon of it," he said. "I think the way the helmet turned out, it suggested teeth too strongly. I wanted it to be more just part of a machine, you know. That's why I would have loved to have been there in the U.K. when they were being made, to see these things develop."

For all the hands involved in producing the stormtrooper, George Lucas credits Ralph McQuarrie as the stormtrooper's principal architect. "For the stormtroopers and Darth Vader, Ralph had a very strong influence. Essentially they are his designs," Lucas says. "The other characters, such as the princess, Mollo actually did."

The paint was likely still drying on the costumes that were rushed to Tunisia, which was doubling for the sand planet Tatooine. Ready or not, the stormtroopers were about to have their first field test.

ACTION! IN TUNISIA

According to production notes, the first filmed sequence featuring stormtroopers—logged as B32: STORMTROOPERS FIND EVIDENCE OF DROIDS—was shot on March 23–25, 1976. The scene: a group of six heavily laden stormtroopers, four on foot and two astride creatures, search the seemingly endless desert around a crashed escape pod. The stormtroopers were played by six local men from the city of Tozeur, who each received 8,500 dinars ($6.50) to wear the armor for a day.

Months of sculpting and casting the armor had come together. The same was true for the stormtrooper's mounts. There are various stories on how the idea to have stormtroopers use giant lizards on Tatooine came to be. Some hold that it came from the painting *Man on Lizard Crossing Over* by Ron Cobb, which had been commissioned by

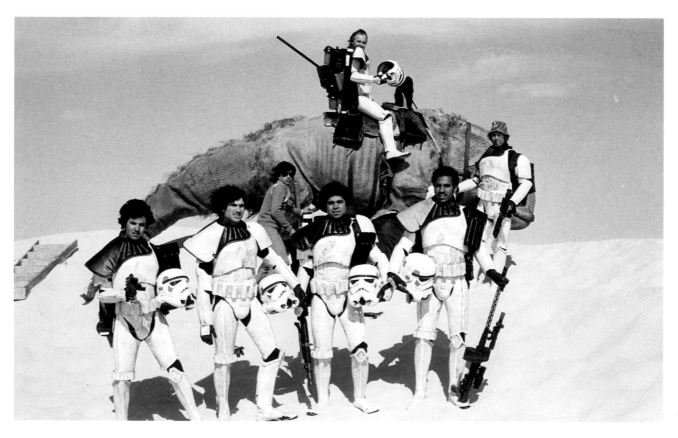

ABOVE: Hired as extras for the production of *Star Wars* (1977), six men from Tozeur pose alongside the prop for the dewback in the Tunisian desert.

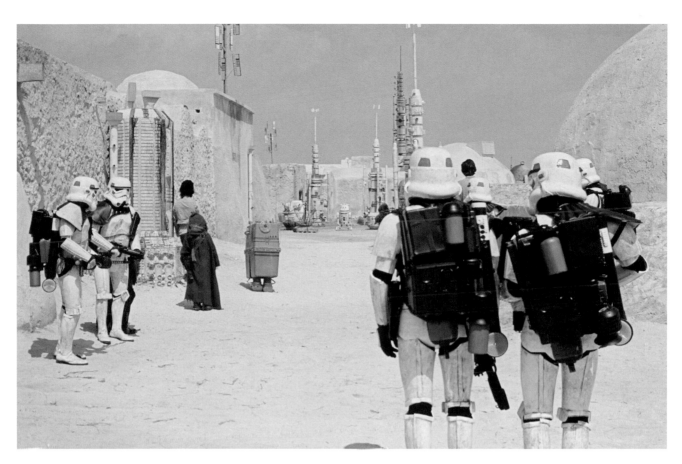

Lucas' friend and fellow film director John Milius, who displayed the painting in his home. In a 2015 interview, Cobb recalled, "Lucas said that he had the idea [for the giant lizard] before he saw the painting, and Milius said, 'No you didn't. I remember the night you came here and pointed at the wall.'"

Regardless of how the idea came to be, *Star Wars* production designer John Barry drew a sketch of the stormtrooper's desert mount, which was eventually named a dewback. Lucasfilm commissioned Fred Pearl, owner of Art Models Ltd. in the London suburb of Wimbledon, to create a large prop of the dewback as well as two props of another beast, the yak-like *jerba*. Working with a small team that included his daughters, Pearl sculpted and cast the dewback's head and tail, which he attached to the body of a prop rhinoceros. Both the head and tail had limited articulation, effectively transforming the prop into a large, mechanized puppet. Pearl also created a removable frill for the creature's neck, which ultimately wasn't used.

Once on location in Tunisia, however, the dewback failed to work properly, so it was relegated to the background in two scenes: the first perched on a sand dune overlooking

the droids' abandoned escape pod, and the second standing outside the Mos Eisley Cantina.

On Friday, April 2, production moved to the town of Djerba, which John Barry and his crew had transformed into the Mos Eisley Spaceport. The sequence SCS: 48 (BEN: "THESE ARE NOT THE DROIDS YOU'RE LOOKING FOR") again required six stormtroopers. Lucas cast twenty-four- year-old Anthony Forrest in the role of Luke Skywalker's friend Fixer. Forrest was at his hotel in Djerba, recovering from a sunburn, when the production unexpectedly conscripted him to put on a stormtrooper costume and play the commander who questions Luke and Ben Kenobi at a roadblock in Mos Eisley. Forrest's scenes as Fixer were cut from the film, but his afternoon as the stormtrooper who falls under Obi-Wan's Jedi mind trick made him one of the most memorable stormtroopers in *Star Wars*.

It was also during this time in Tunisia that Lucas filmed the stormtroopers approaching the Mos Eisley Cantina, as well as the group of troopers looking skywards while Han Solo's freighter, the *Millennium Falcon*, blasted from the spaceport (a special effect added by ILM later).

ABOVE: Assorted props and extras costumed as aliens and droids transformed the streets of Djerba into the Mos Eisley Spaceport, where six stormtroopers await Luke Skywalker's landspeeder for the roadblock scene in *Star Wars* (1977).

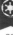

STORMTROOPER VS. SANDTROOPER

Although George Lucas' screenplay for *Star Wars* refers to stormtroopers on Tatooine, these soldiers eventually became known as *sandtroopers*. Lucas' vision of a "lived-in" universe extended to the sandtroopers' armor, which was deliberately distressed to make them appear as if they'd been operating in the desert for some time. Unlike their gleaming white counterparts on Imperial warships, sandtroopers were dirty.

But dirt wasn't the only thing that distinguished the sandtroopers; their helmets and armor also differed. The sandtrooper helmet has curved cheeks and the trapezoidal details on the helmet's back were painted in flat gray. Standard stormtrooper helmets feature thin, black stripes over the gray. On the armor, the sandtrooper's belly plate lacks the rectangular panel and paint details that are found on stormtrooper armor. The sandtrooper also has a more highly detailed diamond-shaped "sniper" knee plate for the left leg.

Not only do sandtroopers carry considerably more gear in the pack on their back, their belts also hold two MP-40 pouches—originally designed for carrying German machine-pistol ammunition during World War II. The standard stormtrooper's belt has thin rectangular boxes that hang on the sides. Costumers positioned both the pouches and boxes to fill in the space between the torso armor and thigh armor, and to make the respective armor pieces look more uniform and connected. For stormtrooper armor, costumers also added vacuum-formed ribbed straps to conceal the connections at the shoulder between the front and back armor. The back of the stormtrooper's belt also carries a cylindrical canister that is not found on sandtrooper belts.

While the subtle differences between the sandtrooper and stormtrooper costumes are consistent with Ralph McQuarrie's ideas for varying designs to help identify ranks, the actual reason for the differences was that the *Star Wars* art and costume department—after rushing the first batch of stormtrooper-cum-sandtrooper costumes to Tunisia—had slightly more time to work on the stormtrooper costumes for sequences filmed in England.

ABOVE: After the *Star Wars* (1977) production left Tunisia, filming resumed at Elstree Studios, where sets had been constructed for various locations in Mos Eisley, including an alley where stormtroopers confer with an alien spy about two runaway droids.

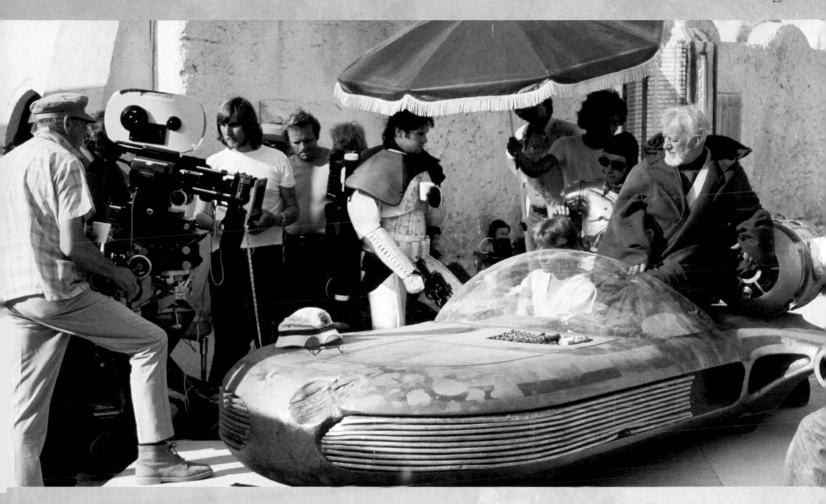

"MOVE ALONG, MOVE ALONG"

In 1976, Anthony Forrest was an actor and musician living in London when he landed the role of Luke Skywalker's friend Fixer in *Star Wars*. However, it was his scene opposite Alec Guinness as a stormtrooper that became his *Star Wars* legacy. In 2016, Forrest recounted his experience.

"It was tipping eighty degrees Fahrenheit, and while walking I'm being dressed head-to-toe in plastic as I glance at the script to memorize my dialogue as fast as I can. The sunburn I got the previous day, mind you, is being sandpapered by the interior of the costume that the props department were happily vacuum sealing me into. Pinching my skin at the elbows and behind the knees at every movement was of little consequence to having the weighty backpack suddenly hoisted on to my sunburnt shoulders. I immediately learned that standing in sand is not a great idea when trying to maintain your balance. George came over to check me out; and although the props department had done a great job on the weathering, he wanted more grit and proceeded to grab handfuls of sandy earth, liberally giving the front of the costume the finishing touches. At this point, they helped me on with the helmet. I couldn't see a damn thing! I had become a bobblehead. I looked left and it went right. I looked right and it went left. . . . Composure and stillness became my mantra for the day. . . .

"The opportunity to work with Alec Guinness was a joy, he was kind and gracious, and I'm sure aware that I had just been thrown into this moment, to stand and deliver in a crucial scene of the film. Years later, he came up to me when we were both working on different productions at Ealing Studios to ask how I was and how I was doing. [Alec] was a master craftsman and Jedi both on and off the set."

ABOVE: In Djerba, cinematographer Gil Taylor (left, wearing blue cap) prepares to film actors Anthony Forrest (unmasked stormtrooper), Mark Hamill, Anthony Daniels (unmasked C-3PO), and Alec Guinness for the roadblock scene in *Star Wars* (1977).

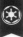
TIE FIGHTER PILOT

With the look of the stormtrooper helmet and armor com-
plete, crafting the costumes for other members and ranks of
the Imperial military began. Like their counterparts in the
Rebellion, Imperial forces included pilots trained to operate
combat starfighters. The look of the Imperial starfighters, or
TIE fighters, had been conceived during a meeting between
McQuarrie and Lucas in November 1974, and then refined
by Colin Cantwell and Joe Johnston. The ILM model-mak-
ers, led by Grant McCune, built the TIE fighters and painted
them in stormy sea blue, a since-discontinued line of color
from Pactra.

"The theory was these ships were churned out by the
Empire in large numbers," model-maker Lorne Peterson
said. The first *Star Wars* movie presents the TIE fighter as a
maneuverable vessel equipped with powerful laser cannons,
but apparently without landing gear. Filmed scenes do not
convey how pilots enter the TIE cockpit, but dialogue in
Star Wars describes the TIE as "a short-range fighter," which
suggests it is incapable of interstellar travel. Such informa-
tion conveys that the Empire kept Imperial pilots, like the

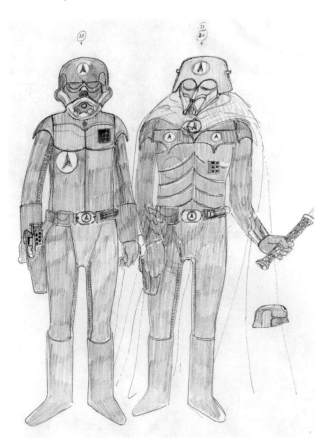

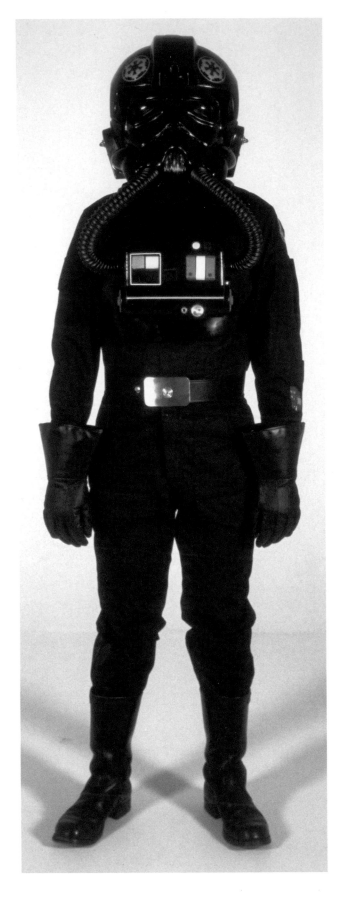

LEFT: Costume designer John Mollo's concept sketches of an Imperial pilot and a "second or third Sith Lord," circa January 1976.
RIGHT: Reference photo of the complete TIE pilot costume.

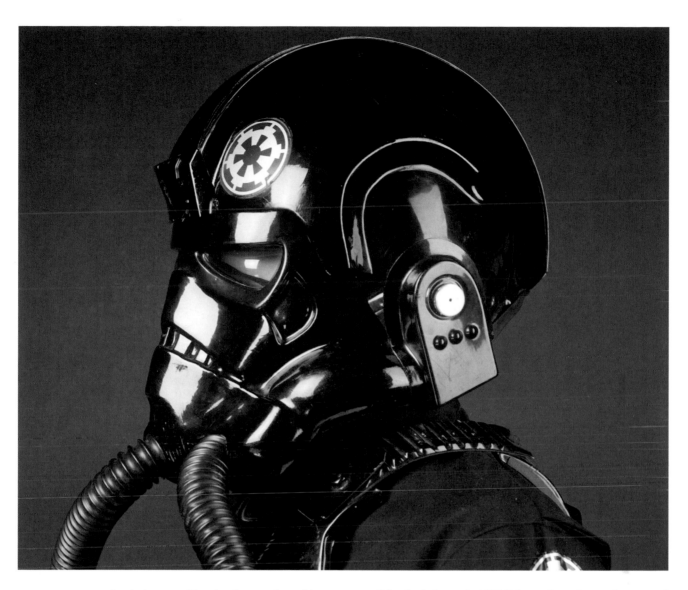

stormtroopers, under their control by simultaneously making their existence dependent on the Empire as a whole and reminding them they are expendable.

John Mollo suggested the stormtrooper helmet could be altered to create the helmets for the TIE fighter pilots. Lucas agreed and thought that the TIE fighter pilot costume should be black, which was consistent with the pilot's appearance in McQuarrie's concept painting. Mollo sketched out a possible helmet for the pilot costume, incorporating the flexible oxygen hoses from McQuarrie's painting. Pieces from a stormtrooper helmet and a rebel pilot helmet were then cobbled together to create the TIE fighter pilot helmet, along with added customized ear caps. Painted black and marked with Imperial insignia, the TIE fighter pilot helmet is considerably larger than most other *Star Wars* helmets.

Like the helmet, the TIE fighter pilot suit was also created from adapted stormtrooper armor. While the rebel pilot costume includes a chest pack held in place with straps, the TIE fighter pilot costume has a chest pack mounted directly onto modified stormtrooper chest armor. The black chest pack was then given pinstripe detailing and colored acrylic buttons based on art director Harry Lange's cockpit control panel design. The chest piece was then fitted over a black off-the-rack jumpsuit. The jumpsuit was decorated with Imperial patches on the shoulders and a pouch on the left forearm with a small vacuum-formed "greeblie"—a term attributed to George Lucas to describe things that add visual detail and texture but don't necessarily have a designated function. Military boots, gloves, and a thick belt completed the costume.

ABOVE: Close-up of a TIE fighter pilot helmet from *A New Hope*. The helmets were then reused in *Star Wars: Return of the Jedi* [1983].

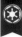

STORMTROOPERS IN COMBAT

When filming moved to Elstree Studios outside London in April 1976, it was not only a change of location but it also signified a change in the filming needs for stormtroopers. At Elstree, extras wore stormtrooper costumes for scenes in the Mos Eisley docking bay as well as for scenes through-out the Death Star. The extras almost immediately realized that the costumes and helmets severely restricted their movement and vision. "Comfort was never a consideration," admits sculptor Brian Muir. "Stormtroopers were not allowed to sit down on the job."

For the voices of the stormtroopers, sound engineer Ben Burtt recorded disc jockeys Terence McGovern, Jerry Walters, Scott Beach, and Morgan Upton as they spoke via a walkie-talkie. Because the Death Star sets were made of wood, Burtt overdubbed metallic footsteps for the stormtroopers.

The script also called for Luke Skywalker and Han Solo to impersonate stormtroopers after they infiltrate the Death Star. Actors Mark Hamill and Harrison Ford were suited up in "standard-issue" armor, which was comprised of armor pieces molded to their dimensions. "When we were wearing the stormtrooper uniforms, you couldn't sit down," Hamill says. "They built us some sawhorses to sit on: and that's the most we could rest all day. It was terrible. You get panicky inside those helmets. You can see the inside of the helmet and it's all sickly green, plus you've got wax in your ears, because of the explosions, and you just feel eerie. I only once freaked out and said, 'Get me outta here!' It really was uncomfortable."

The scene in the Death Star trash compactor was espe-cially challenging, as Hamill and Ford had to move through mucky water and over piles of "trash" props without being able to see their own feet. The scene also called for a creature, the one-eyed dianoga, to pull Luke Skywalker underwater. "During the break after the third time I had gone under," Hamill says, "I pulled a little bit of schmutz that stuck to my stormtrooper costume, looked at George who was intently directing, and sang [to the tune of "Chattanooga Choo Choo"], 'Pardon me, George, could this be dianoga poo poo?'"

In addition, the scenes filmed at Elstree included several action sequences. Peter Diamond, the stunt coordinator for *Star Wars*, had more than two decades of experience as a professional fight arranger and as a film and television actor when he came on board for the film. Diamond—who had

ABOVE: Imperial forces attack and seize a fugitive Rebel Alliance starship in *Star Wars* (1977). The stormtroopers not only blend in with the ship's white-walled interior, but visually heighten the dramatic introduction of the dark, looming form of their commander, Darth Vader (played by actor David Prowse).

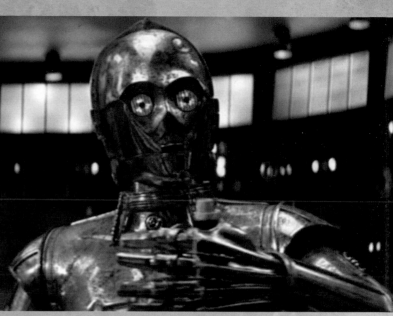

traveled with the production crew to Tunisia where he performed as the Tusken Raider who attacked Luke Skywalker, as well as the Mos Eisley Cantina patron who informed two stormtroopers of the whereabouts of Luke Skywalker and Ben Kenobi—led a team that included two other stuntmen: Greg Harding and Colin Skeaping. All three performed as stormtroopers in various scenes on the Death Star, including the troopers who attempt to stop Luke Skywalker and Princess Leia from swinging across a deep chasm, a stunt arranged by Diamond.

By his own count, Peter Diamond appeared more than fifteen times in *Star Wars.* "I think I had more exposure than Luke Skywalker! I died so many times in *Star Wars*. Because I like to lead from the front with stuntmen, when Mark and Carrie swung over the trench and were escaping, I was the stormtrooper they shot off the top. I did the first fall. You couldn't do the normal stuntman's fall. You couldn't bend, you see. You had to fall straight and then turn onto your shoulder just before you hit the bed." Because Diamond, Harding, and Skeaping were continuously running around, falling, taking hits to their armor, and, due to their limited movement, sometimes couldn't help bumping into one other, the crew began referring to them as "Larry, Curly, and Moe," or "the *Star Wars* Stooges."

However, Diamond noted that the explosive squibs, the small electronic charges generally used to simulate bullet impacts, were nothing to joke about. "The thing about the stormtroopers was that when we got hit, you had a firework effect go off in the front of you. On two occasions, not to me but to the other guys, they caught alight. It was all plastic armor. We had a job to put them out quickly. Falling about was the easy part. The danger came from the squibs."

While filming the shootout in the rebel Blockade Runner, Lucas reconsidered the use of squibs on other characters, specifically the rebels. "There were two shots of actual humans getting hit, with big explosions on their chests. But I cut those out after I saw it. It was a little too extreme. I did have big blasts on the stormtroopers, but I avoided them on humans." Lucas instinctively understood that audiences wouldn't be overly concerned about faceless stormtroopers getting blasted; and by distinguishing stormtroopers from "humans," he underscored the notion that stormtroopers might be inhuman or substantially less than human.

RIGHT TOP: C-3PO holding the stormtrooper comlink, final frame, *Star Wars* (1977). RIGHT BOTTOM: The stormtrooper comlink prop.

IMPROMPTU COMMUNICATION

In the scene aboard the Death Star, when Luke and Han are in disguise as stormtroopers, the heroes part ways with their droid companions. However, they needed a way to communicate. Luke hands C-3PO a comlink. "That's the little communicator the stormtroopers use, and C-3PO uses in one shot," set decorator Roger Christian recalls. "I was in the production designer's office, showing him some plumbing units that he could design into a set. And a call came from the floor, from George, and he says, 'I need a comlink *NOW*! I need a communicator now!' I undid a pipe, and out fell a filter. And I looked at it and saw it had a little grid on the end, with little indented circles around one end, and I went, '*OH MY GOD!*' I ran to my room, stuck one little ring around it, ran to the floor, and put it into George's hand, and he said, 'PERFECT!'

"And there was only one ever made."

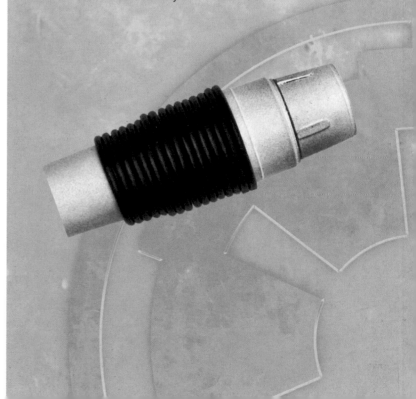

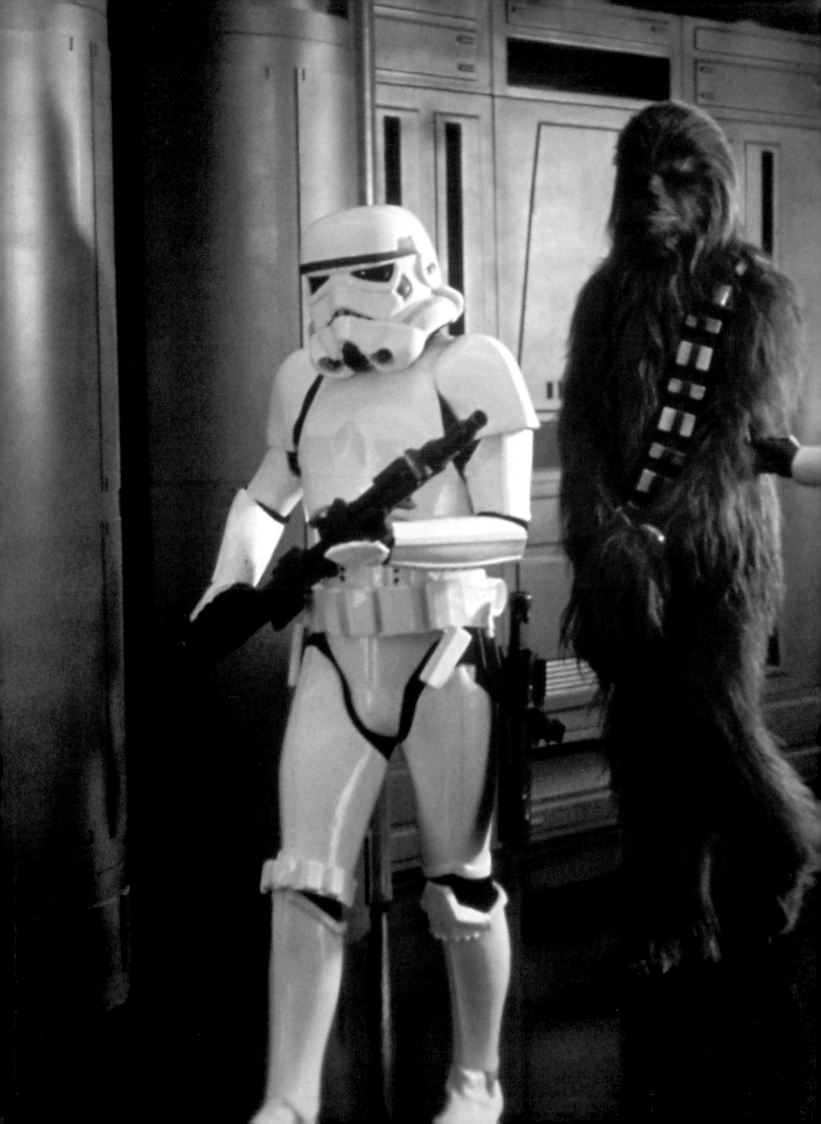

TROOPS
DEPLOYED

During the production of *Star Wars*, *Los Angeles Times* film critic Charles Champlin suspected George Lucas was up to something interesting in England and visited Elstree to see for himself. Champlin's report, an enthusiastic description of the sets, costumes, and props in Lucas' "space fantasy," appeared in the *Los Angeles Times Calendar* on June 20, 1976, along with a photo of "robots with ape-man captive." This photo was the general public's first glimpse of Imperial stormtroopers (albeit actually Han Solo and Luke Skywalker in disguise) with Chewbacca the Wookiee.

Meanwhile, Charles Lippincott, the veteran publicist hired by Twentieth Century-Fox to promote *Star Wars*, was working overtime to spread awareness of the movie to a very specific demographic: fans of science-fiction and comic books. He'd secured a deal with Del Rey Books to publish a novelization of *Star Wars*, and for Marvel Comics to publish a six-issue adaptation. The publishing contracts stipulated that the novelization and the first two issues of the comic adaptation would ship before the movie's release date. "From the very beginning," Lippincott recalls, "it was my intention to market *Star Wars* using comics. The reason why is very simple: It's the same audience. That's a no-brainer today, where Comic-Con is used to premiere a lot of Hollywood product, but in 1976, films weren't marketed that way. Basically, films were conventionally marketed through ads in newspapers, radio, and TV spots."

OPPOSITE: Disguised as stormtroopers, Han Solo (Harrison Ford) and Luke Skywalker (Mark Hamill) escort Chewbacca the Wookiee (Peter Mayhew) through a Death Star corridor in *Star Wars* (1977).

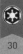

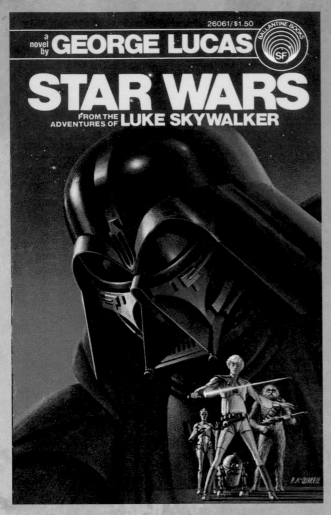

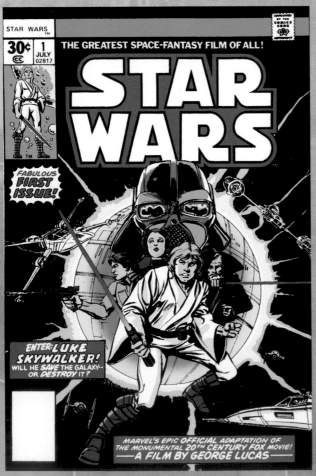

From July to September of 1976, Lippincott presented slide shows to promote *Star Wars* at WesterCon in Los Angeles, San Diego Comic-Con, and MidAmeriCon (the thirty-fourth World Science Fiction Convention, also known as WorldCon) in Kansas City. The latter included a special exhibit, "The *Star Wars* Display," which featured McQuarrie's art, props, and costumes, including a stormtrooper helmet. Although the hard-core science-fiction fans at WesterCon seemed baffled by the idea of a movie that featured noisy explosions in outer space and fantasy-based laser swords, attendees at Comic-Con and WorldCon were nearly universally enthusiastic and impressed by Lippincott's presentations.

STAR WARS ON THE PAGE

The *Star Wars* novelization shipped in December 1976, the same month that Fox released the first theatrical trailer. George Lucas was credited as the novelization's author, but it was actually ghostwritten by Alan Dean Foster. Foster likely based his novelization on Lucas' shooting script, the revised fourth draft of *Star Wars*, dated March 15, 1976. Although Lucas used the word "stormtrooper" throughout the shooting script, the word only appeared in the book twice (as two words: "storm trooper"). The Empire's soldiers were usually referred to as "Imperial troops" or "troopers" in the novel.

The novelization featured numerous scenes and dialogue that were consistent with the shooting script, but differ from the movie's final cut. For example, in both the shooting script and novelization, when Princess Leia, Han Solo, and their allies become trapped in a Death Star garbage masher, Leia encourages Solo to try blasting the compactor's door again *after* they've learned the compactor's walls are impervious to blasters. Foster also took it upon himself to expand details regarding the two stormtroopers who lose their armor to Luke Skywalker and Han Solo on the Death Star. In the shooting script and movie, Luke and Han subdue two members of an Imperial scanning crew along with two stormtroopers aboard the *Millennium Falcon*. Neither the script nor movie explains what becomes of the four individuals that Luke and Han leave inside the *Falcon*, but Foster's novelization includes this passage:

> Someone finally discovered the two unconscious guards
> tied in the service lockers on board the captured freighter.

LEFT TOP: Cover for the first edition of the *Star Wars* novelization with art by Ralph McQuarrie. LEFT BOTTOM: Cover for the first issue of the Marvel Comics adaptation of *Star Wars* with art by Howard Chaykin and Tom Palmer.

Both men remained comatose despite all efforts to revive them.

Under the direction of several bickering officers, troopers carried their two armorless comrades down the ramp toward the nearest hospital bay.

Foster offered no explanation for the two members of the scanning crew, but their fate was eventually revealed in the National Public Radio dramatization of *Star Wars* (1981) by Brian Daley. In Daley's script for *Star Wars*: Episode Eleven: *The Jedi Nexus*, a stormtrooper reports the scanning crew have been "knocked unconscious, and the guards have been shot," and instructs other troopers to take the victims to the sick bay.

For the Marvel Comics adaptation, Lucas hoped to enlist artist Al Williamson. He had long admired Williamson's work on science-fiction titles for EC Comics in the 1950s, and his credits also included *Flash Gordon* for King Comics in the 1960s. Williamson was unavailable for *Star Wars*, so Lippincott suggested artist Howard Chaykin, whose work he admired on *Cody Starbuck*, a space-pirate adventure series that appeared in *Star Reach* magazine. In February 1976, Marvel writer and consulting editor Roy Thomas agreed to script and edit the adaptation. Like Alan Dean Foster, Thomas worked from Lucas' shooting script.

Although Lippincott provided Chaykin with production stills and other visual reference material more than a year before *Star Wars* #1 was scheduled to ship, Chaykin was still working on the first issue in December of 1976, which prompted Marvel to conscript other artists—including Steve Leialoha, Rick Hoberg, and Bill Wray—to assist Chaykin on the remaining issues. With a print run of 250,000 copies, *Star Wars* #1 went on sale April 12, 1977. The issue introduced the "Imperial troops" on page two, panel one, but on page twenty-seven the white-armored soldiers were finally identified as "stormtroopers."

Because various artists worked on the comic book adaptation without standardized character guides for reference, the art was inconsistent. And like the novelization, the comic adaptation contains numerous idiosyncrasies, including depictions of scenes that don't entirely mesh with the movie. In *Star Wars* #2, Imperial sandtroopers patrol the streets of Mos Eisley, while white-armored stormtroopers—lacking the distinctive shoulder armor or backpacks of their counterparts in the movie—investigate the Mos Eisley Cantina and Docking Bay 94. Although Luke Skywalker never draws his lightsaber in combat in the first *Star Wars* movie, the cover for *Star Wars* #3 depicted Luke wielding his lightsaber in one hand and a blaster in the other as he and his allies attack a stormtrooper in a Death Star corridor. *Star Wars* #4, published shortly after the movie's release, also showed Princess Leia encouraging the armor-clad Han Solo to blast the garbage masher's walls.

As with most multimedia projects, the small differences between the *Star Wars* novelization, comic book adaptation, and movie were inevitable. In the shooting script, after Luke

LEGENDS

A PEEK UNDER THE HELMET

George Lucas commissioned Alan Dean Foster to write a sequel novel to *Star Wars*, and proposed a story in which Luke Skywalker and Princess Leia encounter Imperial forces on a jungle planet. Published in February 1978, the novel *Splinter of the Mind's Eye* includes a passage in which Luke and Leia spy upon two stormtroopers:

Two figures were swaying down the center of the street. They wore armor instead of loose clothing, formed armor of white and black. Armor that was all too familiar.

Both men carried their helmets casually. One dropped his, bent to retrieve it, kicked it accidentally up the street. His companion chided him. Cursing, the clumsy Imperial picked up his helmet, and the two continued on their meandering path.

The passage is noteworthy as the first instance of unmasked stormtroopers in a *Star Wars* story. Because the novel offers no description of the troopers' faces, readers can only imagine whether the characters are human, or if the sight of their unmasked faces surprised Luke and Leia.

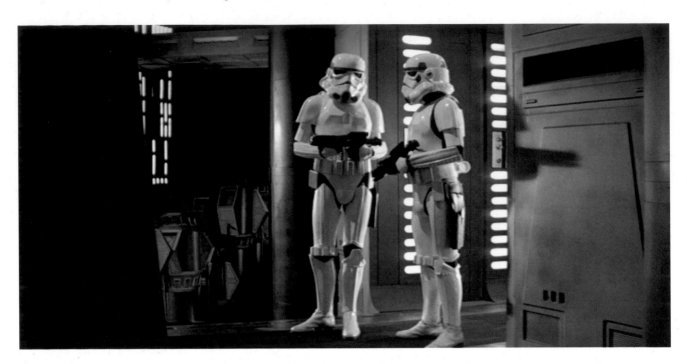

disguises himself as a stormtrooper, an Imperial gantry officer says, "TX-421. Why aren't you at your post?" In the novelization, Foster changed the line to "THX-1138, why aren't you at your post?" in an obvious nod to George Lucas' first feature film. In the comic-book adaptation, the line is consistent with the shooting script. In the movie, the line is "TK-421. Why aren't you at your post?" As Lucas, Alan Dean Foster, and Roy Thomas had no idea whether *Star Wars* would be a success or not—nor could they imagine that fans of *Star Wars* would scrutinize Lucas' script and various adaptations—it's doubtful that they were concerned about minor discrepancies in continuity regarding stormtrooper designations.

In all the early media versions of *Star Wars*, one consistent aspect of the stormtroopers was how they exuded an air of mystery as well as menace. Audiences could surmise that stormtroopers were organic life-forms, but could only guess whether the troopers were humans, aliens, clones, or hybrid creatures, or if their unmasked heads were identical. Text in the *Star Wars* theatrical program described stormtroopers as "drones of the Galactic Empire" and "tools of the Imperial governors and bureaucrats."

The Jedi Knight Obi-Wan Kenobi has little difficulty using the Force to manipulate the stormtroopers, and he refers to them as "weak-minded." However, during the sequence when Kenobi and his allies infiltrate the Death Star, a conversation between two stormtroopers suggests that they have some degree of psychological depth.

FIRST TROOPER: Do you know what's going on?

SECOND TROOPER: Maybe it's another drill.

FIRST TROOPER: Have you seen that new VT-16?

SECOND TROOPER: Yeah, some of the other guys were telling me about it. They say it's, it's quite a thing to . . . [hears noise and looks away from generator] What was that?

FIRST TROOPER: That's nothing. Outgassing Don't worry about it.

While that exchange reveals how stormtroopers routinely follow orders without being fully informed of their mission or situation, the troopers also seem to be inquisitive about new technology—the enigmatic VT-16—and are apparently eager to share information with each other. And given the probability that "some of the other guys" refers to fellow troops, the second stormtrooper conveys a sense of camaraderie as well as a capacity for informal conversation. As for "Don't worry about it," it seems to indicate stormtroopers have the capacity to worry and also to assure a fellow trooper's concerns. Stormtroopers may be susceptible to a Jedi's Force powers, but the dialogue suggests they're not mindless automatons.

ABOVE: Stationed near a tractor beam power terminal in the Death Star, two stormtroopers engage in a brief conversation about VT-16 that conveys they may have minds of their own.

TROOPERS FOR SALE

In February 1977, Charles Lippincott and Fox attorney Marc Pevers attended New York's International Toy Fair, where they met with numerous potential licensees for *Star Wars*. Among the first companies to sign contracts were Factors, Inc., manufacturers of posters, iron-on transfers for T-shirts, buttons, and jewelry; Don Post Studios, producers of a wide variety of head-concealing rubber masks; Ben Cooper, Inc., a manufacturer of inexpensive Halloween masks and costumes; and the Cincinnati-based toy company Kenner Products, a division of cereal-maker General Mills.

Because posters, T-shirts, and buttons are relatively easy to manufacture and distribute, Factors was able to release *Star Wars* merchandise in summer 1977. Factors subcontracted with Weingeroff Enterprises, a jewelry manufacturer in Providence, Rhode Island, to produce a line of jewelry, including a necklace with a painted sculptural pendant of a stormtrooper helmet, which also was released in 1977. Records are sketchy on exact release dates for merchandise from this period; however, the small pendant may have been the first officially licensed sculpt of a stormtrooper helmet available to the public.

Don Post Studios' original line of *Star Wars* masks included Darth Vader, a stormtrooper, C-3PO, and Chewbacca. Advertised for $34.95 in Warren Publishing's *Star Wars Spectacular*, the stormtrooper helmets released in 1977 were injection-molded in heavy PVC plastic with glued in dark lenses, and were further distinguished by the Twentieth Century-Fox copyright molded into the back of the helmet. The helmet's colored details, including the "teeth" across the mouth, were adhesive stickers.

Ben Cooper produced only three *Star Wars* costumes in time for Halloween in 1977: Lord Darth Vader, Luke Skywalker, and Golden Robot/C-3PO. Young *Star Wars* fans had to wait for Ben Cooper to release their first stormtrooper costume, which consisted of a paper mask and a coverall suit with a picture of a stormtrooper emblazoned on the chest. Demand for *Star Wars* costumes was so great that Ben Cooper released more costumes months in advance of the following Halloween in 1978, and also began producing more durable costumes that young fans could wear on more than one occasion throughout the year.

Don Post also released a revised version of the stormtrooper helmet made with lighter weight PVC plastic and

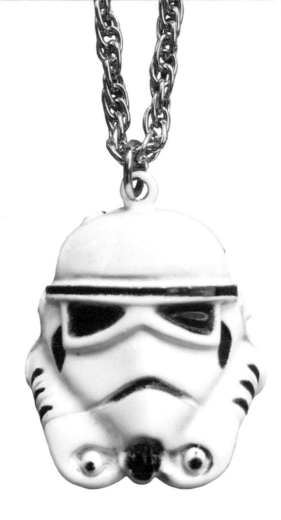

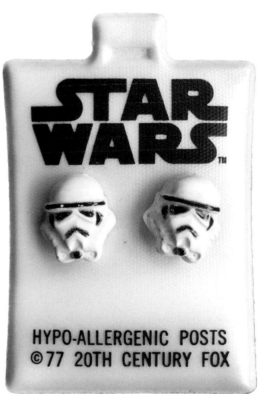

ABOVE: Produced by Factors, Inc., and released in 1977, the Imperial stormtrooper helmet pendant and earrings were among the earliest officially licensed sculptural representations of stormtroopers.

clearer glued-in lenses in 1978. Although the stormtrooper helmet was a popular seller, Don Post halted production after a few years. According to the August 1980 issue of *Questar* magazine, Don Post discontinued the stormtrooper helmet "because it proved too expensive and difficult to produce to satisfy demands." Fortunately, technical challenges were soon resolved and Don Post ultimately resumed production of the helmet.

As for Kenner Products, the company's president Bernard Loomis, vice president Craig Stokely, and design team were enthusiastic about opportunities for *Star Wars* toys. Headed by the vice president of preliminary design David Okada, the design team included Jim Swearingen, Tom Osborne, and Mark Boudreaux, a University of Cincinnati industrial design major who started working at Kenner in a work-study program just as the *Star Wars* line was being launched. However, in the toy industry, the lead time for design, production, and distribution is typically eighteen months. "With less than a year, you take shortcuts," Okada says. "We had all these low-tech things we could do in a hurry if necessary: boxed puzzles, paint-by-number kits, Play-Doh things, even one of Kenner's first board games." Puzzles featuring stormtroopers included Trapped in the Trash Compactor, Stormtroopers Stop the Landspeeder, and Corridor of Lights.

One of Kenner's then-recent successes had been a toy line of twelve-inch-tall dolls based on the popular *Six Million Dollar Man* television series; but because the Kenner team knew that vehicles and accessories would help drive the *Star Wars* line, and because manufacturing spaceship toys to accommodate twelve-inch-tall dolls would have been prohibitively expensive, Loomis proposed that they produce *Star Wars* action figures that were 3¾ inches tall.

The first stormtrooper action figure was one of twelve *Star Wars* figures released in 1978, and was packaged with a blaster rifle. To keep costs down, most figures were designed with only five points of articulation: arms rotated in shoulder sockets, legs shifted at the pelvis, and heads turned at the neck. But unlike the other figures, the stormtrooper's head could not turn because the toy was sculpted with the head and torso as a singular piece. Because of how the storm-trooper's helmet hangs over the chest and neck, it creates an undercut that would have prevented the toy's assemblers

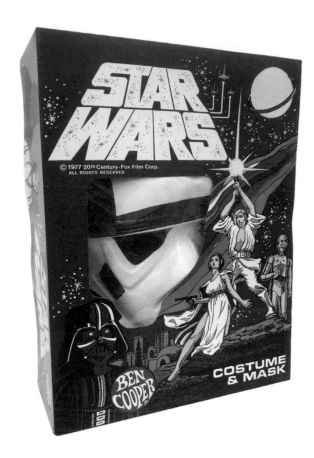

TOP: Stormtrooper costume including paper mask in the original package by Ben Cooper. **BOTTOM:** An advertisement for the head-concealing rubber masks by Don Post.

from pulling the head free from a mold—joining the head and torso was a practical design solution. Although Kenner subsequently redesigned various *Star Wars* action figures after the release of the first movie, they continued using the same mold for the standard 3¾-inch stormtrooper until 1985.

LONDON PREMIERE

At 10:30 a.m. on September 28, 1977, newspaper critics and others in the movie industry watched a trade screening of *Star Wars* at the Dominion Theatre, which could accommodate 1,654 filmgoers, on Tottenham Court Road in London. The Dominion had yet to be equipped with Dolby Special Sound Units, but that didn't stop *The Sun* and *The Daily Mail* from running advance reviews for the movie, which was scheduled to premiere on December 27. *The Sun*'s highly favorable review was featured as a four-page spread, while *The Daily Mail*'s critic, Margaret Hinxman, described *Star Wars* as "mindless comic-strip fun."

On December 19, the Science Museum in Kensington debuted a special two-week exhibition that displayed a pair of stormtrooper costumes along with R2-D2, C-3PO, and Luke Skywalker's landspeeder, which Twentieth Century-Fox had flown in from the United States for the occasion. On December 27, *Star Wars* opened in two West End cinemas simultaneously: the aforementioned Dominion and the Leicester Square Theatre, which could accommodate 1,407 filmgoers. Together, the two cinemas had already reached £140,000 in advance ticket sales before they took the step of adding two extra daily performances. Just as *Star Wars* had broken box office records in the U.S., it proceeded to break all records in the U.K. Those outside London had to wait until January 29, 1978, to see the movie in its general release.

THE EXPANDING KENNER LINE

First released in 1978, Kenner's TIE Fighter toy, which retailed for $14.99, had several action features. An opening hatch could be lifted up with a lever to reveal a cockpit that could fit a single action figure (not included). Unlike the muted gray TIE fighters seen in the movie, Kenner's first version was made of white plastic.

RIGHT: Stormtroopers featured in the animated sequence produced by Nelvana Limited for the *Star Wars Holiday Special* (1978).

FIRST ANIMATED TROOPERS

On November 17, 1978, the CBS television network broadcast the *Star Wars Holiday Special*, which featured principal actors and recycled footage from *Star Wars*, as well as comedy sketches, musical performances, and a new animated cartoon. George Lucas selected Nelvana Limited, a Toronto-based animation studio, to produce the cartoon, which introduced a new character, the bounty hunter Boba Fett, to Luke Skywalker and his allies during an adventure on a moon in the Panna system. Lucas supplied an original story written by Lenny Ripps and Pat Proft, and specifically requested that the cartoon's art style be modeled after comics by Jean "Moebius" Giraud, whose work appeared in *Heavy Metal* magazine. Frank Nissen designed the cartoon's characters and layouts, and Ken Stephenson was the animation director. Stormtroopers initially appeared as background characters to establish the Empire's presence on the Panna moon before they use a laser-cannon-equipped speeder to pursue Boba Fett and Chewbacca.

Lucasfilm provided stormtrooper helmets and costumes for the special's live-action sequences, in which stormtroopers invade Chewbacca's home on "the planet Kazook," an apparently early name for the Wookiee planet Kashyyyk. Less of a sequel to *Star Wars* than a variety show, the *Star Wars Holiday Special* was a critical disaster. However, Lucasfilm was sufficiently pleased with the quality of the cartoon, and several years later, they commissioned Nelvana to produce the Saturday-morning cartoon shows *Star Wars: Ewoks* and *Star Wars: Droids: The Adventures of R2-D2 and C-3PO*.

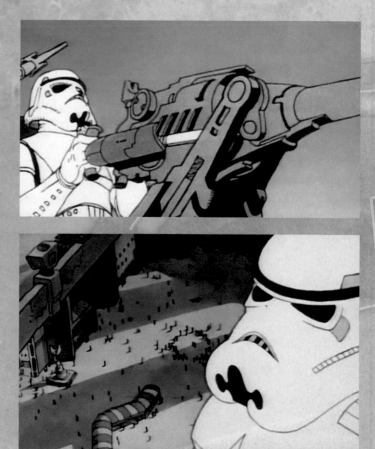

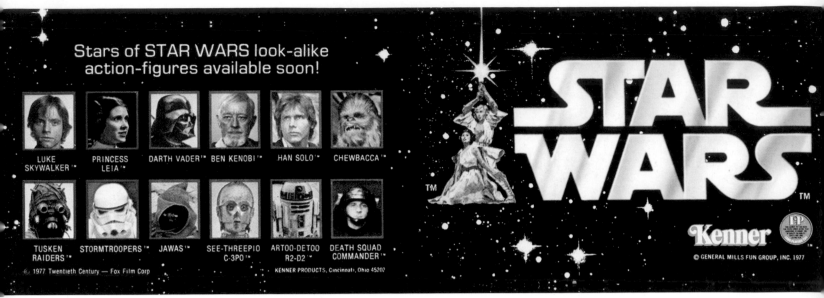

Because Kenner had yet to produce a TIE fighter pilot action figure, the TIE Fighter's box featured photos that presented Darth Vader and a stormtrooper as suitable pilots. Later in 1978, Kenner released the TIE fighter in a box with additional contents: action figures of both Darth Vader and a stormtrooper.

The following year, the toy was repackaged with *The Empire Strikes Back* logo, but it wasn't until 1982 that Kenner finally released a TIE fighter pilot action figure. But when they repackaged the TIE fighter as a bluish colored "battle-damaged" version to coincide with the release of *Return of the Jedi* in 1983, the box featured a photo of Lando Calrissian and Admiral Ackbar standing beside a TIE fighter occupied by Darth Vader. Go figure!

Also in 1979, Kenner released the dewback. Despite the creature's brief screen time in *Star Wars*, Kenner's designers decided a toy version of the mount would be a good accessory for stormtrooper action figures. However, because *Star Wars* action figures had legs with limited articulation, the designers faced a challenge: How could an action figure straddle the dewback? "Then someone tried a trapdoor in the top of the dewback," David Okada says, "so the figure could stand, but look like it was sitting. It was bizarre, it was hokey, but it looked okay, so Lucasfilm said yes." A molded saddle with bulked-up sides made a "seated" rider's legs appear to be covered.

Rather than replicate the film's prop with fur details and rhinoceros's abdomen, the designers took creative liberty, omitting the fur and putting scales over the creature's entire body. Each of the dewback's four legs were articulated, and an inner mechanism linked the tail to the head: move the tail, and the head moves side to side, or move the head and the tail wags.

Kenner also released the Imperial Troop Transporter that year. Their promotional catalogs touted the toy as "a working replica of the Imperial stormtroopers 'hovercraft' vehicle." In fact, the transporter was not a replica at all, but the first original *Star Wars* toy vehicle without any basis in the movie. Kenner designers had been considering the idea of creating new vehicles that could also serve as storage containers for *Star Wars* action figures, and convinced Lucasfilm that a transporter could have existed off-camera.

"There was a desire to bridge the gap between the figures and the higher priced 'on-screen' vehicles," Mark Boudreaux says. "What would be the best way to do this . . . Wouldn't it be great to offer the fans a way to purchase a 'complete play experience' at a very consumable price? From a design perspective, developing 'inspired-by, off-camera' vehicles seemed to be the best option.

"We knew we wanted a troop transport of some type, but it had to be more than just a carrying case," Boudreaux continues. "It needed to have fun toy features to help drive the child's imagination and bring the fantasy to life." After Boudreaux learned about a compact module that could store six prerecorded sounds, he cut and glued together sheets of styrene to construct a concept vehicle around

ABOVE: A page from the 1977 Kenner *Star Wars* toy catalog.

the module. Boudreaux's concept also included kit-bashed bits from *Star Wars* existing toys. "My original design had a wedge-shaped cockpit with an X-wing engine mounted on top. For an Imperial vehicle, the wedge-shaped front was determined to be too close to the styling of the rebel snowspeeder." One of his Kenner colleagues, Tom Troy, reworked the concept, which was the design that ultimately went into production.

The transporter featured six distinct sound effects: a stun rifle, laser cannon, transporter engine, R2-D2 beeps, C-3PO quote ("R2-D2. Where are you?"), and a stormtrooper battle command ("There's one. Set for stun!"). The vehicle was also equipped with a synchronized radar scope and laser cannon, and held compartments for two drivers, six passengers, and a droid prisoner. Kenner designers also added diabolical "prisoner immobilization units" that could be fitted over the heads of captive action figures, and enabled—according to a pamphlet packaged with the toy—stormtroopers "to try to brainwash those loyal to the rebels."

An additional pamphlet presented an illustrated story in which a stormtrooper squad, in contact with "*Dewback*™ ground units," travels in a troop transporter while searching for R2-D2 and C-3PO on Tatooine. After finding the Jawa sandcrawler that delivered the droids to Luke Skywalker's home, the stormtroopers fire the transporter's cannons to rupture the sandcrawler. Although the pamphlet's story content helped reinforce the notion that the transporter was an official "off-camera" *Star Wars* vehicle, the story isn't entirely consistent with a relevant scene in the movie. After Luke and Ben Kenobi discover bantha tracks near the ruined sandcrawler, Ben comments, "These tracks are side by side. Sand People always ride [banthas] single file to hide their numbers." Examining the blast points on the ruined sandcrawler, Ben concludes that Imperial stormtroopers are responsible. *Star Wars* fans may allow the possibility that a squad of bantha-riding stormtroopers cleaned up after the attack . . . off-camera. However, Lucasfilm wasn't overly concerned about discrepancies between the toy pamphlet's story and situations in the movie.

Despite the action depicted on Tatooine, the Imperial Troop Transporter's pamphlets do not feature illustrations or any mention of these Imperial troops as sandtroopers. The reason: Kenner did not produce a sandtrooper action figure until 1996.

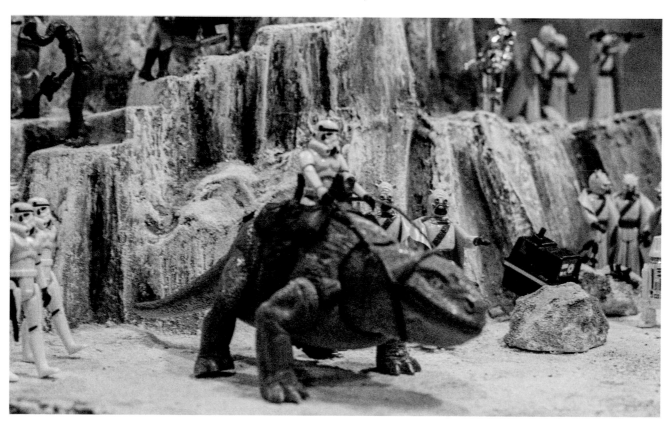

ABOVE: Kenner stormtroopers, a dewback, and Tusken Raiders on display at the 1979 Toy Fair.

LEGENDS

MARVEL STORIES, 1978–1979

Following the theatrical release of *Star Wars* and the six-issue, comic-book adaptation, Marvel Comics began producing stories that took *Star Wars* characters in new directions. The comics' creative teams could only imagine what might occur in future *Star Wars* movies, but to prevent potential continuity problems, they generally avoided introducing revelatory information about the Empire and the history of its formation. However, the comics did offer a few intriguing details about stormtroopers and their attitudes.

Star Wars #16: "The Hunter" introduced the character Valance, a battle-hardened leader of bounty hunters with a lifelong hatred of droids. A flashback sequence reveals Valance was once a "stormtrooper officer of ruthless promise," but that career ended when a rebel X-wing starfighter launched a "serial torpedo" that destroyed his battalion and nearly killed him. After the retreating Imperials left him for dead at a politically neutral medical facility, the facility's personnel saved Valance by replacing half of his body with cybernetic parts. From this experience, Valance became a self-loathing "borg" who despised rebels and Imperials alike. Although Valance was a former stormtrooper, and half of his head was a mechanical construction, readers may consider him the first stormtrooper to appear unmasked in *Star Wars* comics.

Valance returned in *Star Wars #29:* "Dark Encounter," in which he confronts a pair of stormtroopers on the planet Centares before a fateful meeting with Darth Vader. Although Valance's bounty-hunter credentials pass the stormtroopers'

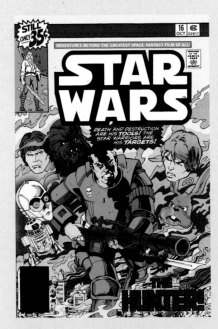 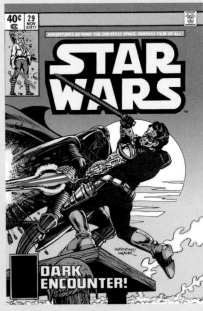 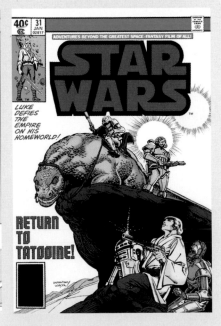

TOP: Vader confronts the former stormtrooper Valance in *Star Wars #29:* "Dark Encounter" by writer Archie Goodwin and artists Carmine Infantino and Bob Wiacek (Marvel Comics, 1979). **BOTTOM (FROM LEFT):** Cover art for *Star Wars #16:* "The Hunter" by Walt Simonson (Marvel Comics, 1978); cover art for *Star Wars #29:* "Dark Encounter" by Infantino and Wiacek; cover art for *Star Wars #31:* "Return to Tatooine" by Infantino and Wiacek (Marvel Comics, 1979).

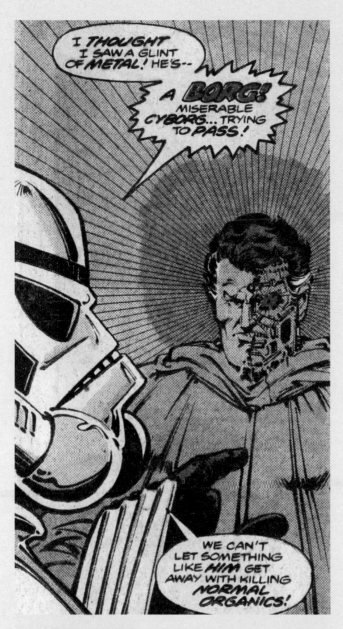

scrutiny, the troopers became outraged when they realized he's a cyborg. One trooper says, "We can't let something like him get away with killing normal organics!"—strongly implying that most stormtroopers regard cyborgs as less than human. The stormtroopers' obvious hatred of cyborgs underscores Valance's stigma. Even his former allies find him—or more precisely his physical condition—despicable.

In *Star Wars #31:* "Return to Tatooine," a mission brings Luke Skywalker back to his homeworld where he discovers an Imperial patrol with a dewback in a remote location of the Dune Sea. Soon afterward, R2-D2's sensors intercept an "Imperial troop carrier" in the area, and it is immediately recognizable as Kenner's Imperial Troop Transporter. Because Kenner released both the transport and a dewback toy in 1979, the same year *Star Wars #31* went on sale, it's an easy assumption that writer Archie Goodwin may have incorporated the vehicle and creature into "Return to Tatooine" to establish continuity between the toys and comics.

Comic Strips

The *Star Wars* syndicated newspaper comic strip debuted in the *Los Angeles Times* syndicate on March 12, 1979. Russ Manning, whose experience in comic strips included more than ten years of work on *Tarzan*, wrote and penciled the initial *Star Wars* serials with Mike Royer lettering and inking. Manning's stories introduced several variants of Imperial soldiers and pilots, including black-armored stormtroopers, TIE fighter pilots in gray and red armor, and white-armored Imperial firefighters. Incorporating locations and situations from the televised *Star Wars Holiday Special* (1978), Manning also introduced a team of unmasked Imperial troopers—one of whom had brown skin—on a mission to the Wookiee planet Kashyyyk.

In a subsequent serial, *Planet of Kadril* by writer Russ Helm and artist Alfredo Alcala, Darth Vader traveled to Kadril to test an Imperial-engineered gas called *pacifog*, which, according to Vader, "enhances the weakest traits of its victims." The stormtroopers who accompanied Vader were equipped with special filters to block the pacifog, but Vader and the Kadrillians soon learn that if the filters were removed or damaged, the gas had a very different effect on troopers—it caused their bodies to rapidly bloat and transform into ooze that seeped through their armor. After a Kadrillian asks if bloating up is a "weak trait" in humans, Vader replies, "Humans have so many." The dialogue was noteworthy as it was the first time stormtroopers were confirmed to be human beings.

TOP: A stormtrooper is clearly prejudiced against the cyborg Valance in *Star Wars #29:* "Dark Encounter" by writer Archie Goodwin and artists Carmine Infantino and Bob Wiacek (Marvel Comics, 1979). BOTTOM: Unmasked stormtroopers in the *Star Wars* syndicated comic strip by Russ Manning and Mike Royer for Sunday, August 19, 1979.

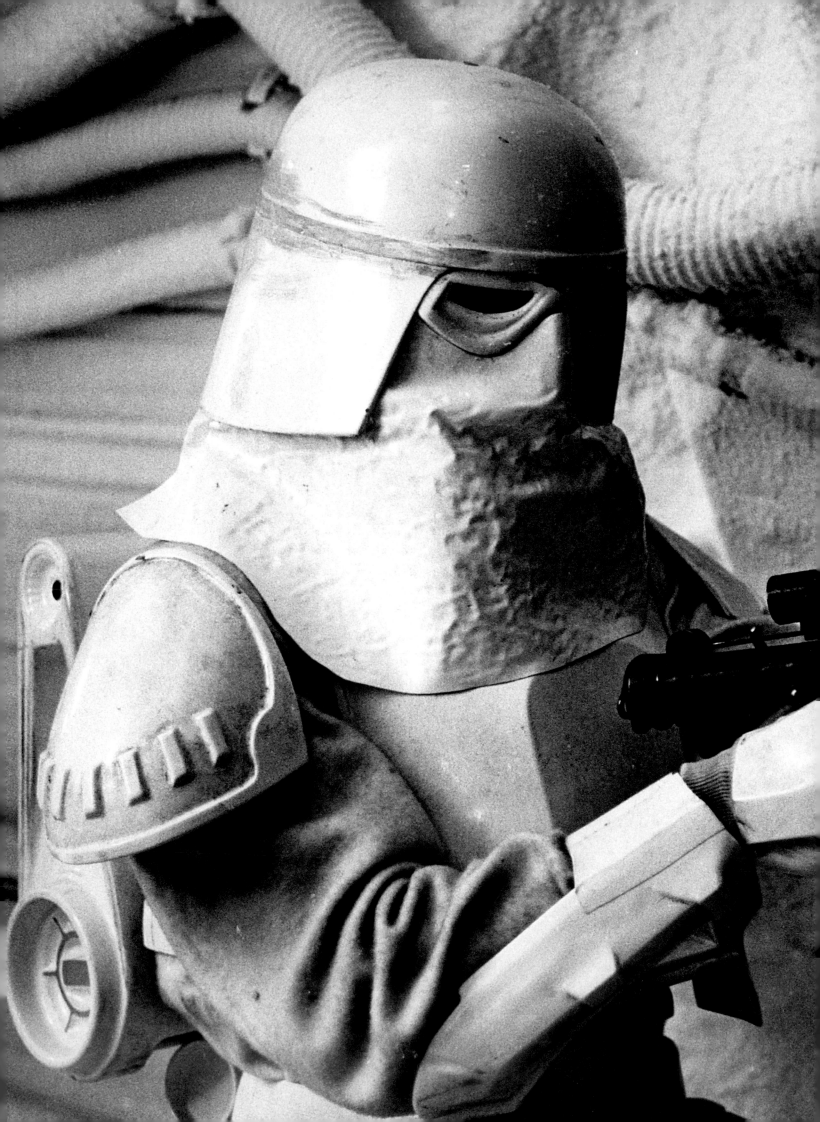

SPECIALIZED TROOPERS

With the great success of *Star Wars*, George Lucas could afford to dismiss any plans he'd had to recycle costumes and props for a low-budget sequel. Because directing *Star Wars* had been a mostly stressful experience for Lucas, he selected veteran director Irvin Kershner to helm *The Empire Strikes Back*. Kershner's credits included feature films and the award-winning made-for-TV movie *Raid on Entebbe* (1977). Kershner had also been one of the judges at the 1968 National Student Film Festival in which Lucas' student film *THX-138. 4EB* won top prize. In the autumn of 1977, Lucas was still working on the story for the first *Star Wars* sequel when he enlisted Ralph McQuarrie and Joe Johnston to create concepts for the ice planet Hoth, where Lucas envisioned a battle sequence. McQuarrie and Johnston initially focused on the environments but soon began developing concepts for cold-weather Imperial troops and rebel soldiers.

"George mentioned the idea of the Imperial snow troops having a kind of samurai feel," Johnston says. "He didn't want it to look Japanese; he just wanted it to have that multilayered look, with layers of armor. It was supposed to be your basic stormtrooper from *Star Wars*, but a winterized version of it."

McQuarrie illustrated two types of snowtroopers: an officer design and a standard infantry soldier. The officer design evolved from Lucas' idea that the Empire might deploy squads of identical white-armored super commandos; according to *The Empire*

OPPOSITE: An Imperial snowtrooper from *The Empire Strikes Back* (1980).

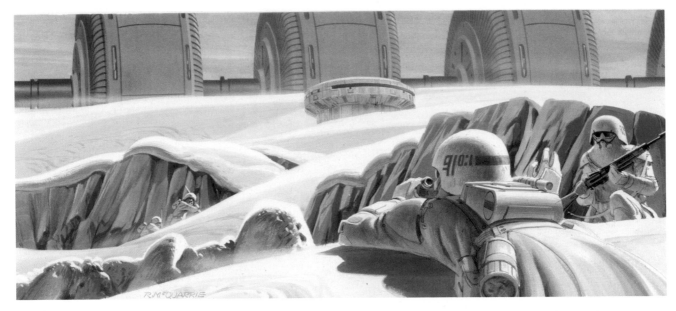

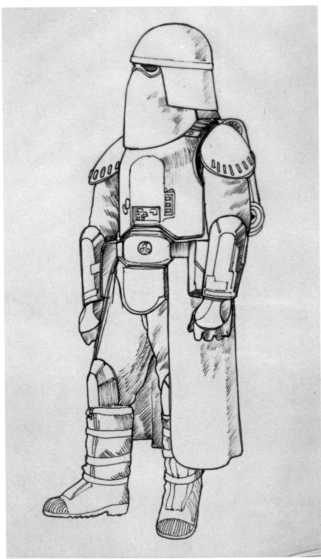

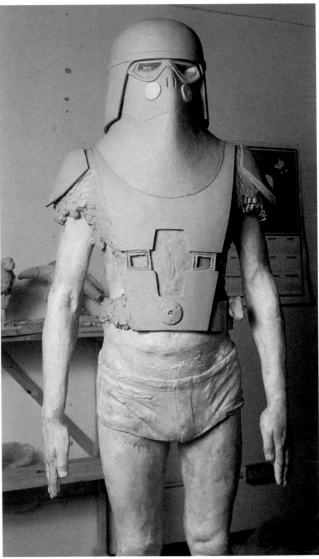

TOP: The *Attack on Generator (14 hours)*, painting by Ralph McQuarrie, June 23–24, 26, 1978. **BOTTOM LEFT:** Snowtrooper concept sketch by Joe Johnston, late 1977. **BOTTOM RIGHT:** The snowtrooper costume under construction.

Strikes Back Sketchbook (1980) by Joe Johnston and Nilo Rodis-Jamero, the super commandos were "troops from the Mandalore system armed with weapons built into their suits." McQuarrie and Johnston casually referred to the super commandos as "Super Troopers," and their preliminary designs evolved into a soldier who wore a head-concealing helmet with a T-shaped visor and a side-mounted periscopic sensor device, and a backpack that held a missile launcher. Lucas ultimately decided that the design for the Super Trooper would be better utilized for a single character he'd conceived for *Empire*, the bounty hunter Boba Fett.

As for the standard infantry snowtrooper, McQuarrie said, "My helmet shape is a bit like a Russian soldier maybe. But almost any helmet you make is going to be compared to some type in the history of military garb." McQuarrie's concept helmet also featured pronounced breathing nozzles, which he imagined having a specific purpose. "They are little heaters that I assumed warmed the air as you breathed in, since they were in this frigid air. The whole face is covered, like aviators in World War I that had to fly in subzero temperatures. You had to cover your face or you were sure to get your nose frostbitten." Johnston added the hood that covered the snowtrooper's neck, which McQuarrie thought was a "nice addition."

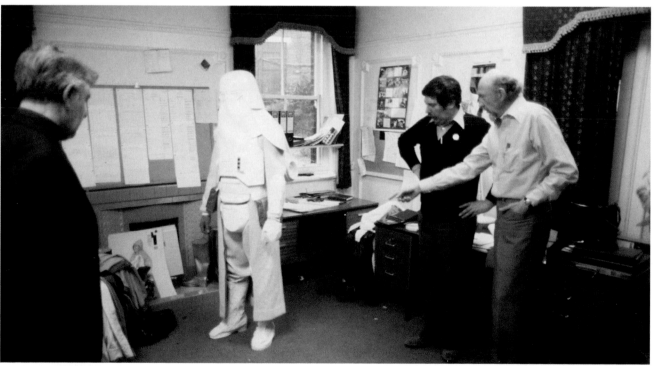

TOP: On June 28, 1978, assistant film editor Duwayne Dunham dons the all-white prototype "Super Trooper" costume that inspires the all-white snowtrooper but is ultimately modified for the bounty hunter Boba Fett. **BOTTOM:** Property manager Frank Bruton (far left), costume designer John Mollo (arms akimbo), and director Irvin Kershner (pointing) discuss the final stormtrooper costume, early 1979.

When John Mollo arrived to begin work on *Empire* at Elstree Studios in October 1978, Lucasfilm provided him with a script, storyboards for a few sequences, and a binder containing costume design sketches by McQuarrie and Johnston. The script and art indicated the production would require costumes for snowtroopers as well as traditional stormtroopers. Mollo's team estimated that the thirty "new stormtroopers in battle order" would cost £1,250 ($2,569) per costume, making them *Empire*'s most expensive costumes. However, that estimate was offset by the belief that the production would also save money on the traditional stormtroopers by reusing costumes from the first film.

In translating McQuarrie's and Johnston's costume design into a practical costume, Mollo made adjustments to the breastplate, shoulder and knee armor, and belt. Modeler Jan Stevens used clay to sculpt the helmet, which was then molded and reproduced in vacuum-formed plastic. Except for the lack of breathing nozzles, the finished helmet almost exactly replicated the refined sketches. Mollo's team produced all the helmets and armored pieces, and the soft components were manufactured by Caledonian Costumes.

A snowtrooper commander costume was also created for *Empire*. Unlike the standard snowtroopers, whose faces were covered by two layers of glued-together vinyl, the commander had a rigid face shield with rectangular "nostrils." The commander's costume was further distinguished by a holster for a small sidearm while the standard troops carried blaster rifles. The commander's costume also had rank markers on his chest plate. A modified snowtrooper chest piece was also utilized for the snowtroopers' unmasked commanding officer, General Veers. Although filmmakers traditionally review a costume designer's sketches to make decisions about costumes, Irvin Kershner preferred to review physical prototypes. This proved frustrating for John Mollo, as Kershner routinely altered Mollo's more elaborate concepts to simplify elements in an effort to maintain the visual simplicity of costumes from the previous movie. But the result was a satisfying finish: a new, distinctive stormtrooper outfitted for a specific environment.

However, even with fabric components for legs and arms, the snowtrooper costumes and helmets proved to be almost as cumbersome and difficult to wear as the traditional stormtrooper costume. Atmospheric visual effects,

specifically smoke used to simulate steam inside the rebel base on Hoth and also in the carbon-freezing chamber on Cloud City, added to the discomfort. David Prowse, the actor in the Darth Vader costume, recalls filming his entrance to the rebel base: "They decided to put two stuntmen dressed as snowtroopers in front of me and six actors behind. So here we are in this tiny set waiting for the action to start. The effects men set off the charges in the wall and we got this enormous explosion. Of course, the cave walls are polystyrene and that went everywhere. The two stuntmen went running through the hole, but, because they couldn't see through their masks, they tripped over the polystyrene blocks and fell. I started to make my dramatic entrance at about the same time, but I couldn't move—one of the actors behind me had stepped onto my cape. I tried to get away and my cape came off and I fell on top of the two stuntmen." Accidents aside, the scenes involving snowtroopers had to deal with an altogether different hazard: the cutting room floor. In the script, wampa snow creatures infiltrate the rebel base, and the rebels manage to trap the creatures in a locked chamber. After Darth Vader's arrival at the base, C-3PO discreetly tricks the snowtroopers into unintentionally releasing the creatures, which immediately attack the invading troops. Because neither the imprisoned wampas nor their Imperial victims survived the film's final cut, one may assume these lost characters survived to fight another day.

ABOVE: Costumers make adjustments to an extra's snowtrooper costume on set, 1978.

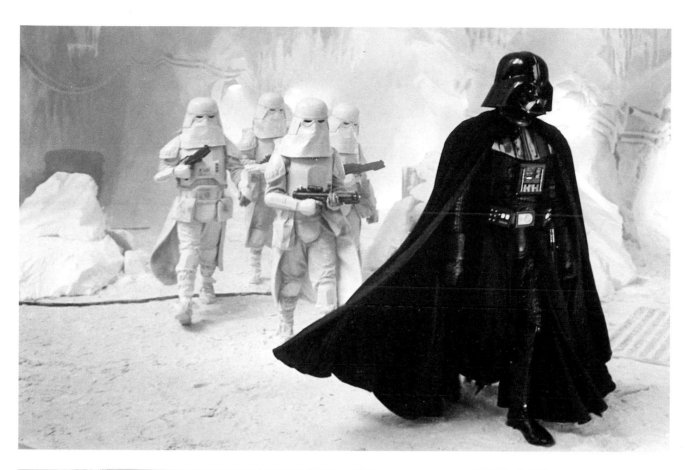

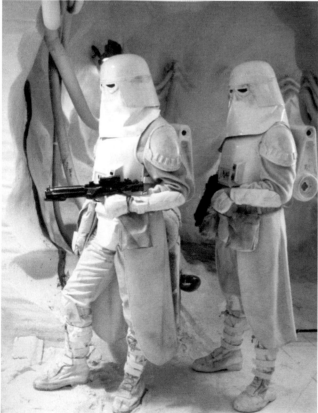

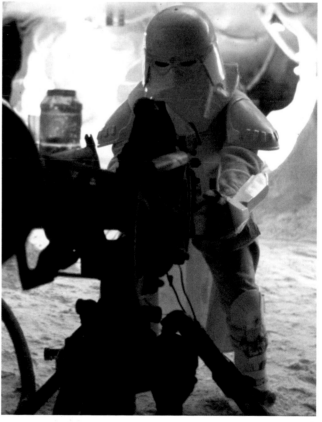

TOP: Darth Vader, played by David Prowse, leads a squad of stormtroopers into the rebel base on the ice planet Hoth, 1978. **BOTTOM LEFT:** Deleted scenes from *Empire* included snowtroopers searching for rebels in icy corridors. **BOTTOM RIGHT:** A snowtrooper mans a tripod-mounted blaster cannon.

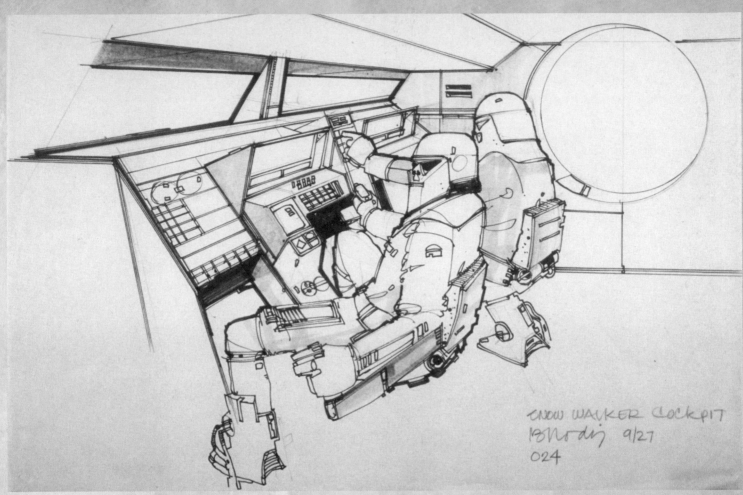

SNOW WALKER COCKPIT
18 Nov dig 9/27
024

IMPERIAL WALKERS

The Empire Strikes Back still didn't have a script when George Lucas assigned Ralph McQuarrie and Joe Johnston to design new vehicles for the Imperial troops. Johnston says, "George knew at the outset that there was going to be a snow battle and he knew we were going to have armored speeders. But he hadn't really decided on what kind of vehicles the Empire would have or how they were going to film it. At first they considered using existing military tanks, redressing them to look alien. I did a bunch of sketches using these tanks as a basis."

However, Johnston eventually realized that his tank concepts would do little to impress audiences, who would have no difficulty recognizing the "alien" war machines as actual tanks with modified exteriors. In late 1977, he came up with something completely different: an armored vehicle that moved on two legs. Lucas liked the concept but wanted to see a larger, more imposing vehicle.

"Then I ran across a Xerox that a friend of mine had," Johnston says. "It was a promotional brochure put out by U.S. Steel . . . and contained a whole slew of full-color paintings indicating, 'What steel will be used for in the future.' The paintings were done by Syd Mead. Interestingly enough, one of the paintings showed a four-legged walking truck! That's where the initial walker idea came from."

Johnston and McQuarrie produced numerous sketches of Imperial walker concepts in different shapes and scales. After Lucas approved the walker concepts, ILM enlisted Phil Tippett and Jon Berg, animators and model-makers, to bring them to life. "If there was one person responsible for getting the walkers on

ABOVE: Concept sketch for the interior cockpit of an Imperial walker by Joe Johnston.

the screen," Johnston says, "it was Jon Berg. He developed the entire armature, working from just a couple of my rough sketches."

"I remember somebody had done a sketch on possibly doing the walkers through some sort of marionette system," Jon Berg says. "We had to figure out, first, how we were going to make these big machines—just *make* them—and then how we were going to make them *move*. It was a close collaboration between Phil [Tippett], Joe Johnston, Dennis Muren [*Empire*'s visual effects supervisor], and myself, and then we brought in Tom St. Amand to help build all the parts after I figured out what parts we needed to build."

Dennis Muren determined that creating models and using stop-motion animation would be the most practical way to create the illusion of mammoth vehicles walking over ice and snow. To better visualize how the mechanical walkers might appear to move on-screen, Berg proposed studying the movements of a large quadruped. "I remember saying, 'This thing looks so much like an elephant, why don't we just go out and shoot some film?'" Accompanied by Muren, Tippett, and a camera crew, Berg visited the elephant Marjdi at Marine World/Africa U.S.A., a tourist attraction in Redwood Shores, California. "We shot quite a bit of footage of her walking back and forth, so we could get an idea of the motions an animal that size and configuration goes through in just walking."

Berg worked for three months constructing a prototype armature for the walker. Tom St. Amand then deconstructed Berg's prototype and machined all the parts necessary to make multiple versions, producing three eighteen-inch-tall models with articulated parts. The ILM Model Shop crafted the walkers' upper bodies and other details to make them appear armored. In total, the team built three eighteen-inch models, two small walkers less than two inches tall, and one four-foot-tall walker.

Dialogue in *Empire* identifies the walking vehicles as "Imperial walkers," but writer Donald F. ut's novelization of *The Empire Strikes Back* (April 1980) helped popularize the vehicles as All Terrain mored Transports. Subsequently, Joe Johnston and Nilo Rodis-Jamero's book *The Empire Strikes Back chbook* (June 1980) introduced the transport's acronym: AT-AT.

mpire does not show how the orbital Imperial fleet delivers the AT-ATs to the surface of the ice planet w the snowtroopers board and disembark the ambulatory vehicles. Subsequently published books ulated that the Y-85 Titan dropship could carry four AT-ATs and four AT-STs and also illustrated AT-ATs ling" to unload troops and vehicles through a wide side hatch with an extendable ramp.

ston at his drawing board, surrounded by storyboards for *Empire*, 1978. **GATEFOLD:** Joe Johnston's concept sketch of ker featuring an aft-mounted bubble-canopy blaster turret, but the turret was omitted for the final model. Notice George approval—*WONDERFUL!* (sic)—in the bottom right.

STORMTROOPER MK II

For *The Empire Strikes Back*, filming required Imperial stormtroopers for various scenes set on Cloud City, and the production anticipated that no more than twelve stormtroopers would appear on-screen in any single shot. With twenty-four Imperial stormtrooper costumes left over from *Star Wars*, John Mollo initially budgeted to refurbish the helmets and armor at £100 or $205 per costume. The costumes' fastening systems, which had required ongoing repairs during the filming of *Star Wars*, were upgraded with more durable materials. Helmets and armor received fresh coats of white paint. The "teeth" on the helmets, which had been painted gray for *Star Wars*, were painted black for *Empire*. The props department also produced new lightweight

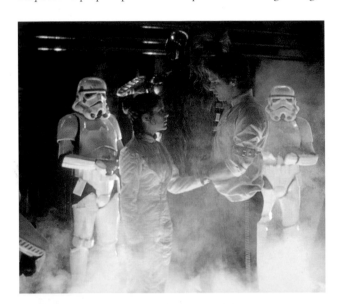

blasters in fiberglass resin, making the blasters easier for actors to carry in holsters.

Unfortunately, as filming commenced on *Empire*, it became apparent that the refurbished stormtrooper costumes had taken such a beating in *Star Wars* that the repairs couldn't conceal the damage. On June 11, 1979, the day before principal photography began for the carbon-freezing chamber scene, Gary Kurtz met with Mollo regarding complaints about the condition of the costumes. Cracks in the body armor and chips in the helmets' paint rendered the costumes as no longer camera-worthy. Evidently, Kurtz and Mollo decided new costumes were needed as quickly as possible. However, because *Empire* was already behind schedule, filming continued using old stormtrooper costumes, and with the standby wardrobe crew using white gaffers tape to make frequent repairs.

For the new costumes, plasterers took new molds off of an existing stormtrooper suit. Mollo made notes for improvements: "Glue shoulders to arms; attach glove plate to lower arm; edge body with white plastic; fix belt hooks; close legs with elastic and hook bars." To Mollo's eye, the white-plastic trim would give the armor's edges a better finish.

A fresh batch of helmets were produced with new ear caps that were glued instead of screwed to the sides, and the back of the helmet was reshaped to have a lower-profile bulge at the neck. Vacuum-formed in white ABS plastic, the new helmets would not require painting as the originals had. A pair of bubbled green lenses replaced the dark flat lenses in the eye holes, which made the helmets look better but distorted the wearer's already limited vision.

A full prototype of the new costume—Mollo designated it the "Mk II"—was completed on June 19, 1979. Although the new costumes had been made, in part, for the scenes with Princess Leia, Chewbacca, and Lando Calrissian blasting their way out of Cloud City, it's possible the costumes weren't ready in time, as a close viewing of *Empire* reveals that the Mk II costume doesn't appear in any of those scenes. In fact, the Mk II can be identified in only one shot in *Empire*. The distinctive white edge trim of the Mk II is clearly visible on a stormtrooper in the carbon-freezing chamber. After production wrapped, Lucasfilm put the Mk II costumes into storage before using them at events to promote *Empire*'s theatrical release.

TOP: The stormtroopers who bracket Princess Leia and Han Solo in the carbon-freezing scene were clad in the Mk II helmets with bubble lenses and new white-trimmed armor. **BOTTOM:** Close-up of the Mk II stormtrooper from the carbon-freezer scene. Note the white trim on his arm whole.

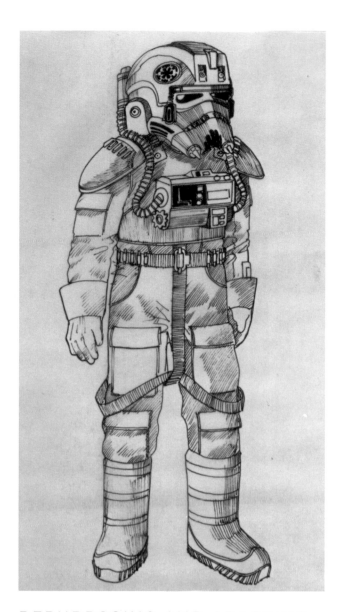

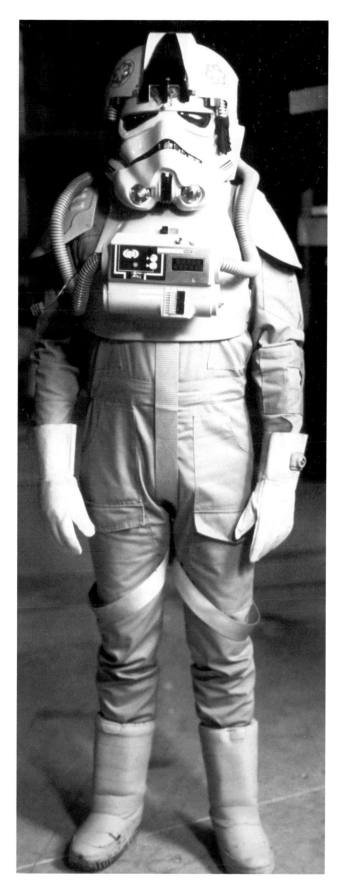

REPURPOSING AND ADAPTING

Because *Empire*'s production had fallen behind schedule and gone over budget, John Mollo's team had neither the time nor money to create all new costumes from scratch. For example, the two AT-AT driver costumes were repurposed from TIE fighter pilot costumes—which had been created from repurposed stormtrooper pieces during the filming of *Star Wars*. They repainted and refinished the black TIE fighter helmets and body armor and added new insignia and decals, as well as greeblies to the chest pack and an electronic component to the back plate. Perhaps the best example of an artistic decision driven by deadlines and thrift was the AT-AT pilots shoulders, which were inverted snowtroopers' shoulder armor. Comparative photos reveal AT-AT pilots'

LEFT: Concept sketch for the AT-AT driver; one of two AT-AT driver costumes by John Mollo, circa late 1978, which featured repurposed parts from other costumes. **RIGHT:** Reference photo of the complete AT-AT driver costume, 1978.

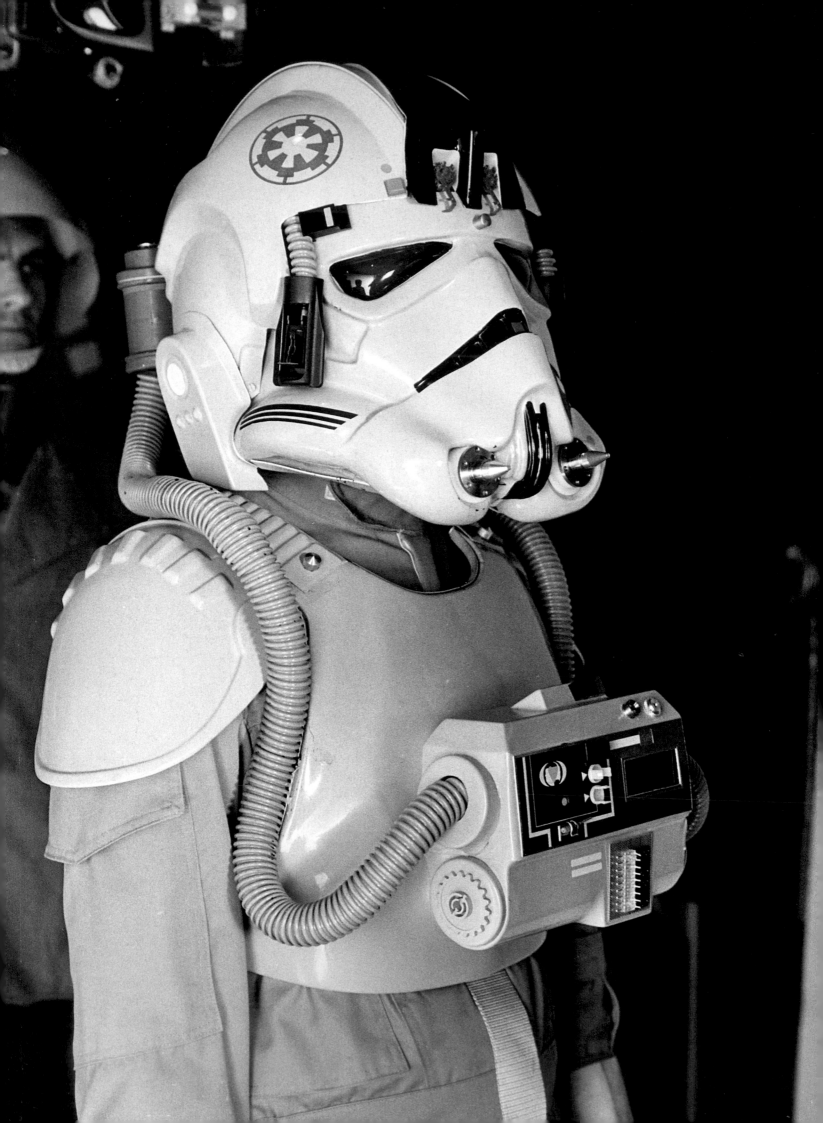

shoulder armor "upside down" from their snowtrooper counterparts.

Although only two AT-AT driver costumes were produced for *Empire*, costumers added red stripes to the back of the helmets for some shots. The red stripes would effectively designate different AT-AT drivers were at the controls of different AT-ATs.

Not only was stormtrooper armor used to create various pilots and drivers within the Imperial armor, but pieces of white armor cropped up in other costumes.

The Empire Strikes Back introduced six bounty hunters: Boba Fett, the droids IG-88 and 4-LOM, the aliens Bossk and Tuckuss (later renamed Zuckuss), and the humanoid Dengar. Although concept artists and costumers invested many hours into developing and refining Boba Fett's costume before they even had a script for *Empire*, the remaining costumes were produced relatively quickly by utilizing previously used props and costumes.

Dengar, played by actor Morris Bush, wore a combination of stormtrooper body armor and a snowtrooper chest plate with various greeblies that were all painted brown and attached to a jumpsuit. His boots and gloves were repurposed from the Hoth rebel costumes. The diverse assemblage suggests Dengar may have appropriated his armor and clothes over the course of various bounty hunts.

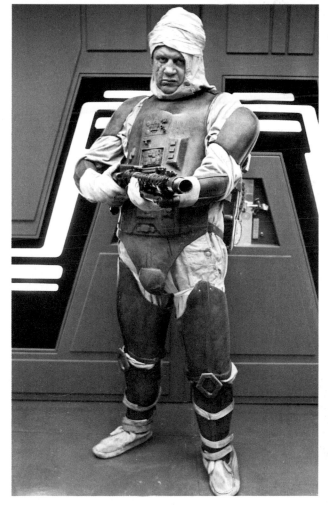

OPPOSITE: Close-up of a costumed AT-AT driver on the set of *Empire*, 1978. Note the additional detail to the forehead, mouth, and temples of the helmet with the familiar stormtrooper eyes and nose. **TOP:** Film still from *Empire* (1980), with a rear view of the two AT-AT driver costumes, each modified with a red stripe on the back of the helmet. **BOTTOM:** Actor Morris Bush poses as the bounty hunter Dengar, who appears to wear "scavenged" Imperial armor, 1978.

EMPIRE PREMIERE

Although numerous production challenges, including a blizzard in Norway and a huge fire that burned down Stage 3 at Elstree Studios, caused *The Empire Strikes Back* to fall behind schedule and go over budget, *Empire* was released as planned. The world premiere was held on May 17, 1980, at the Kennedy Center in Washington, D.C., with most of the principal actors in attendance. In London, the film had a Royal Charity Premiere at the Odeon Cinema in Leicester Square on May 20. For the London premiere, Lucasfilm and Twentieth Century-Fox resurrected a British holiday, Empire Day, which members of the British Empire had observed between 1902 and 1958 to celebrate Queen Victoria's birthday on May 24.

Although Empire Day was subsequently changed to British Commonwealth Day and finally Commonwealth Day in 1966, Lucasfilm believed their own "Empire Day" would resonate with the British public. On May 20, costumed stormtroopers appeared throughout London to hand out buttons reading "Happy Empire Day" and to stage promotional photo ops. *Empire* was a critical and commercial success. Gene Siskel, film critic for the *Chicago Tribune*, said, "*The Empire Strikes Back* joins *The Godfather, Part II* as one of the rarest of films—a sequel that lives up to and expands upon its original." *Empire* also boasted a cliffhanger ending that gave new meaning to audacious and left audiences eagerly awaiting the concluding chapter of the *Star Wars* trilogy.

ABOVE: To publicize the premiere of *Empire* (1980) in London on Tuesday, May 20, 1980, Twentieth Century-Fox dispatched stormtroopers for humorous photo opportunities. **OPPOSITE:** Princess Leia (Carrie Fisher) held at blaster point by a couple of costumed stormtroopers on the set of *Empire Strikes Back*, 1978.

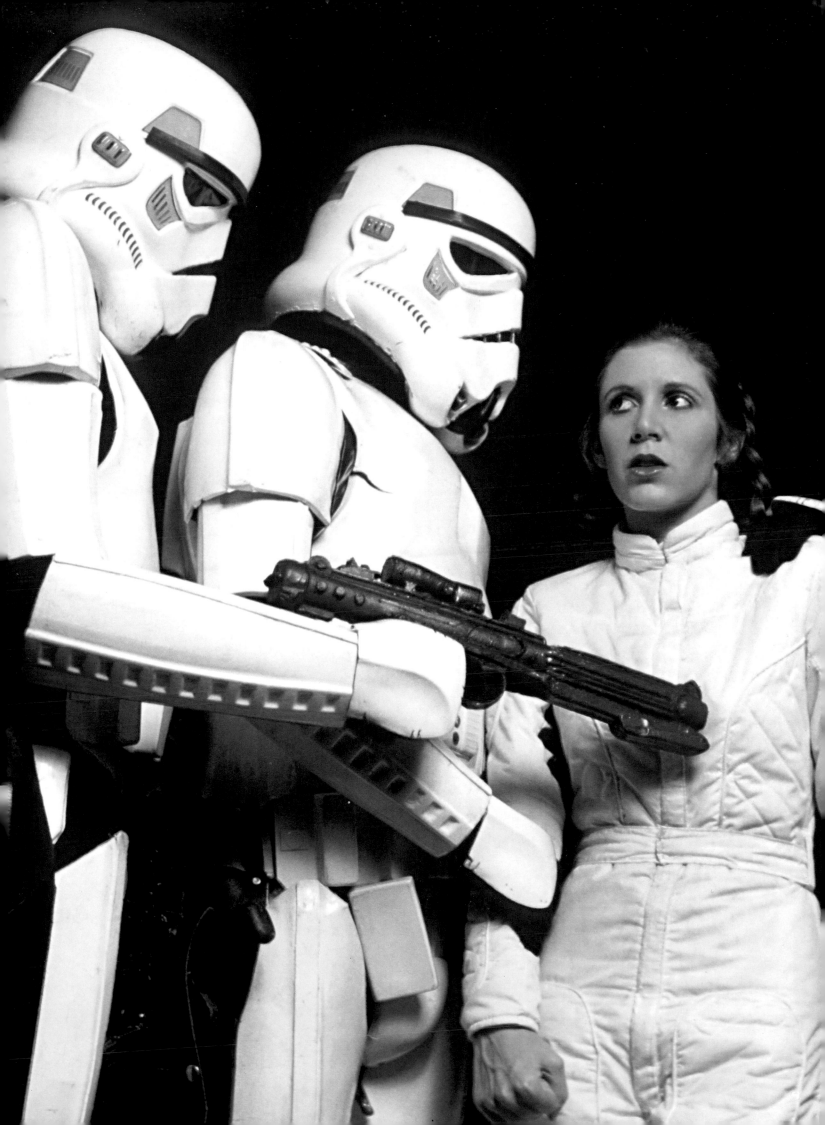

MINI-RIGS

By the time of *Empire*'s release, a combination of inflation and the increasingly higher price of plastic moti-vated Kenner to produce a line of smaller, relatively inexpensive vehicles as accessories for *Star Wars* action figures. The result was a line dubbed Mini-Rigs, which Kenner designer Mark Boudreaux developed and designed from scratch. Like Kenner's Imperial Troop Transporter, the Mini-Rigs did not feature vehicles seen on-screen in *Star Wars* or *Empire*, but Boudreaux championed the idea that they were *Star Wars* vehi-cles that were "just out of camera range."

In spring 1981, Kenner released the first wave of Mini-Rigs, which included the Imperial-oriented MTV-7 (Multi Terrain Vehicle) and INT-4 (Interceptor). According to Kenner's 1982 Toy Fair catalog, the MTV-7 is "used by the Empire to scout the hostile ice planet, *HOTH*. It carries one Action Figure. It has spring-loaded legs and a movable laser cannon." The INT-4 has "an opening hatch and movable laser cannon," features "landing skids and remote controlled wings to fly short missions," and "even fits in the body of an AT-AT!"

"The fortifications surrounding Echo Base inspired the design of the MTV-7," says Boudreaux. "We—there were actually two of us working on 'breadboard' concepts for the first three Hoth rigs—[Mark B. and Mark D.]. Mark came up with the idea for a vehicle that could lower its profile, enabling the Imperial snowtroopers to use the rebels' own trenches to attack and outflank the Hoth troopers. The original bread-board used large diameter foam wheels attached to an articulated frame. I then refined the design to what you see in production.

"The look of the INT-4 was inspired by the head of the AT-AT/AT-ST. I thought of the AT-ATs like a naval task force, deploying aerial assets to protect the fleet. Since the interior of the toy version of the AT-AT was quite large, the idea was to develop a 'carrier-based' attack fighter with folding wings."

Kenner used the release of *Return of the Jedi* to launch another Mini-Rig, the ISP-6 (Imperial Shuttle Pod). "ISP-6 took on the look of the Imperial Shuttle," Boudreaux says. "The concept was to provide Darth Vader with his own personal transport craft. The features of the large shuttle inspired the features incorpo-rated into the Mini-Rig. I really liked being able to build in a simple mechanism that would allow the wings to automatically fold up when landing." Kenner's 1983 Toy Fair catalog describes the vehicle as "always ready to provide fast transport for the Imperial forces from their shuttle to other bases of operation. Its rear viewing mirror and movable wing cannons are indispensable when under rebel attack." Kenner's much larger Imperial Shuttle shipped the following year.

ABOVE: The INT-4 box, ISP-6 (top) and MTV-7 (bottom) were three Imperial vehicles from Kenner's relatively inexpensive line of Mini-Rigs for *Star Wars* action figures.

BIKER SCOUT

Preparation for *Return of the Jedi* began almost immediately following the May 1980 release of *Empire*. In the fall of 1980, Lucasfilm enlisted Ralph McQuarrie, Joe Johnston, and Nilo Rodis-Jamero to begin creating concepts for *Return of the Jedi*. Just as *The Empire Strikes Back* introduced an Imperial soldier equipped for an ice planet, *Jedi* introduced a soldier outfitted for a forest world. George Lucas encouraged the idea of an Imperial biker scout, which the designers initially referred to as the "scooter trooper," as they were to be soldiers with more advanced tactical training that would ride a vehicle Lucas described as a "rocket-powered scooter." Their early sketches for the vehicle displayed a variety of bulked-up engines and seating configurations, with some resembling aerial go-karts. Rodis-Jamero drew "moveable directional vanes" on the front of one craft, and Johnston incorporated the vanes onto a spindlier, dart-like bike.

With the design of the bike taking shape, the artists honed the look of the troopers. It became immediately obvious that a standard trooper simply did not look right atop the bike. "The biker is lighter, he can move faster," Rodis-Jamero says. "They carry pistols. They're more of a surgical team. Stormtroopers are almost like blunt instruments. . . . [Biker scouts] had to look lighter. The audience could [identify them] immediately—I get it; this is the SWAT team. They go faster and cut deeper."

In the summer of 1981, Lucasfilm brought in Richard Marquand to direct *Jedi*, and his interest in the film's sequential visual structure led him to collaborate with Rodis-Jamero on storyboards for several scenes. Marquand was so impressed by Rodis-Jamero's concepts and sketches that he proposed to George Lucas that Rodis-Jamero should be *Jedi*'s costume designer. Although Rodis-Jamero was enthusiastic about the opportunity to design costumes, he admittedly had no experience with manufacturing costumes. Jim Bloom, the

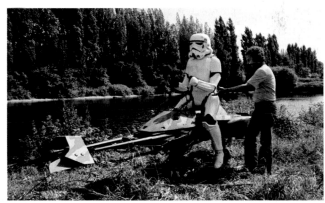

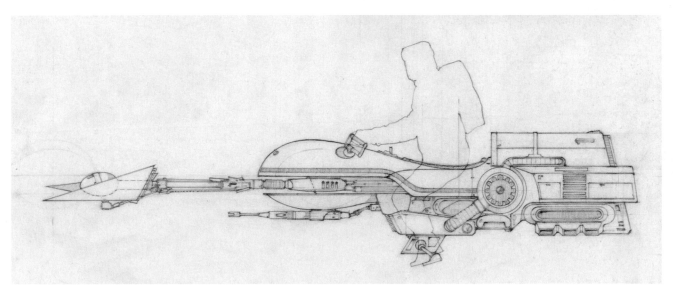

TOP LEFT: Concept sketch of an Imperial scout on a speeder bike by Nilo Rodis-Jamero, 1981. **TOP RIGHT:** This photo of assistant art director Michael Lamont with a stormtrooper mounted on a speeder bike at Elstree Studios confirmed that standard stormtroopers made the vehicle look "top heavy." **BOTTOM:** Schematic for the full-size speeder bike prop.

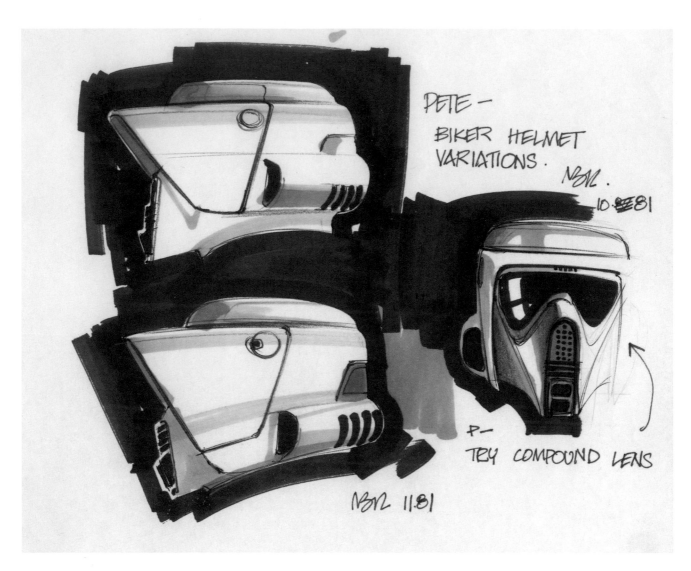

PETE —
BIKER HELMET
VARIATIONS.
NBR.
10.3781

NBR 11.81

P —
TRY COMPOUND LENS

co-producer of *Jedi*, suggested Rodis-Jamero should collaborate with costume designer Aggie Rodgers, whose credits included Lucas' *American Graffiti* and *More American Graffiti*.

For *Star Wars* and *The Empire Strikes Back*, studio craftsmen and technicians with extensive experience in creating specialty costumes and props manufactured the costumes with hard-surfaced components such as helmets and armor. But for *Jedi*, the producers assembled an in-house production team that consisted largely of industrial designers and pattern makers who had never worked on films before. Industrial designer Pete Ronzani led a team that included sculptor Chuck Wiley, industrial designer Richard Davis, sculptural designer Jim Howard, and pattern makers Ira Keeler and Sam Zolltheis, with additional assistance from Ron Pleschia and Gordon Vogel. The women in the costume department referred to Ronzani's team as the "plastic boys." Their first

assignment, in the fall of 1981, was the biker scout costume.

"We started on the biker costume because that was the most complex," Ronzani says. "It was a challenge to make it all work during filming and during the stunts."

"When the script was being developed," Rodis-Jamero says, "the scouts were always in action. And when I looked at the hard shell of the stormtrooper, I thought, *They can't move*. It's impossible. So I pitched the idea to George that it's more cloth than anything. If you look at the outfit, it's mostly cloth. It appears to be hard, but it's not." Rodis-Jamero's early sketches for the biker scout explored possibilities for open-faced helmets but he eventually shifted to the idea of a face-concealing helmet with an adjustable visor that could tilt up and away from the face. "The flip-up face was actually born during a conversation I had with George. He was complaining about the fact that normally when he

ABOVE: Nilo Rodis-Jamero's concept sketches explore the lines of the biker scout helmet's visor and overall profile, November 1981.

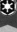

MICRO COLLECTION

Howard Bollinger was vice president of product design and engineering at Kenner when he conceived the *Star Wars* Micro Collection, a line based on painted die-cast metal figures packaged with vehicles or modular playsets. The playsets could be fitted together to construct the "worlds" of the Death Star, Hoth, and Bespin. To ensure the proper detail, Kenner artists sculpted the figures two to four times the size—or "four-up"—of their final production size. The resulting Micro Collection figures were about 1¼ inch tall and in fixed poses, without any articulation.

Four Micro Collection play-sets—Death Star Escape, Death Star Compactor, Hoth Generator Attack, and Bespin Freeze Chamber—came with stormtrooper figures, and a Micro Collection Imperial TIE fighter came with a TIE fighter pilot. Each playset and vehicle featured a "Build Your Armies" mail-in offer. By send-ing proof of purchases to Kenner, the buyer would receive three Hoth rebel soldiers and three Hoth storm-troopers, including one manning a tripod-mounted laser cannon.

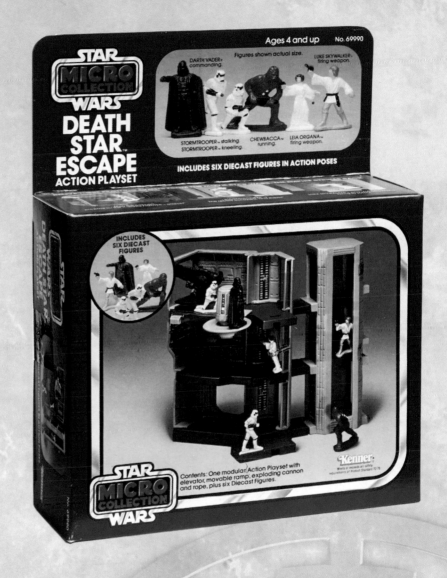

Kenner employees not only designed the Micro Collection figu-rines, but posed for them too. Mark Boudreaux recalls, "Charlie Kovach was a part of the sculpting group that developed the four-up sculp-tures. At the time, I worked in the Preliminary Design Department, so my responsibility was to develop the designs and generate the layout drawings for all of the preliminary models that were made. The design-ers took turns in front of the 'spot-light.' We set up four SLR 35mm cameras in a conference room, one in each corner, with the designer posed in the center. On the count of three, we all pressed the shutter release!"

The Micro Collection launched in the summer of 1982, and Kenner planned to produce additional play-sets beyond the initial run. Unfortunately, Kenner soon realized by way of sales reports that *Star Wars* fans preferred to buy larger, articulated action figures. By January 1983, Kenner discontinued the Micro Collection line.

ABOVE: The Death Star Escape Action Playset was part of Kenner's short-lived *Star Wars* Micro Collection line that included two die-cast stormtrooper figures.

is ready to go, to call for action, the stormtroopers had to put their helmets on because they didn't like to put their helmets on until the last minute. George was saying, 'Oh my God, the time they cost me.' So I go, 'You know, there's a roundabout way of solving that. Just make a flip-open face mask, so they're always wearing the helmet. And make sure it's comfortable.'"

Collaborating on the biker scout helmet with Ronzani, Rodis-Jamero approached the job "as a practical and industrial design assignment. First, I wanted ventilation to the head. Number two, could it move when they were supposed to move? Number three, it had to open and it had to survive the shooting schedule. People would keep flipping it up and down, up and down until it broke, right? So we were prepared for that. We were assuming that a percentage of them would break, so we upped the percentage of our manufacturing."

Originally, the production required twelve biker scout suits for ten biker characters. By the time filming started, the costume department produced twenty-four biker scout suits and an additional six stunt helmets. *Jedi* stunt coordinator Glenn Randall requested the stunt helmets, which the costumers fitted around crash helmets. The stunt helmets also had face plates molded in a soft urethane for use in crash and impact shots.

Working from Rodis-Jamero's sketches, Jim Howard sculpted the mock-up version of the biker scout helmet in plasticine clay. After Rodis-Jamero and Lucas approved the

clay mock-up, Ira Keeler translated it into a pattern that he carved from wood, and which would be used to form sheets of plastic into wearable components. For the armor, Sam Zolltheis translated the clay mock-ups into patterns that he made from rigid foam and Bondo, an auto-body filler that can be shaped and sanded easily to produce a smooth finish. According to Chuck Wiley, Zolltheis "made his patterns out of anything he could find. The biker chest plate was made out of two-by-fours, pressboard, chicken wire, plaster, and Bondo." After the sculpted patterns were finished, they went onto a vacuum-forming machine to form the helmet pieces and armor in haircell ABS plastic. Richard Davis was the principal painter for the hard components, and he wet-sanded the pieces before using a polishing compound to produce a mirror finish. Ronzani's team assembled the pieces and also designed and vacuum-formed the pistols for the biker scouts.

For the costume's soft components, Aggie Rodgers' wardrobe team adapted a store-bought Avirex jumpsuit for the base layer, similar to jumpsuits used for the rebel pilot costumes. Costumers added dyed suede patches to the thighs and a leather panel to cover the seat of the trousers. They created a custom top with short quilted raglan sleeves to cover the upper half of the jumpsuit, and a midriff belt of polished white cotton that held canvas cargo patches. A dickey with a trapunto-quilted neck concealed the gap between chest armor and helmet, and modified motorcycle gloves covered the hands. Boot maker John Schrader applied

TOP LEFT: Plasticine clay mock-up of the biker helmet by Jim Howard. **TOP RIGHT:** Pete Ronzani (left) and Nilo Rodis-Jamero (right) inspect the biker scout helmet in progress, fall 1981.

EMPERIAL BIKER
BOOTS

ADD ON

PETE !

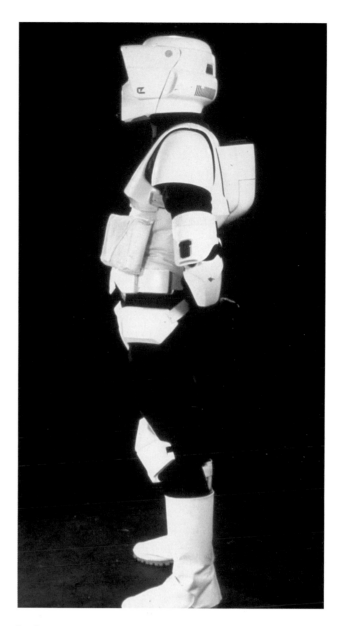

leather upper covers to Sierra Trading Post desert hiking boots, transforming them into footwear for the biker scouts.

When Richard Davis modeled the biker scout suit for George Lucas, it was not quite finished. "I was making the holsters for the gun at the time," Ira Keeler says, "and [members of the production team] said, 'You know what, we need to get that gun on so George can see it. How fast can we do it?' I remember I was down on my hands and knees, drilling a hole through the boot . . . We riveted on the holster while Dick had his foot in the boot, with George standing there. I was very carefully holding my hand inside trying not to drill a hole in his foot." Fortunately, Keeler left Davis' foot unscathed, and Lucas approved the biker scout costume.

TOP LEFT: Detailed sketches of biker footwear by Rodis-Jamero, 1981. **TOP RIGHT:** A test fitting of the biker scout costume, 1981. **BOTTOM:** Reference photo of the biker scout boot with the holster for a blaster pistol on the ankle.

MK II STORMTROOPER UPDATED

The Mk II stormtrooper costumes produced for *The Empire Strikes Back* were only three years old and remained in good condition when *Return of the Jedi* began filming. However, *Jedi* required many additional stormtrooper costumes, so wardrobe supervisor Ron Beck directed the wardrobe team at Elstree to create approximately fifty new helmets and suits of armor.

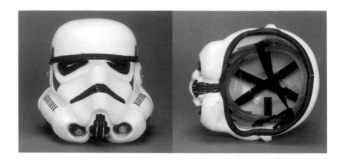

Plasterers reused the molds for the Mk II armor and helmets for the *Jedi* stormtrooper suits, which were vacuum-formed from ABS plastic in the Elstree plasterer's shop. Like the Mk II, the armor was trimmed by hand, edged with a vinyl trim, and assembled with an elastic rigging system. The *Jedi* stormtrooper armor differed from the Mk II in the type of plastic used, which gave them a pristine white finish.

The helmets were distinguished by an adjustable plastic liner, similar to those used in construction hard hats. Glued inside the helmet, the plastic liner kept the helmet in place better than the previous foam-lined versions and allowed the helmet to turn when the actors turned their heads.

Sign-writer Bob Walker provided various graphics for the helmets, which were again fitted with bubbled green lenses. However, stunt coordinator Glenn Randall anticipated the vision-distorting lenses would cause problems for his stunt performers, and he requested a number of helmets be made with high-quality lenses to provide clearer vision. Pete Ronzani's plastics team developed a special mold to form lenses that had the least distortion possible.

The *Jedi* stormtrooper costumes were first used at Elstree for the shots with the Emperor arriving aboard the second Death Star. Afterward, the costumes were shipped to the U.S., where the redwood forests of Smith River, California,

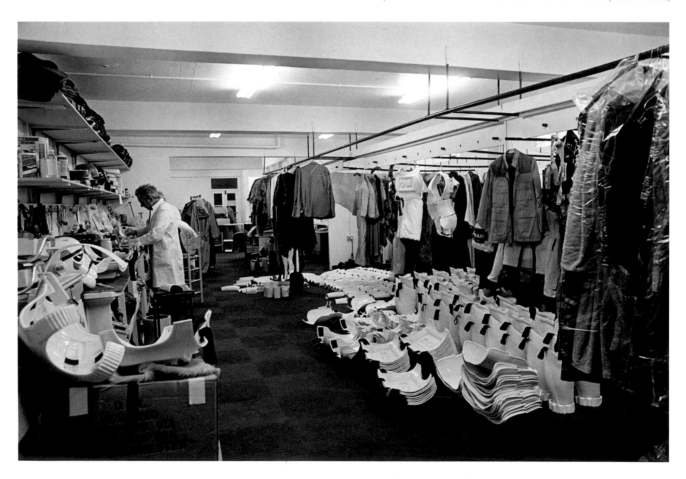

TOP: Produced for *Return of the Jedi*, new stormtrooper helmets were upgraded with interior liners to make them more comfortable.
BOTTOM: Wardrobe assistant Patrick Wheatley prepares newly manufactured stormtrooper costumes at Elstree Studios.

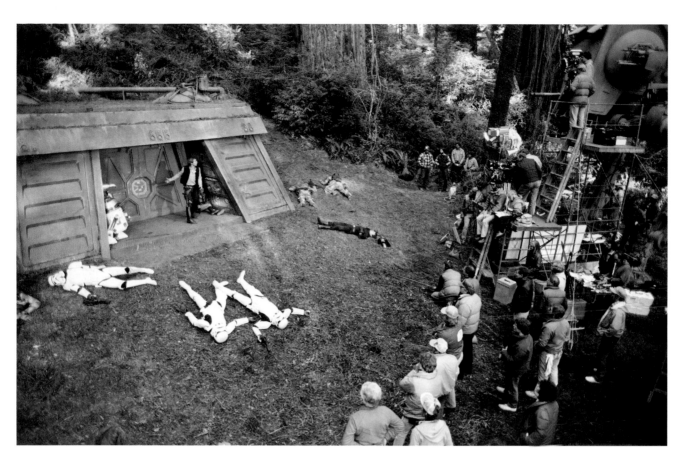

would double as the site of an Imperial base on the Forest Moon of Endor. The paint department and wardrobe team used black and brown spray paint to deliberately distress the armor, making the stormtroopers look as if they'd been stationed in the forest for months.

Impromptu modifications to the costumes were made for practical purposes. When scenes required actors in stormtrooper costumes to run and fall, white towels were stuffed under the armor to offer some protection. However, the plastic armor was hardly impervious; armor began to break, and the elastic rigging systems between components began to fail. And despite the minimal-distortion lenses in helmets worn by stuntmen, they still had extremely limited vision, which was potentially hazardous while working on the location's uneven terrain. At costume supervisor Mary Still's request, the wardrobe department in San Rafael, California, produced some flat lenses for the helmets.

For the climactic battle sequence on Endor, the special effects department rigged a number of stormtrooper chest plates with explosive squibs. After cutting blast-shaped holes through the armor, and airbrushing blue and black

paint around the holes, the special effects team applied a paper-thin layer of plastic to the outside surface and placed squibs behind the precut holes. When an effects technician detonated the charges by remote off-camera, a spark-filled explosion would blow through the thin plastic surface, revealing the precut hole and airbrushed "scorch" marks.

When production wrapped in California, the *Jedi* stormtrooper costumes were retired. Except for occasional promotions, the costumes would remain locked away for more than a decade.

TOP: Stormtroopers are scattered on the ground as Han Solo talks to Chewbacca in the AT-ST as the cameramen and crew look on, 1982.
BOTTOM: The inside of this stormtrooper chest plate shows the cut and patched hole where an explosive squib would be attached.

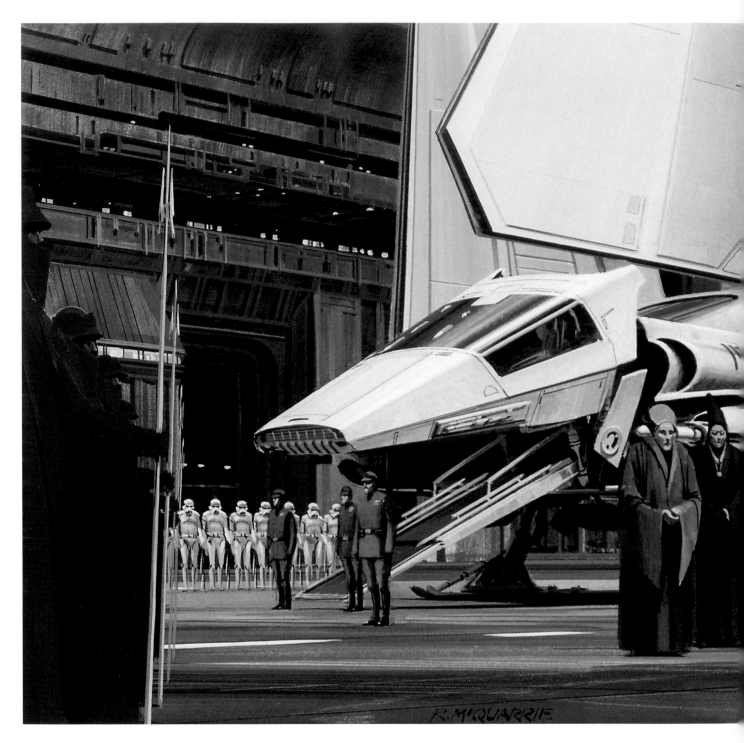

R.M CQUARRIE

EMPEROR'S ROYAL GUARD

"I was looking for an angle to describe the Emperor without describing the Emperor," says Nilo Rodis-Jamero of his concept for the Emperor's royal guard. "To me that's what good design is—you surround the main course with something that implies more." The crimson-robed figures are to the Emperor what the white-armored stormtroopers are

to Darth Vader: accessories that look best when bracketing their superiors—like lethal bookends.

The royal guards only appeared in a few scenes in *Return of the Jedi*, but they were entirely Rodis-Jamero's idea. "I kept pitching to George that this one guard defines the Emperor," Rodis-Jamero says. "It became that red guard, [the one that] actually didn't do anything other than stand there. George

ABOVE: While stormtroopers and royal guards stand at attention, Vader arrives on the second Death Star in this production painting by Ralph McQuarrie.

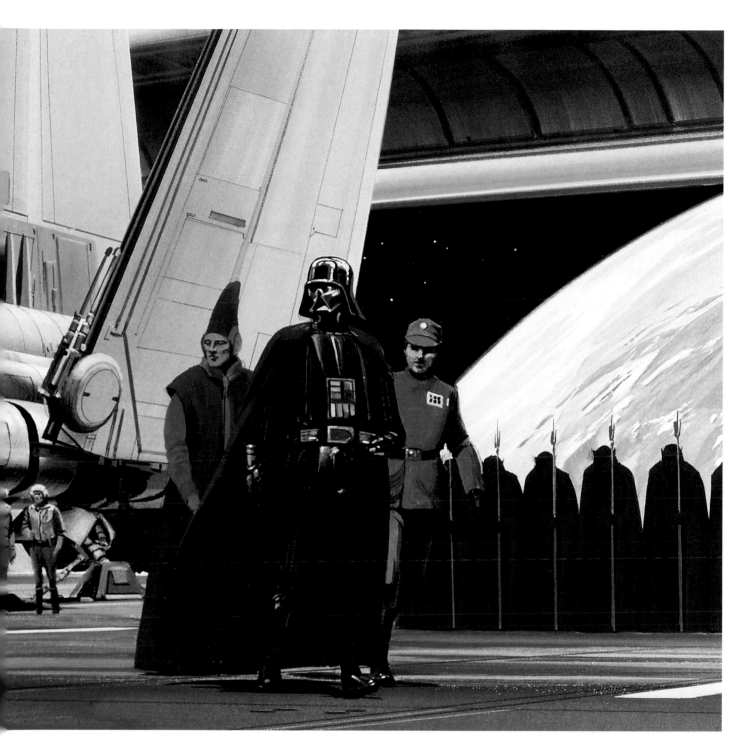

really paid attention to those things that were never in the script. That's the beauty of working with him. They belonged to that moment and that scene. It was easy to describe that to him and to get through to him, and off you go."

Aggie Rodgers' experience on *American Graffiti* influenced the choice of color for the guard's helmet and cloak. "They wanted to have the red guards an ordinary red,"

Rodgers says. "But I said, 'Oh no—it's George Lucas.' I had done a whole movie with candy apple red cars with him. So it had to be the suckling candy apple red!" Textile artist Edwina Pellikka matched a Pantone color to dye the velvety material for the cloaks, and stitcher Laurie Rudd constructed six robes for the film. The costume department created a set of undergarments that included a

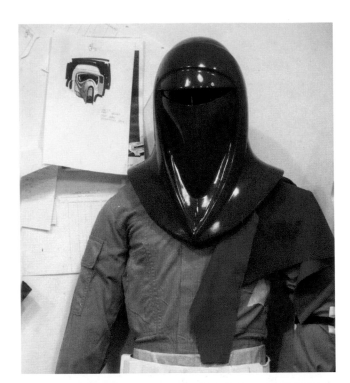

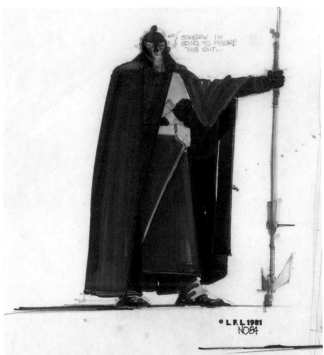

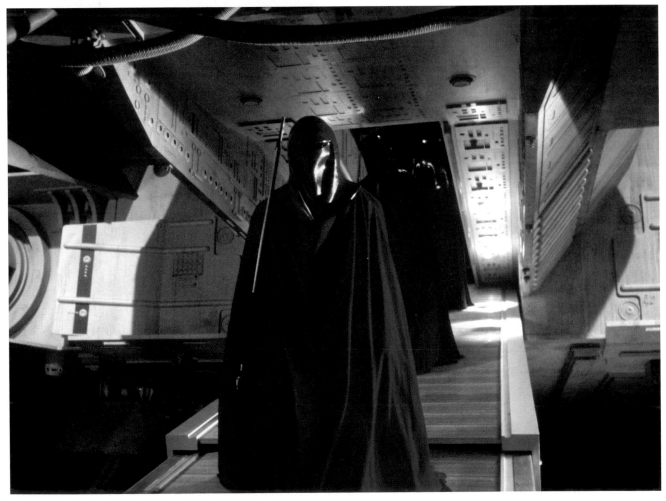

ABOVE LEFT: Elements of the Imperial Guard costume assembled on a mannequin in the workshop. **ABOVE RIGHT:** Early concept sketch of an Imperial Guard by Nilo Rodis-Jamero, 1981. **BOTTOM:** Members of the Imperial Royal Guard descend from the Emperor's shuttle in *Return of the Jedi*.

LEGENDS

WHO ARE THE ROYAL GUARDS?

Just as the first three *Star Wars* movies offered no information about the identities of stormtroopers, *Jedi* reveals no on-screen information about the royal guard. The shooting script for *Jedi* does not include mention of the royal guard's first appearance in the movie, when they disembark from the Emperor's shuttle. In fact, the script mentioned the guards only once, when Darth Vader entered the Emperor's throne room on the Death Star.

> Two red Imperial Guards stand watch at the elevator as the door opens to reveal Vader.

Lucasfilm provided a shooting script as well as production stills for author James Kahn to write the *Jedi* novelization, but given the limited information about royal guards, Kahn had to rely on his imagination. After the Emperor's shuttle arrives in the Death Star hangar . . .

> The shuttle came to rest on the pod. Its ramp lowered like a dragon jaw, and the Emperor's royal guard ran down, red robes flapping, as if they were licks of flame shooting out the mouth to herald the angry roar. They poised themselves at watchful guard in two lethal rows beside the ramp.

Later, when Vader visits the Emperor's throne room . . .

> Two royal guards stood either side of the door, red robes from neck to toe, red helmets covering all but eye slits that were actually electrically modified view-screens. Their weapons were always drawn.

Other books would eventually introduce more information about the royal guard.

tabard with an obi, boots, and gloves—all dyed in a deeper maroon color.

Jim Howard sculpted the initial version of the royal guard's helmet, which was designed to fit very tightly to the wearer's head. Rodis-Jamero says, "The original notion was to make it as narrow as possible. If it looked impossible to fit on a human head, then perhaps it wasn't human." Pete Ronzani was the model for the test fit for the helmet. He trimmed the first completed plastic parts and assembled them with duct tape.

The resulting costume? Actors were unable to turn their heads side to side, their left arms were totally pinned by the cloak, and they required ongoing attention from the dressers. Audiences would never guess that the gaunt, streamlined helmets and heavy velvet cloaks were secured to each other with clips from dog leashes. Because the royal guards looked simultaneously imposing and mysterious, they *worked*.

Although *Return of the Jedi* effectively wrapped up the original *Star Wars* trilogy and left many fans believing that the rebel heroes had defeated the Empire once and for all, the *Star Wars* saga was hardly over. And the stormtroopers were just getting warmed up.

"STORMTROOPERS" NO MORE?

Random House published numerous *Star Wars* tie-in, spin-off, and pop-up books to coincide with the releases of *Star Wars*, *The Empire Strikes Back*, and *Return of the Jedi*, and many of those books featured Imperial stormtroopers. Interestingly, Random House *Star Wars* books released during the publishing campaign for *Jedi* in 1983 did not contain the word "stormtroopers," and typically replaced that word with "Imperial troops." One may assume an editorial directive forced the change, possibly to avoid a word that had long been associated with the Nazi political militia. However, many *Star Wars* fans must have been baffled by text for the two-page spread in *The Ewoks Join the Fight* (1983), as the text indicates "a dozen Imperial scouts" bursting into a control room even though the illustration clearly shows five stormtroopers.

After the *Jedi* publishing campaign, the word "stormtroopers" remained largely absent from Random House *Star Wars* books until the 1990s. A rare exception was Lee J. Ames' *How to Draw Star Wars Heroes, Spaceships, and Other Fantastic Things* (1984), which presented instructions for drawing an Imperial stormtrooper in ten steps.

STORMTROOPER ALLIANCE

In 1983, after the release of *Return of the Jedi*, Marvel Comics editor Louise Simonson encouraged aspiring writer Randy Stradley to pitch a story for *Star Wars*. Stradley proposed an adventure in which a stormtrooper crashes his TIE fighter after he shoots down Princess Leia's shuttle on the planet Yinchorr, and the trooper and Leia form a temporary alliance to survive before Leia reunites with Han Solo. Stradley's script, "The Alderaan Factor," was not only the first *Star Wars* story to depict a stormtrooper removing his helmet, but also Stradley's first professional work in comics.

To heighten the drama, Stradley conceived that the stormtrooper was a native of Alderaan and a former servant from Leia's palace. "It just made sense that creating some kind of connection between the stormtrooper and Leia would up the drama of their confrontation," Stradley said. "Also, while we, the readers, were introduced to Leia as a woman of action, a real down-to-earth dame, she was still a princess. I

figured there had to be some people who resented her wealth and privilege—possibly even some from Alderaan—and a few of them might seek out service to the Empire as a way to advance themselves or even seek vengeance on a system that put them on the lowest rung."

Given that Kenner had marketed TIE fighter toys with photos of stormtrooper action figures as pilots, perhaps it's not surprising that few *Star Wars* fans questioned why Stradley's story didn't feature a TIE pilot instead. Stradley says, "Until just a few years ago, no one ever asked me why a stormtrooper was piloting a TIE fighter. You have to remember that this was back in the day when VCRs were priced between $400 and $700—far beyond the reach of a struggling freelancer—and the Internet was still ten years away, so there was no opportunity to review any of the films to refresh my memory on details. In my mind, I knew I wanted Leia to confront a stormtrooper, so I wrote 'stormtrooper.' I never heard a word from the editor, or from Lucasfilm via her, or from artist Bob McLeod. My suspicion is that either we had all forgotten that TIE pilots wear black uniforms, or we were all just asleep at the wheel." Although published a year after the release of *Jedi*, "The Alderaan Factor" began with a continuity note to indicate the story takes place *before* the events of *Jedi*. Did the unmasked stormtrooper have anything to do with that particular time setting? "I have no idea what, if any, discussions occurred between Marvel and Lucasfilm regarding the events and images in my story," Stradley says. "The only feedback that I *know* came from Lucasfilm was that I was asked to set the story, which I originally set after *Return of the Jedi*, sometime between *The Empire Strikes Back* and *Jedi*. I have no idea why that request was made, but I dutifully changed Han to Luke and the story was accepted."

ANIMATED TROOPS RETURN

Produced by Nelvana on behalf of Lucasfilm, the animated cartoon series *Star Wars: Ewoks* and *Star Wars: Droids: The Adventures of R2-D2 and C-3PO* premiered on the ABC television network on the morning of Saturday, September 7, 1985. Stories for *Ewoks* were set prior to the events of *Return of the Jedi* while the *Droids* stories were set before the events of the first *Star Wars* movie, which had been

ABOVE AND OPPOSITE: Cover art and interior page from *Star Wars #86:* "The Alderaan Factor" (Marvel Comics, 1984), written by Randy Stradley, penciled by Bob McLeod, and inked by Tom Palmer.

RAARR!

LEIA!

I'VE GOT YOU! DON'T WORRY. JUST HAND ME THE *GUN.*

YEAH, SURE. THEN YOU LET ME *FALL,* RIGHT?

YOU UNDERESTIMATE ME, PRINCESS.

BESIDES, I *OWE* YOU FOR SAVING ME FROM THE MONSTER. SAY, YOU'RE *HEAVIER* THAN YOU LOOK!

LIGNN!

≤WHEW!≥

WE MAKE A PRETTY GOOD *TEAM* DON'T WE, *PRINCESS?*

16

retitled *Star Wars: A New Hope*. Several episodes of *Ewoks* and *Droids* feature Imperial stormtroopers.

Because of ABC's Standards and Practices Board, the animated stormtroopers were not allowed to brandish blaster rifles or pistols. In the Summer 1985 issue of *Bantha Tracks*, the journal of the official *Star Wars*/Lucasfilm Fan Club, Lucasfilm executive producer Miki Herman explained: "Nobody ever gets killed on Saturday morning network television. You can get stunned. But, if someone is stunned and knocked down, you have to show them moaning. That's because the network feels it would be very traumatic for the kids if the character doesn't recover immediately. That's for heroes. For bad guys, you can have them done in by their own evil deeds. But again, no blood. They can disappear. No human or droid with human characteristics can get killed."

And so the creative team at Nelvana armed the storm-troopers with weapons that didn't resemble blaster rifles or pistols. In the *Droids* series, stormtroopers wield long pikes that release beams of energy that "demobilize" targets, causing droids to shut down. In *Ewoks*, stormtroopers

carry baton-like weapons with distinctive handgrips. Like their live-action counterparts, the animated troopers keep conversation to a minimum.

Random House published a series of *Droids* tie-ins and spin-offs, including the picture book *Escape from the Monster Ship*, an adaptation of "Tail of the Roon Comets," the tenth episode of *Droids* and the first to feature stormtroopers. Apparently in keeping with Random House's then-current policy to avoid the word "stormtroopers," the book's narra-tive refers to the illustrations of white-armored individuals as "guards," and without any mention of the Empire or an Imperial affiliation. One can assume that most readers identified the guards as stormtroopers.

THE EPIC CONTINUES?

By the mid-'80s, interest in *Star Wars* had largely waned because Lucasfilm did not have any immediate plans to make more *Star Wars* films. Although Kenner Products was aware that interest in *Star Wars* toys had declined, in 1984

ABOVE LEFT: Mungo Baobab, a hero from the *Droids* cartoon series, subdues two stormtroopers in an illustration that Kenner intended for the card back of a Baobab action figure that was only produced as a prototype. **ABOVE RIGHT:** *Star Wars #107*: "All Together Now" (Marvel Comics, 1986), cover art by Cynthia Martin and Joseph Rubinstein, including the definitive "Last Issue" label.

they proposed a new line of toys, The Epic Continues, which they hoped to release in 1986, and which would have featured Clone Warriors. But Lucasfilm rejected Kenner's proposal.

In 1986, Marvel Comics published *Star Wars* #107, with the words "LAST ISSUE" prominently displayed on the cover. Later that year, ABC canceled the animated series *Ewoks and Droids Adventure Hour*, which had presented new *Ewoks* cartoons with previously broadcast episodes of *Droids*.

WEST END TROOPERS

By 1986, *Star Wars* licensing had all but flatlined. Fortunately, one new licensee, West End Games (WEG), kept the franchise alive. Founded by Daniel Scott Palter in 1974, WEG began as an independent publisher of historical and fantasy board games. In 1986, WEG released *Star Wars*: The Roleplaying Game, which contained rules and guidelines for game masters and players and featured previously published art by Ralph McQuarrie and Joe Johnston. The following year, WEG released *The Star Wars Sourcebook* by Bill Slavicsek and Curtis Smith, which included detailed information about standard stormtroopers, Cold Assault Troops, and Scouts.

The Star Wars Sourcebook also introduced Zero-G stormtroopers, an elite division "trained to operate exclusively in outer space. Imperial spacetroopers are deadly commandos of the highest order, second only to the Imperial Royal Guard in training, dedication, loyalty, and destructive capability." Although the *Sourcebook* didn't feature any illustrations of the spacetroopers, subsequently published sourcebooks—notably *Star Wars: Imperial Sourcebook* by Greg Gorden (1994)—present the troopers wearing bulky suits of armor that perform as personal spacecraft and attack vehicles.

WEG contracted Grenadier Models Inc. to produce miniature metal figurines of *Star Wars* characters to supplement the role-playing game WEG released with the initial round of *Star Wars* miniatures in 1988, and the figurines became popular collectibles as well as game supplements. Bob Charrette and Julie Guthrie sculpted the figurines, which included stormtroopers in various poses and a sandtrooper, TIE fighter pilot, royal guard, scout trooper, and Zero-G assault stormtroopers.

TOP: Cover art for *Star Wars:* Graveyard of Alderaan by Bill Slavicsek (West End Games, 1991). **BOTTOM:** *Star Wars:* Miniatures Battles Starter Set by Stephen Crane and Paul Murphy (West End Games, 1995).

NEW NOVELS AND COMICS

In 1991, Lucas Licensing renewed *Star Wars* publishing with a series of new novels and comic books. Bantam Spectra released Timothy Zahn's *Heir to the Empire*, the first novel in a trilogy that began six years after the events of *Return of the Jedi* and involved an Imperial admiral's plan to create an army of clones to serve as ready-made stormtroopers. Dark Horse Comics followed with *Dark Empire*, a six-issue series by writer Tom Veitch and artist Cam Kennedy. *Dark Empire*'s story was set seven years after the events of *Jedi* and involved a civil war between mutinous Imperials and those who remained loyal to Emperor Palpatine, whose evil spirit lived on.

Except for those *Star Wars* stories set many years or centuries before the foundation of Palpatine's Empire, novels and comics routinely featured stormtroopers. In 1994, Dark Horse began publishing comic-book adaptations of Zahn's trilogy. For *Heir to the Empire*, artist Fred Blanchard created a uniquely long-armed spacetrooper. In *Dark Force Rising* (1997), artists Terry Dodson and Kevin Nowlan rendered the moment that Luke Skywalker and Han Solo discover unmasked bodies of cloned Imperial troops.

In 1995, Bantam Spectra published the short story anthology *Tales of the Mos Eisley Cantina*, which included the story "When the Desert Wind Turns: The Stormtrooper's Tale" by Doug Beason. Creatively expanding upon situations from the first *Star Wars* movie, Beason identified the stormtrooper who discovered a droid part while searching the sands around the abandoned escape pod on Tatooine and named the trooper Davin Felth. Hardly a mindless servant to the Empire, Felth chose to become a spy and serve the Rebellion. The story was significant in how it portrayed a stormtrooper as a human capable of changing for the better.

TIE FIGHTER PC GAME

Developed by Totally Games and published by LucasArts, the space-flight-simulation computer game *Star Wars: TIE Fighter* (1994) was a sequel to *Star Wars: X-wing* and was the first *Star Wars* video game that put the player on the side of the Empire. The game's story began after the Battle of Hoth in *The Empire Strikes Back* and allowed players to adopt the role of Maarek Stele, a rookie TIE fighter pilot. The game

TOP: *Star Wars: Heir to the Empire* by Timothy Zahn (Bantam Spectra, 1991) with cover art by Tom Jung. BOTTOM: The cover of *Heir to the Empire* #6.

was initially released with a booklet, *The Stele Chronicles* by Rusel DeMaria, which provided an account of how Maarek Stele came to serve the Empire and also information about pilot training.

As with the comics, novels, and role-playing games, the story aspects of TIE Fighter were part of what became known as the *Star Wars* "Expanded Universe": Lucasfilm-authorized stories that literally expanded on characters and situations introduced by the *Star Wars* movies. Fans were still rejoicing about new Expanded Universe stories when they had reason to become even more excited: In 1994, Lucasfilm announced that George Lucas was planning to make new *Star Wars* movies.

ABOVE: Box artwork for the video game *Star Wars: TIE Fighter: Defender of the Empire* (1994), featuring the character Maarek Stele.

STAR WARS RETURNS

Star Wars fans endured a long few years of what has become known as "the dark times." There were no movies or animated TV shows, no action figures—just a barren, dismal wasteland at toy stores absent of any *Star Wars* section. The majority of fans had no expectation of new films. Most believed the *Star Wars* phenomenon had, for the most part, reached its end. One of the few bright, shining lights during this time came from LucasArts, which continued to put out popular *Star Wars* games, including Dark Forces and Rebel Assault II. However, some of LucasArts' most-loved titles during this era—Monkey Island, The Dig, and Grim Fandango—weren't based on *Star Wars* at all.

Then in 1995 a new hope shined in the darkness. *Star Wars* toys appeared on shelves once again, seemingly rising from nowhere. The most important cog in Lucasfilm's licensing machine—the action figure—had finally been reinstalled, signaling that *Star Wars* was back in business.

RETURN OF THE TOYS

July 1, 1995, saw the return of Kenner's *Star Wars* action figures. Kenner, which had been bought by Hasbro in 1991, released a new The Power of the Force line, named after the final vintage wave in the 1980s. Collectors rejoiced! These were the first action figures to hit stores since the *Droids* and *Ewoks* animation-style figures

LEGENDS

A DARK FORCE IN GAMING

Dark Forces was released by LucasArts on February 28, 1995, for PC and Mac, with a version for PlayStation releasing the following year. The story followed Kyle Katarn, a mercenary and former stormtrooper working for the Rebel Alliance, who uncovered the Empire's "Dark Trooper Project," led by General Rom Mohc. It was followed up with *Star Wars* Jedi Knight: Dark Forces II in 1997 (subsequent games in the series all took on the "Jedi Knight" moniker and dropped "Dark Forces"). The game introduced dark troopers, originally as a type of battle droid that served as a "super stormtrooper." The innovative first-person 3D shooter was helmed by Daron Stinnett, lead programmer Ray Gresko, and graphics and story line artist Justin Chin. Stormtrooper voices were all performed by Denny Delk.

Within the game, dark troopers were developed in three stages. Phase I troopers were a primitive droid with an exposed phrik "skeleton." They carried an arm-mounted blast shield (on the left arm) and cutting sword (on the right arm). Phase II dark troopers had an armored exterior made to resemble stormtroopers. They used repulsorlift jetpacks to fly and were armed with long-range explosive rockets and a plasma shell assault cannon. Phase III dark troopers

TOP: Box art for *Star Wars:* Dark Forces (LucasArts, 1995). Iconic LucasArts' game packaging became collectible memorabilia. **BOTTOM:** Dark trooper concept art by Justin Chin for Dark Forces, 1994.

(only a single prototype existed in the game) were the pinnacle, operating autonomously or as a power suit. This third-stage dark trooper was a veritable robot tank, heavily armored with weapons tubes firing an endless supply of seeker rockets. The ultimate source of the dark troopers was a production facility aboard Mohc's flagship, the *Arc Hammer*. They were then deployed much the same way as Imperial probe droids—via hyperspace capsules.

George Lucas was sensitive to violence in his video games. Blood and gore was increasingly common in games like Wolfenstein 3D and Doom, but it was intentionally omitted from LucasArts games such as Dark Forces. "I was pretty proud of what we'd made, and I was kind of waiting for him to be blown away," Daron Stinnett told *Game Informer*. "We had stormtroopers and [Imperial officers], and we were shooting them, and he was not happy that we were shooting those guys." According to Stinnett, Lucas felt that the player shouldn't be killing Imperial officers in the game, explaining that he originally made stormtroopers because he didn't want it to feel like the heroes in his *Star Wars* movies were shooting other humans. "I was so destroyed," Stinnett explained. "But then I showed him how to play it and he got into it. By the time cameras got rolling, he was running around and jumping over pits and shooting things and having good fun, at least for the cameras, I'll say." Lucas would later appear on CNN's *Future Watch* to promote the game himself.

Dark Horse produced a trilogy of novellas by William C. Dietz based on the game, which were adapted into radio dramas by HighBridge Audio. The first, Dark Forces: Soldier for the Empire, was released on February 15, 1997. Hasbro produced a Dark Trooper (Phase III) action figure in 1998, followed by a Dark Trooper (Phase I) and another Dark Trooper (Phase III) in 2009. Acquiring the latter meant buying five separate Walmart exclusive Droid Factory 2-packs, to build the massive, super-articulate figure.

In November 1995, LucasArts released *Star Wars*: Rebel Assault II: The Hidden Empire, using live-action footage of stormtroopers wearing costumes and armor from *Return of the Jedi* (provided by the Lucasfilm archives). Most notable were the rebel characters Rookie One (played by Jamison Jones) and Ru Murleen (played by Julie Eccles) who disguise themselves as stormtroopers to steal a top-secret TIE Phantom.

"I recall one scene where I, as the character of Rookie One, knocked out a stormtrooper and put on his suit to avoid detection in the enemy's base," Jones told Dennis Pellegrom for his *Star Wars Interviews* blog in September 2010. "Let me tell you, those things are almost impossible to move in and the helmet is almost impossible to see out of. In the scene, I had to run through the blue sound stage pivoting around blue marks on the blue floor that would later become boxes and debris and other set pieces, run up a flight of blue stairs and crouch behind a blue nothing that would later become some sort of mechanical unit I was hiding behind. It was crazy trying to make all that happen and look like I knew what I was doing and where I was going."

Meanwhile, board games were going through an awkward experimental phase in the 1990s. In July 1996, Parker Brothers released *Star Wars*: The Interactive Video Board Game (Assault on the Death Star). Played with a VHS tape that ran simultaneously, it was part of an odd, short-lived genre of hybrid games, unique to the time. The goal of the game was to stop Darth Vader before he destroyed a rebel supply base on the planet D'rinba IV. It notably featured new live-action footage with actors wearing film-used stormtrooper costumes. It also included a very authentic Darth Vader, played by both David Prowse and James Earl Jones. Gilbert Taylor, cinematographer for *A New Hope*, wove together both new footage and existing shots from the original trilogy.

TOP: Packaging art for the PlayStation edition of *Star Wars*: Rebel Assault II The Hidden Empire (1995). **BOTTOM**: A game screenshot. Rebel Assault II was revolutionary in its use of live-action video footage, made viable with a combination of advanced compression technology, automation of some of the player's movements, and a revolutionary new gaming media: the CD.

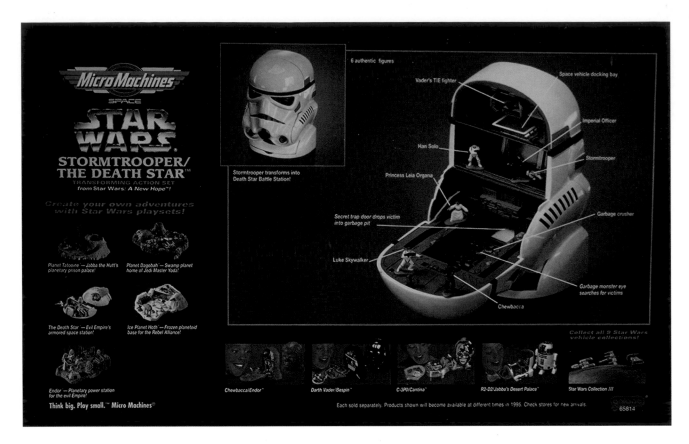

in 1985, ten years earlier. The first waves were odd—their muscle-bound sculpts were reminiscent of mini He-Man figures. Fortunately, that trend didn't last, and more accurate representations eventually won out.

The first new stormtrooper figure, which came with two weapons, was released in the initial wave in 1995. In September of that year, Kellogg's cereal contained a mail-in exclusive Han Solo in Stormtrooper Disguise action figure with a removable helmet, but no blaster. A year later welcomed a new Death Star Gunner with Imperial Blaster and Assault Rifle, Sandtrooper with Heavy Blaster Rifle, and Luke Skywalker in Stormtrooper Disguise with Imperial Issue Blaster. As the figures increased in popularity, so did the selection. The 1997 offerings more than doubled from the previous year and included an AT-ST Driver with Blaster Rifle and Pistol, Emperor's Royal Guard with Force Pike, and Snowtrooper with Imperial Issue Blaster Rifle. The year after that an AT-AT Driver with Imperial Issue Blaster and Death Star Trooper with Blaster Rifle, as well as an Expanded Universe Imperial Sentinel from the *Dark Empire* comics, were released. In 1999 a much better articulated stormtrooper was sold with a blaster rifle and rack, as well as

a CommTech Chip that allowed the figure to "speak" (with the help of a CommTech Reader).

Action figures were not the only toys generating excitement. In 1995, Galoob began producing *Star Wars* Micro Machines playsets, reminiscent of Kenner's Vintage Micro Collection series. The Micro Machines Stormtrooper/The Death Star Transforming Action Set included one-inch figures of Chewbacca, Han Solo (in stormtrooper disguise), an Imperial officer, Luke Skywalker (also in stormtrooper disguise), Princess Leia, a stormtrooper (fallen in battle), and Darth Vader's TIE fighter, which could be detached from an upper hangar bay. A central corridor had a trapdoor and slide leading to a functional trash compactor below. There was even a tiny articulated dianoga inside. The set was later reissued in 1997, with updated packaging. Galoob's series had a total of fourteen ingenious transforming character bust playsets, including the TIE Fighter Pilot/Academy, Royal Guard/Death Star II, and Boba Fett/Cloud City.

Hasbro also revived the twelve-inch action figure line, which included a Stormtrooper Action Figure Kit, two Sandtrooper variants, a Dewback & Sandtrooper, TIE Fighter Pilot Action Figure Kit, Han Solo & Luke Skywalker in

ABOVE: The box for the Galoob Stormtrooper/The Death Star transforming set that was released in 1995 as part of their Micro Machines playset series.

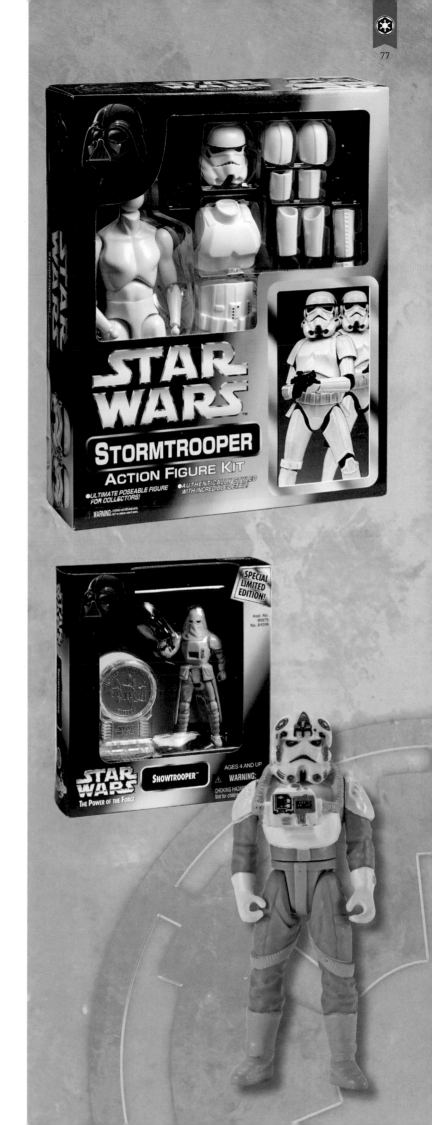

Stormtrooper Disguise 2-pack with a mouse droid (each was also available separately), Grand Moff Tarkin & Imperial Gunner with Interrogator Droid, Death Star Trooper with Imperial Blaster, AT-AT Driver, AT-ST Driver, Snowtrooper in two variants, and Speeder Bike with Scout Trooper.

In 1996, Galoob also released their *Star Wars* Action Fleet TIE Interceptor. The ship was about five inches long and came with a stand. There were two tiny figures included: a standard TIE pilot and a TIE pilot with a removable helmet. It was said that the person underneath was meant to be George Lucas, although at that small size, it was hard to tell for sure! Several slight packaging and color variants of the set were made.

Galoob was purchased by Hasbro in 1998, and the Micro Machines line experienced a revival with a whole new series of toys for *The Force Awakens* in 2015. The new toys included a First Order Stormtrooper Playset that converted into a part of Jakku. A mini Poe Dameron and First Order transporter were included.

ABOVE: An original prototype sculpt for the 1990s Kenner sandtrooper action figure. **RIGHT TOP:** Hasbro Japan Marmit Stormtrooper Action Figure Kit. **RIGHT MIDDLE:** Snowtrooper from the Millennium Minted Coin Collection (1998). **RIGHT BOTTOM:** AT-AT Commander that was included with Imperial AT-AT Walker (1997).

LEGENDS

COMIC DEVELOPMENTS

Dark Horse Comics was a central figure in the *Star Wars* Expanded Universe since its first issue of *Dark Empire* in 1991. The publisher released *Heir to the Empire* #6, an adaptation of the groundbreaking Timothy Zahn novel, on April 1, 1996. On pages nineteen and twenty, the rebels encountered a spacetrooper: "a stormtrooper in zero-gee armor." The troopers were hiding inside mole-miner machines stolen from Lando Calrissian and being used by Admiral Thrawn. Illustrated by Olivier Vatine and Fred Blanchard, the heavily armored spacetrooper had a bulky jetpack and an elbow-mounted cannon—closely resembling the dark

troopers in Dark Forces. Hasbro released a Spacetrooper action figure in their 1998 Expanded Universe line, based on the portrayal in this comic.

In 1996, Lucasfilm launched *Shadows of the Empire*, a multimedia extravaganza with film-level merchandising and marketing—video game, novel, comic books, soundtrack, and action figures—but without an actual film. It introduced a new class of troopers, the red Coruscant guard.

In *Shadows of the Empire* #1 (Dark Horse Comics, May 7, 1996), illustrated by Kilian Plunkett, Prince Xizor was pictured meeting with the Emperor in a throne room

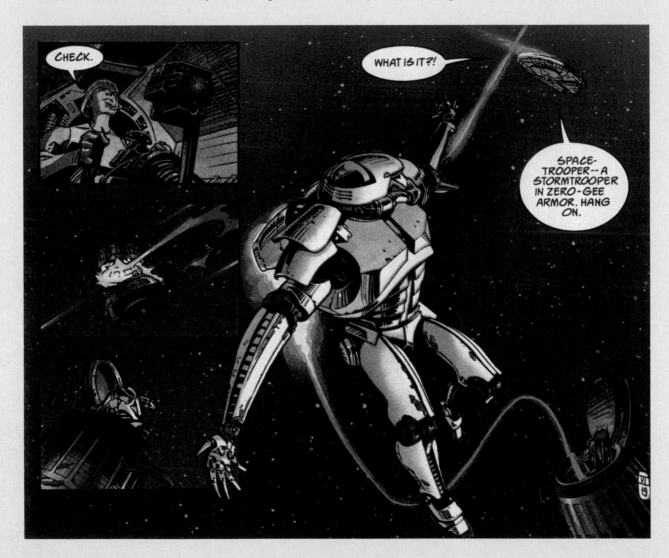

ABOVE: Interior cell from *Heir to the Empire* #6 (Dark Horse Comics, 1996).

lined with stormtroopers on Coruscant. While the image was consistent with a theme in the Expanded Universe (EU) that stormtroopers were loyal only to the Emperor, it was at odds with scenes from the original trilogy, where the closed-off Emperor was accessible only to Vader, his royal guard, and key advisers, as seen in *Return of the Jedi*. In the films and licensed artwork, stormtroopers are seen under the command of Vader, rather than the Emperor himself.

On December 18, 1997, StarWars.com launched their first web comic, Dark Horse's *Crimson Empire* #0. The comic kicked off a six-issue series featuring rogue Royal Guard Kir Kanos and established a new mythology and heightened fan interest in these mysterious guardians of the Emperor. Hasbro produced one Emperor's Royal Guard action figure in 2012 as part of their Vintage Collection, which included alternate armor pieces based on representations from the *Crimson Empire* comics.

TOP LEFT: Kenner's Spacetrooper action figure included a fold-out 3D Playscene on the back of the card, allowing fans to reenact the space scene from the comic. TOP RIGHT: Cover of the 2012 reissue of *The Crimson Empire Saga* (Dark Horse Comics, 2012). BOTTOM RIGHT: Cover to *Crimson Empire III #5: "Empire Lost"* (Dark Horse Comics, 2012).

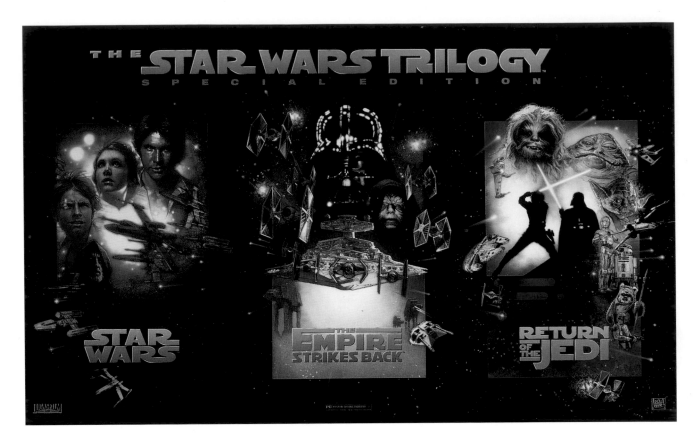

THE *STAR WARS* TRILOGY SPECIAL EDITION

In 1997, *Star Wars* returned to theaters in a wondrous new form—the Special Editions. George Lucas used these revolutionary—and controversial—new versions of his classic films both as a chance to finish what he started and correct what he considered were a few of the original films' shortcomings.

The three films were released in theaters at monthly intervals, beginning with *A New Hope* on January 31, 1997. George Lucas reportedly spent $10 million on restorations and alterations (roughly what he spent to film the original 1977 version) and $2.5 million each on *The Empire Strikes Back* and *Return of the Jedi*. One of the most significant changes appeared early in the film, where, originally, a small group of sandtroopers and a single dewback searched for R2-D2 and C-3PO in the desert on Tatooine. George Lucas wanted to add a much larger detachment of stormtroopers, additional animated dewbacks, and a new Imperial transport shuttle (the shuttle design first appeared in *Shadows of the Empire* and would come to be known as a *Sentinel*-class landing craft many years later).

"I was always very frustrated about the fact that I couldn't get the dewbacks to actually move or do anything," lamented Lucas. "They were basically just big rubber statues." Concept illustrator, animal anatomist, and creature designer Terryl Whitlatch created new designs for lifelike dewbacks with sandtrooper riders to move across the scene, taking into account their size, bulk, speed, and postulating their natural history to create the most realistic creature possible.

"In 1994, I was brand new at ILM and hired to work on and design many of the animals (the zebras are all mine) for *Jumanji*. Anything remotely related to an animal, whatever the project, was generally handed to me," recalls Whitlatch. "One day, Dennis Muren came by (I was so new that I didn't even know who he was) and asked me to redesign the dewback."

The only reference supplied by ILM was a postage stamp–sized image. For ideas, Whitlatch looked to real-world creatures. "I took my inspiration from land iguanas, iguanodons, and ceratopsian dinosaurs, as in triceratops."

George Lucas created a "used universe" that implied history, thus eventually everything is bound to get a back-story, especially the creatures. "A scenario for me would have been that the Tatooine natives had already been using [the

ABOVE: Three movie posters for The *Star Wars* Trilogy Special Edition appeared separately in cinemas, but were designed by legendary artist Drew Struzan to be combined to form a single image. Struzan also created posters for the original *Return of the Jedi* release, the prequels, and a preview poster for The *Force Awakens*.

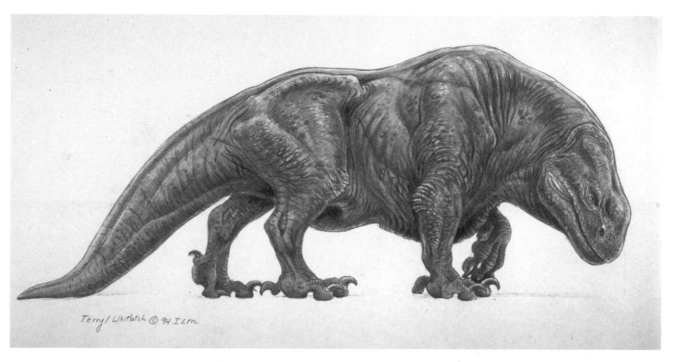

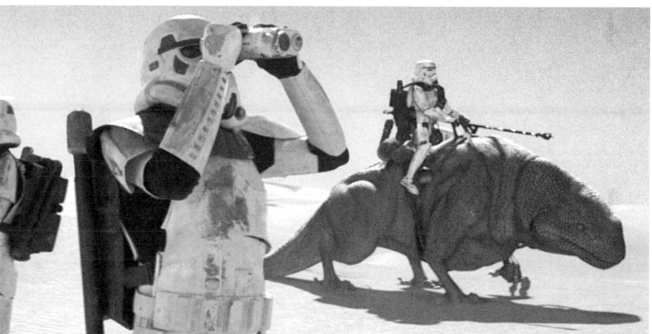

dewbacks] as desert transports for thousands of years prior to the arrival of the first stormtroopers, as in Bedouins and camel/dromedary caravans," Whitlatch muses. "The first stormtrooper division commanders to arrive on Tatooine would have seized upon this local way of life and seen its advantages, and naturally followed suit."

Like all of her *Star Wars* designs, Whitlatch completely nailed the dewback. "I gave the finished design to my art director, and a week later, he came to my desk and told me that it created quite a stir at the Ranch, and that the Ranch really liked it. It took me a few seconds to realize he was telling me George Lucas really liked it. I think I was happy for the rest of my life hearing that."

The new extended scene of the sandtroopers and dewbacks was pre-visualized using rough CGI animatics created by David Dozoretz. This would give the team at ILM a

TOP: Concept sketch of a dewback by Terryl Whitlatch, 1994. Whitlatch drew inspiration from iguanas for the facial and head structure and triceratops and related dinosaurs for body anatomy and movement. BOTTOM: Final frame from *Star Wars: A New Hope* Special Edition (1997), showing the updated dewback.

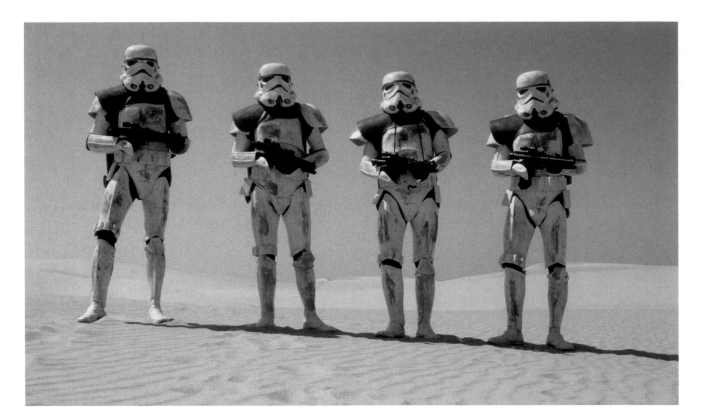

roadmap for constructing the entire scene. This trial run exercise would become the basis for the pre-visualization process used throughout the making of the upcoming prequel trilogy.

To fill out the scene, new shots were filmed August 10 and 11, 1995, in Arizona, with additional actors wearing original film-used stormtrooper costumes (though new backpacks had to be re-created). Oddly, they were dressed in Mk II armor, setting them apart from the rest of the troopers in the film. Digital dewbacks and stormtrooper riders were then added to create the finished scene.

George Lucas seemed tentatively satisfied with the results. "I hope the sequence now establishes that there was more stormtroopers on the planet, and it's not just two or three stormtroopers. There's actually a lot of them. The danger is greater and they are a more formidable element in the movie than they were before."

Animated digital dewbacks and stormtroopers were also added in Mos Eisley Spaceport outside the cantina. Set decorator Roger Christian recounted the frustrations that he and John Barry had over the dewbacks outside the cantina: "John always regretted it. He was always embarrassed by that one. The animals came under my set dressing, but he had to

build it. But that one, we would have liked to have done a better animal. If we'd had more time and more money, we would have liked to have done more articulation so it would have looked better. . . . It would have been nice to have a wagging tail, with flies, like a proper western for the space age." The newly animated dewbacks and stormtroopers outside the cantina would create a sense of more activity in Mos Eisley, and also intensify the sense that the heroes had to venture into the epicenter of danger in order to escape from the planet.

The new scene with Jabba the Hutt waiting in the *Millennium Falcon*'s launch bay was added using a deleted vintage scene, augmented with a CGI Hutt replacement for the original human actor (it would be further tweaked in the DVD release). The scene includes a cameo of Boba Fett, played by Mark Austin. His appearance here (as well as new shots added to *Return of the Jedi*, performed by Don Bies) would give the character greater weight and help justify the inclusion of Boba and Jango Fett in the upcoming prequel trilogy and therefore facilitate their connection to the clone troopers.

The Special Editions also gave the sandtroopers in Mos Eisley new CGI recon drones (Mark IV sentry droids, with

ABOVE: Sandtroopers from *Star Wars: A New Hope* Special Edition (1997). **OPPOSITE:** *Star Wars: A New Hope* Special Edition storyboards depict the addition of new ronto creatures moving across the screen (top) and hovering droids assisting the sandtroopers in their patrols of Mos Eisley.

IDs like IM4-099, to be exact). These hovering robotic helpers were designed by art director Doug Chiang and artist Jay Shuster. Droids of this new class would go on to appear in the prequel films as well.

In addition to these larger changes, there were many small changes, including new dubbed lines, characters inserted in the backgrounds, and cleanups of antiquated visual effects. When Han Solo and Chewbacca chase a squad of stormtroopers on the Death Star, for instance, they no longer run into a small group of stormtroopers. Instead they run headlong into an entire hangar bay full of troopers and TIE fighters, before comically reversing course.

Other elements were restored that were somehow lost along the way with various releases of the movie. The stormtrooper's line, "Close the blast doors!" for example, was restored to the scene when Chewbacca and Han leap through the doors on the Death Star. The line had been omitted in the audio track of the 1993 Definitive Collection on VHS. It now creates a comedic situation as the stormtroopers then become locked on the other side and immediately counter with, "Open the blast doors! Open the blast doors!"

The Empire Strikes Back Special Edition, released on February 21, 1997, saw subtler changes. Legendary concept artist Iain McCaig followed in the footsteps of Ralph McQuarrie and got in front of the camera. "I was involved in *Empire* as well . . . Jay Shuster and I donned stormtrooper costumes and appeared in a scene with Darth Vader, where I learned that stormtroopers are so mean because the armor is continuously pinching your many tender parts . . ." Toward the end of the film, new shots were added of Vader leaving Cloud City, followed by stormtroopers, and boarding his shuttle. The *Return of the Jedi* Special Edition had no significant changes made concerning stormtroopers.

TOP: A scene enhanced for the *Star Wars: A New Hope* Special Edition shows Han Solo running into a hangar full of stormtroopers. **BOTTOM:** A new shot added to *Star Wars: The Empire Strikes Back* Special Edition (1997) shows Darth Vader walking to his shuttle on Cloud City.

MINI HELMETS: THE LEGACY OF RIDDELL

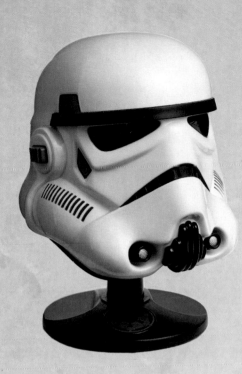

In 1996, Riddell Sports (official maker of NFL football helmets and renowned manufacturer of helmets for the U.S. military in World War II) partnered with SOEDA (Swearingen, Osborne, Effler Design Associates), Inc., to produce a set of five authentic miniature helmets called the *Star Wars* Trilogy Collection. The line included an X-wing Pilot, Darth Vader, Boba Fett, See-Threepio, and a Stormtrooper. Designed by Chris Reiff, the 1:4 scale helmets had intricate details and weathering. Also, for the first time, these helmets displayed in-universe interior details of the helmets, complete with air filtration and communication systems. Six prototypes of a future TIE fighter pilot helmet were also created, but the final product was never released on the market. The helmets came with a certificate of authenticity signed by Lucas Licensing vice president Howard Roffman, finely detailed blueprints with all interior and exterior parts labeled by Reiff, assembly instructions, a mailing list request form, and a mechanical stand.

The Riddell helmets had a lasting impact, not only on future helmets and figures produced by licensees like Sideshow Collectibles, but publishing as well. In the autumn of 1998, DK Publishing produced the landmark *Star Wars: The Visual Dictionary* which featured new props fabricated just for the book, including the interior face plate of a stormtrooper helmet created by ILM model maker Don Bies. This helmet was based on the earlier Riddell designs by Chris Reiff. DK's later compendium *Star Wars: The Complete Visual Dictionary* was first published in 2006 and included additional diagrams and background information for all of the Republic and Imperial troopers, their weapons, vehicles, and other gear.

Almost ten years later, Master Replicas purchased the molds from Riddell and began producing their own line of scaled helmets in 2005, which included the Stormtrooper Helmet, as well as a Shadow Stormtrooper Helmet as a "30th Anniversary Convention Exclusive." They also added fantastic replicas of a 501st Legion Trooper Helmet, Clone Commander Gree Helmet, Shock Trooper Helmet, Utapau Shadow Clone Trooper Helmet, and a standard Phase II Clone Trooper Helmet.

In 2015, Hasbro would release their Black Series Titanium Series mini helmets, beginning with pieces from *The Force Awakens*, and followed by *Rogue One: A Star Wars Story* and the other yet-unreleased films. The helmets arrived in two-packs and were well-made, but they lacked internal detailing.

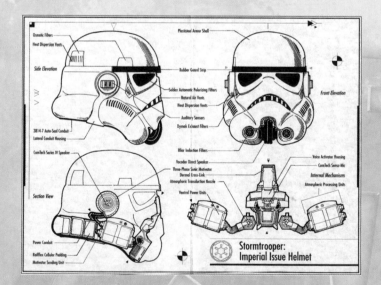

TOP: A Riddell Stormtrooper mini helmet. BOTTOM: Blueprints included with the Riddell Stormtrooper mini helmet. These blueprints would definitively establish the in-universe designs of stormtrooper helmets henceforth. The details would not be used in commercially sold costuming helmets however.

A NEW AGE IN *STAR WARS* COSTUMING

As word of the Special Editions reached the public, two fans were planting the seeds for one of the most significant developments in *Star Wars* fandom. "Back in 1995, I was healing from a debilitating auto accident when a coworker and friend of mine named Tom Crews chatted me up about *Star Wars*," recalls Albin Johnson. "We found we shared a deep love of the movies, and we were excited at the prospect of the rereleases coming to theaters soon. We joked we should dress up as stormtroopers, but we only considered it a joke. No one heard of stormtrooper armor being available anywhere. It was something limited to the costume shops of Lucasfilm probably. But Tom did some digging and found an obscure Usenet forum article offering a set of 'original stormtrooper armor' from an estate sale. Well, that got our attention.

"After weeks of thinking about it, I threw down the money and bought a set. Tom ordered his shortly afterwards. I ended up wearing my set of stormtrooper armor to the *Empire Strikes Back* premiere. It was amazing—I was blown away by the response from the fans. But it was nothing compared to the reaction a few weeks later when Tom joined me at the *Return of the Jedi* premiere. Before, when I trooped alone, people came up and poked me and made sport of the costume. But with Tom in armor standing next to me, the fan reaction was quite different. People stood a ways off, pointed, and regarded us in more of a state of awe. It was as if we were more accurately portraying stormtroopers when together because we looked like a patrol of some kind. Instead of just one fan in clumsy armor, we looked like we represented a military presence.

"That's when it occurred to me how incredible it would be to magnify that effect with five stormtroopers, maybe even ten! I had this fantasy of twenty or more stormtroopers at one time. What a sight that would be!" Indeed, it would be. Johnson had no idea at the time that he and his big heart were on the road to founding the most beloved and influential *Star Wars* fan organization ever: the 501st Legion (more on this in chapter 7).

ABOVE: In 1997, when friends Albin Johnson and Tom Crews first considered wearing their stormtrooper armor in public, they were nervous about how they appeared and how well they might be received by other fans. Fortunately the enthusiastic fans that gathered were very reassuring.

ABOVE: Johnson started documenting their stormtrooper event appearances on his website. Stories began to take shape as they assigned themselves identification numbers and captioned their photos with comical adventures. The numbers of fellow *Star Wars* costumers also began to grow.

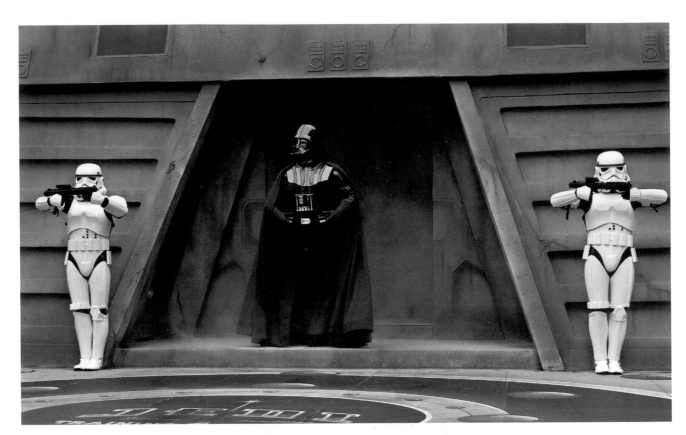

NEW CULTURAL INROADS

Ten years after the Star Tours ride opened at Disneyland, the first *Star Wars* Weekend was held at Walt Disney World on February 21–23, 1997, the same year that the Special Editions appeared in theaters. That year, the Star Tours gift shop, "Endor Vendors," was rebranded "Tatooine Traders." A *Behind the Force* documentary was shown about the making of the *Star Wars* trilogy, and several *Star Wars* celebrities gave interviews. There were also plenty of costumed characters around for photo opportunities too. The celebration expanded in 2001 when the "Jedi Training Camp" was born, which would later become the ever-popular "Jedi Training Academy." *Star Wars* Weekends were held for five weekends in February and March 1997, then again in May 2000 and 2001. They were canceled in 2002, but would be held every summer from 2003 through 2015. Celebrity guests would include Temuera Morrison (Jango Fett and clone troopers), Daniel Logan (Boba Fett and young clones), Bodie Taylor (young adult clones), Dee Bradley Baker (voice of all animated clone troopers), Rick McCallum (prequel trilogy producer and Special Edition stormtrooper), Doug Chiang (art director), and Iain McCaig (concept designer).

SET FOR STUN?
ANY CLOSER AND YOU'LL FIND OUT.
AS CLOSE TO THE FORCE AS YOU CAN GET

STAR WARS WEEKENDS

2015

TOP: Darth Vader makes his entrance during the *Star Wars* weekend show. The same stage is also used for the Jedi Training Academy, which is a popular show and activity in Disney Parks. **BOTTOM AND OPPOSITE:** Posters advertising *Star Wars* Weekends. Disney ended *Star Wars* Weekends after 2015, instead increasing the overall presence of *Star Wars* in its parks, and began construction of a new *Star Wars*–themed land to open in 2019.

GET A TASTE OF THE DARK SIDE.

"*TROOPS* owes its notoriety to being [one of] the first [widely popular fan films]," says Kevin Rubio. "It came about in an era before YouTube, hi-speed downloads, home editing software, VOD, internet distribution, and even the term 'fan film.' And yet, because of its notoriety, it directly or indirectly helped popularize or push forward many of these things.

"We didn't have money for sets, so it had to be a story using only locations. We were in Southern California (an area where deserts are plentiful), so Tatooine became the obvious setting. An abandoned comic script by Steve Melching [now a story editor on *Star Wars Rebels*] and David McDermott became the inspiration for using stormtroopers, and VFX, headed by then fledgling FX supervisor Shant Jordan, raised the bar visually for all fan films to follow."

TROOPS parallels the events of *A New Hope*. The stormtroopers, members of Black Sheep Squadron who speak with Minnesota accents reminiscent of *Fargo* (1996), begin by recovering a stolen Imperial droid from a group of Jawas. As a gag, the droid is actually Tom Servo from *Mystery Science Theater 3000*. Next, they move on to a domestic disturbance at the Lars' homestead and give an alternate take on the events that lead to the deaths of Luke Skywalker's Aunt Beru and Uncle Owen. The film ends with a call to a disturbance at the Mos Eisley Cantina.

The stormtrooper cast included Eric Hilleary and Cam Clarke (voice) for Captain Jyanix Bauch; David Max and Jess Harnell (voice) for Officer Daemon Mott; Kenar Yegyayan and Drew Massey (voice) for Officer Ayches Ram; Eric Hilleary and Paul Pistore (voice) for Captain Reh Taeh; Caleb Skinner and Kevin Rubio (voice) for Trooper

Meanwhile, *TROOPS*, a fan film directed by Kevin Rubio (whose writing credits now include *Power Rangers Samurai*, *Star Wars: The Clone Wars*, and *Thunderbirds Are Go*), premiered at San Diego Comic-Con on July 18, 1997. The hilarious mockumentary was set in the *Star Wars* universe and parodied the television show *COPS*. The ten-minute short was filmed at El Mirage Lake in California's Mojave Desert using movie-quality costumes designed by Caleb Skinner, David Max, Kenar Yegyayan, and Kohar Yegyayan.

TOP LEFT: A promotional image of *TROOPS* (1997). **TOP RIGHT:** Two stormtroopers question a Jawa in *TROOPS*. **BOTTOM LEFT:** The opening credits in the fan film *TROOPS*.

HK-888; and Kenar Yegyayan and Dave Fouquette (voice) for Trooper HK-883.

"You can't manufacture a phenomenon," acknowledges Rubio. "It was a film born out of passion, practicality, and a desire to make a mark in 'this business we call show.'"

Rubio's *TROOPS* was a touchstone in the fan-film movement. It received Lucasfilm's inaugural Pioneer Award in their 2002 Fan Film Awards. Its primary distribution was online via TheForce.net, but it was also released as a free DVD included with the premier issue of *Total Movie* magazine in 2000 and as a bonus feature on the twentieth anniversary DVD of *COPS* in 2008.

Later that same year, on October 29, 1997, George Lucas and the Smithsonian's National Air and Space Museum in Washington, D.C., opened *Star Wars: The Magic of Myth*. The exhibit featured more than two hundred costumes, models, and props from the Lucasfilm archives, including costumes belonging to a stormtrooper, snowtrooper, scout trooper, TIE pilot, Imperial officer, and models of a 74-Z speeder bike, an AT-AT, AT-ST, various TIEs, and an Imperial Star Destroyer. The exhibit traveled the world, welcoming

more than a million visitors. A companion book with the same name, written by Mary Henderson, was released on November 3, 1997, complete with photos from the exhibit and explorations of the real-word mythic roots of *Star Wars*. DK Publishing expanded on the *Star Wars* connections to earthly mythology with the book *Star Wars: The Power of Myth*, released on March 1, 2000.

THE PHANTOM MENACE AND BEYOND

Fans had waited impatiently for sixteen long years. At the turn of the century, George Lucas finally answered their desperate pleas with a new *Star Wars* movie. *Star Wars: The Phantom Menace*, the first in a new trilogy of films, began a new era for the franchise when it premiered on May 19, 1999. Stormtroopers, however, would not be part of it.

"Thank God there were no stormtroopers there [on the set for Episode I]," Ewan McGregor told Scott Chernoff for *Star Wars Insider*, "or I would have been out of control. I always wanted to be in a stormtrooper outfit. . . . Maybe

TOP LEFT: The National Air and Space Museum's 1997 exhibit of *Star Wars: The Magic of Myth*. The exhibit remained open through January 31, 1999, then traveled the country from 2000–2002, with a final exhibition in Sydney, Australia, through February 2003. **TOP RIGHT:** The snowtrooper costume on display as part of the *Star Wars: The Magic of Myth* exhibit.

they'll be coming up in Episode II or III, so let's just see if I can contain myself."

McGregor would be disappointed in that regard, and the only new Republic soldiers introduced in *The Phantom Menace* were the blue Coruscant Royal Guards, adorned with Roman Centurion–like helmets, seen only as background characters. However, the one place stormtroopers were actively seen was in publishing and merchandise. That same month as *The Phantom Menace* release, LEGO produced its first *Star Wars* sets, embarking on one of Lucasfilm's most successful licensing partnerships.

The initial sets tied in with *The Phantom Menace* as well as the original trilogy. Surprisingly, the first trooper minifigures that LEGO released were not classic stormtroopers, but a pair of biker scouts in 1999's Speeder Bikes (set 7128). The first stormtrooper minifigures did not appear until 2001 when the LEGO TIE Fighter (set 7146) was released. These figures only had printing on their front torsos and helmets. Their heads were blank yellow pieces; they would not receive faces under their helmets until 2012. This design choice was emblematic of the stormtrooper mythos: faceless foot soldiers who possessed no individuality. Stormtroopers were disposable fighting drones of the Empire, after all. Only after fans were exposed to soldiers with personality and heart in the animated series *The Clone Wars* (2008) would stormtrooper minifigures be endowed with the personal identity of a face.

The original TIE pilot minifigure was also released in the 2001 TIE Fighter set. It used a black stormtrooper

ABOVE: A stormtrooper waits among the crowd for the stars to arrive at the premiere of *Star Wars: The Phantom Menace* at Leicester Square, London, July 14, 1999.

helmet mold at first and would not be updated with a more representative helmet until 2010. The first Royal Guard minifigures, carrying black spears for force pikes, appeared in 2001's Imperial Shuttle (set 7166).

Perhaps it's ironic that just as *Star Wars* began to experience a renaissance, stormtroopers—one of the most iconic symbols of the franchise—took a backseat. Instead George Lucas turned the focus on their predecessors, the clone troopers of the Republic. It would be the fans and the licensees who kept the stormtrooper phenomenon alive for the next thirteen years.

TOP: Speeder bikes would remain a popular subject for LEGO *Star Wars* sets and their designs would be tweaked many times. The models pictured featured folding landing gear. BOTTOM LEFT: A built scout trooper and speeder from the LEGO Speeder Bikes set. BOTTOM RIGHT: The LEGO TIE Fighter featured removable wings, just like the original Kenner toy. A buildable landing support rig was also included.

RISE OF THE CLONES

The years 2002 through 2014 were the busiest period yet for Lucasfilm and *Star Wars*, with the release of the last two prequel trilogy movies, the birth of Lucasfilm Animation, and an explosion of next-generation video games from LucasArts.

During this time period, George Lucas explored a series of questions: What were the Clone Wars? Who were the clones? Where did the clones come from? And why did the clones betray the Jedi? Lucas knew that his movies had to keep their focus on the story of Anakin and the fall of the Jedi. The films would only give fans a taste of the Clone Wars, so Lucas used two animated series as well as video games such as *Star Wars*: Battlefront and *Star Wars*: Republic Commando to explore who these super-soldiers really were.

As the *Star Wars* Trilogy Special Edition reinvigorated the franchise and started a new "digital era" for *Star Wars*, it also marked a change in terms of how stormtroopers and the upcoming clones would be presented. Troopers of all types were largely created through computer animation and voice acting. Although digital technology was used as part of the visual spectacle, the utility of CGI animation also gave George Lucas the opportunity to explore who these mysterious new soldiers were beneath their armor.

ATTACK OF THE CLONES

In 1977's *A New Hope*, Obi-Wan Kenobi takes Luke Skywalker

OPPOSITE: A frame from *Star Wars: Attack of the Clones* (2002). Look closely to find red, green, yellow, and blue striped clones in the shot.

to his home in the Jundland Wastes and begins to tell him about Anakin Skywalker:

> LUKE: *No, my father didn't fight in the wars. He was a navigator on a spice freighter.*
> OBI-WAN: *That's what your uncle told you. He didn't hold with your father's ideals; he thought he should've stayed here and not gotten involved.*
> LUKE: *You fought in the Clone Wars?*
> OBI-WAN: *Yes, I was once a Jedi knight, the same as your father.*

Moments later, Princess Leia's holographic message makes a plea to Obi-Wan, "General Kenobi. Years ago you served my father in the Clone Wars. Now he begs you to help him in his struggle against the Empire."

These lines were the only hints that fans received about the Clone Wars for twenty-five years. Fans speculated about the context of the war and the nature of the clones themselves—not knowing at the time that the clones were actually the forerunners of stormtroopers until *Attack of the Clones* premiered on May 16, 2002.

FROM SCIENCE FICTION TO REALITY AND BACK

When *A New Hope* arrived in theaters, cloning was the domain of science fiction. It wasn't until 1996, when Dolly the sheep became the first mammal cloned by nuclear transfer, that cloning became a household topic. The growing moral concern over cloning was addressed on July 31, 2001, when the U.S. House of Representatives passed the Weldon-Stupak Human Cloning Prohibition Act to ban "human embryo farms." So by the time *Star Wars* returned to the subject, the idea of a clone army didn't seem so far-fetched.

At the opening of *Attack of the Clones*, neither the Jedi nor the Republic are aware of the clones. When Obi-Wan Kenobi arrives in Tipoca City on Kamino (in search of a mysterious bounty hunter), Prime Minister Lama Su informs him that ten years earlier a mysterious Jedi named Sifo-Dyas had commissioned the Kaminoans to develop a clone army for the Republic. As Kenobi tours the facility, he observes every stage of development, from fetuses to clone children (played by thirteen-year-old Daniel Logan), twenty-year-old clones (played by Bodie Taylor), and fully trained clone soldiers (played by Temuera Morrison).

The clones were grown by the Kaminoans in a sterile incubation facility with calm, white interiors—designed in part by Lucasfilm artists Jay Shuster and Edwin Natividad to illustrate the elegant efficiency of Kaminoan science. The "hatchery," as it was known at ILM, was the studio's most difficult CGI environment to render up until that time. In some shots there were fifty or more batch pods visible,

ABOVE: Storyboard frame of Obi-Wan receiving a tour of the Kamino cloning facilities. At this point neither the look of the Kaminoans nor Obi-Wan had been finalized for the film.

were computer-generated characters, using motion-captured performances. ILM staff stood in for the armored clones, marching on the motion-capture stage and then duplicated thousands of times to create the Grand Army of the Republic. Their performances were then fine-tuned by animators. This marked a profound difference with stormtroopers seen in the original trilogy, who were all actors wearing physical armor. There was not a single physical clone costume created for use on-screen for *Attack of the Clones*.

Artist Doug Chiang initiated the new clone trooper design by coming up with several different helmet variations—all of them white. Both he and George Lucas recalled old ideas that Boba Fett might have been a stormtrooper himself, and so hybridized their designs with Mandalorian armor for the final synthesis. Thus the common design elements actually suggested Jango Fett's armor was an in-universe influence on the development of clone armor. Jango's armor was originally planned to be all white too, which would have made the connection all the stronger, but Lucas settled on silver in the end.

Michael Patrick Murnane sculpted the resulting clone armor maquette, which was painted by R. Kim Smith. The design was intended to suggest an armor made of metal rather than heavy plastic (or "plastoid composite," as it's known in-universe), like that worn by stormtroopers. However, the idea that the clone armor was constructed of plastoid composite would persist via other *Star Wars* media. George Lucas added the helmet fin, a distinctively Art Deco–style flourish reminiscent of *The Rocketeer* (1991). Bruce

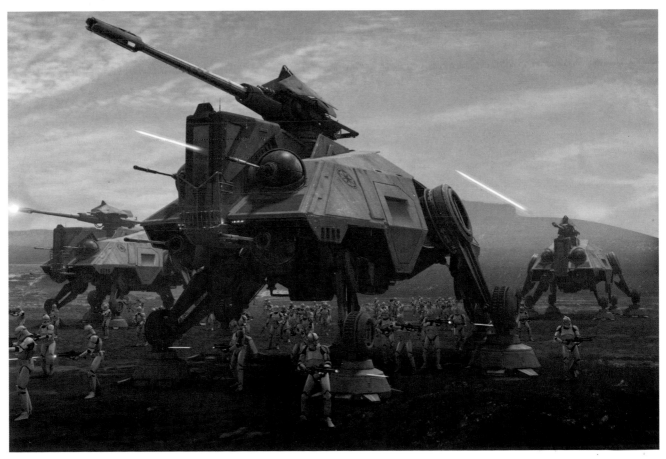

ABOVE: Scenes from the battle on Geonosis in *Attack of the Clones*. Concept artist Ryan Church conceived All Terrain Tactical Enforcer (AT-TE) walking tanks as a precursor to AT-AT walkers seen in *The Empire Strikes Back*. The vehicle would go on to appear in *The Clone Wars* (2008) and *Star Wars Rebels* (2014).

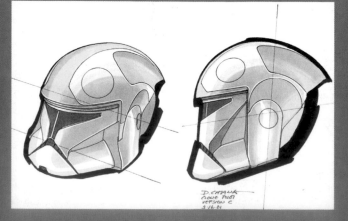

TOP: *Attack of the Clones* concept art depicting the gun turrets on the Republic gunships for the Battle of Geonosis, November 1999. **MIDDLE:** A sketch by concept artist Doug Chiang of clone troopers in Tipoca City, Kamino, 1999. **BOTTOM:** Concept sketch for the *Attack of the Clones* clone trooper helmet by Doug Chiang, 2001.

OPPOSITE (CLOCKWISE FROM TOP LEFT): An early concept of clone troopers on the surface of Geonosis by artist Doug Chiang, 1999; concept sketch for the *Attack of the Clones* trooper by artist Jay Shuster, 1999; a rough concept painting of Padmé with clone troopers outside Dooku's hangar by Ryan Church, 2002.

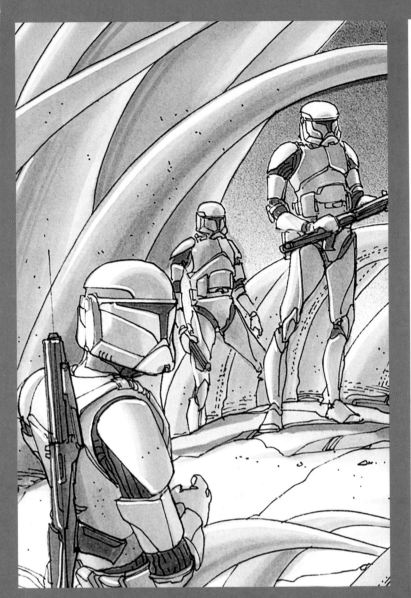

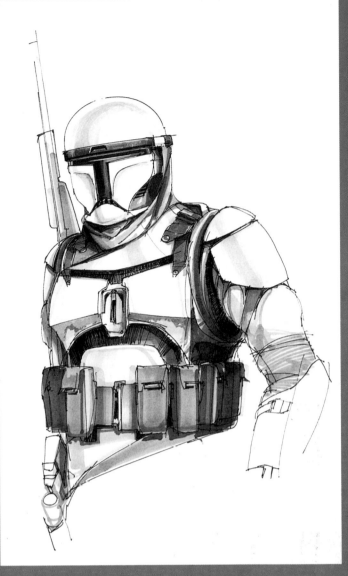

DJB-771
DOOKU'S EXIT
RYAN CHURCH
13 FEB 02
SW2

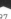

each one carrying up to 102 fetus chambers. George Lucas brought the cameras close enough to the pods that fetuses had to be created with fine details like fingers and hair, and individual animations. Clone children were then educated at individual workstations in a factory production-line setting, without any individual attention. Young actor Daniel Logan was cloned digitally—he was filmed at a single console around 175 times—and the footage was composited to create a large congregation of student soldiers.

After his tour, Kenobi is taken by the Kaminoan Taun We, to meet the template for all of these clones: a bounty hunter dressed in Mandalorian armor named Jango Fett. In addition to providing his own DNA, Jango also helped train the clones for combat. As part of his payment, Jango required one unaltered clone, whom he named Boba and raised as his own son.

While the unmasked clones were played by a trio of Maori actors from New Zealand, all the helmeted clones

TOP: Obi-Wan touring the Kamino facility as it appears in the completed film. Actor Ewan McGregor performed on an empty stage against a green screen. **BOTTOM:** Actor Bodie Taylor portrays young adult clones in the Kamino cafeteria. His performance was recorded many times and then duplicated.

Holcomb, from the hard-surface modeling team, created the digital armor, while creature modeler Dylan Gottlieb fashioned the black body glove the troopers wore underneath.

Back on Coruscant, Jar Jar Binks convinced the Senate to grant Chancellor Palpatine emergency executive powers, which he then uses to take control of the clones and form the Grand Army of the Republic. The clone's first major battle was on Geonosis.

The last, haunting line in the film is spoken by Yoda, "The shroud of the dark side has fallen. Begun the Clone War has." This is followed by Chancellor Palpatine and key dignitaries overlooking their new clone army. To compose the scene, concept artists referenced, among other things, Hitler's Nuremberg Rallies and Leni Riefenstahl's propaganda film *Triumph of the Will* (1935). The scene would be echoed later, with even greater potency, at a rally of The First Order on Starkiller Base in *The Force Awakens*.

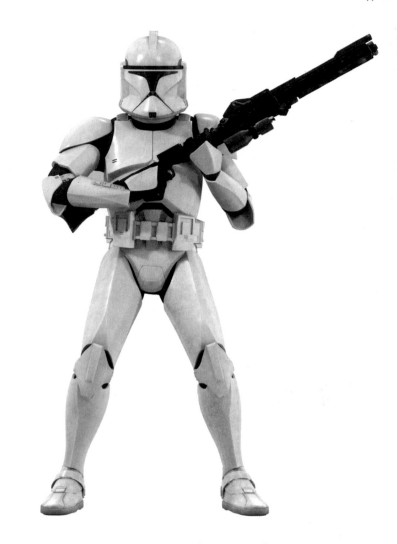

THE FIGURE OF A CLONE

Unlike stormtroopers, whose ranks were denoted by the color of pauldron on their shoulder, clone ranks were displayed according to the color of stripes on their armor. Sergeants had green stripes, lieutenants had blue, captains had red, and clone commanders had yellow stripes. This meant that many clone action figures, LEGO minifigures,

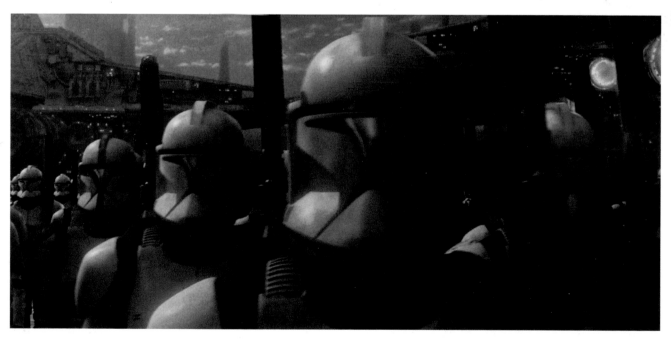

TOP: A clone trooper rendered from *Attack of the Clones* holds a DC-15 blaster rifle. Much like the DLT-19 used by stormtroopers and 4-LOM in the original trilogy, the DC-15A is based on a German Maschinengewehr MG34 from World War II. **BOTTOM:** Final frame from *Attack of the Clones*. Note the colored stripes on the helmets to denote rank.

busts, maquettes, and other merchandise invariably came in five different colors, including plain white, to collect! Of course there were clone pilots too, who had a completely different helmet design.

Hasbro officially released four "Sneak Preview" figures in advance of *Attack of the Clones*, on March 23, 2002. These figures included Jango Fett, Zam Wesell, R3-T7, and a Clone Trooper. Toys "R" Us later sold an exclusive silver version of the Clone Trooper in 2003 for the silver anniversary (twenty-fifth) of *Star Wars*. However, most merchandise for *Attack of the Clones* hit stores for the first time April 23, 2002. Fans lined up at participating stores for special "Midnight Madness" events beginning at 12:01 a.m. Another figure that was released early on was the Clone Trooper with Speeder Bike, which featured removable armor plates and an arm rigged to "throw" an electro grenade.

LEGO's first Phase I clone trooper was included with its Republic Gunship (set 7163). The cut-out visor on the figure's helmet revealed a faceless black head underneath.

The blaster was a black LEGO loudspeaker piece capped with a transparent blue stud. The minifigure would carry that same blaster unchanged until 2007, and it would otherwise be the only Phase I trooper version that LEGO produced until 2008. LEGO has since produced dozens of different Phase I minifigures.

Not all LEGO sets released during this time revolved around clone troopers. The first snowtrooper minifigure that was included with the *Millennium Falcon* (set 4504) was released in 2003. It had a black headpiece, black hands, and a torso printed, rather oddly, with clone trooper armor. Snowtrooper minifigures received their first face prints in 2012 and would receive a nice helmet upgrade in 2014. The first AT-AT driver also appeared in 2003 as part of the exciting AT-AT set (4483). It featured a repainted stormtrooper helmet, but that would be remedied with a new mold in 2010. Sandtroopers first arrived in 2004's Mos Eisley Cantina (set 4501), but they didn't receive their signature dirt splatters until 2012's Droid Escape (set 9490).

LEGENDS

STAR WARS GALAXIES: AN EMPIRE DIVIDED

On June 26, 2003, Sony Online Entertainment and LucasArts launched *Star Wars* Galaxies: An Empire Divided for the PC. This was the first large-scale massively multiplayer online role-playing game (MMORPG) for *Star Wars*. Sony released three expansion packs before servers were finally shut down on December 15, 2011.

The stormtroopers in Galaxies were all non-player characters (NPCs) controlled by the game. They could be allies or enemies depending upon whether players were aligned with rebel or Imperial factions. However, players who joined the Imperial faction could craft—purchase or be rewarded with—stormtrooper armor to wear. Crafting revealed materials necessary to create the armor, such as animal hides, polymers, steel, reinforced fiber panels, and fiberplast.

Star Wars Galaxies expanded the stormtrooper mythology by exploring their activities at a micro level on worlds around the galaxy, as well as featuring a number of new or specialized troopers, including shadow stormtroopers, black and gold novatroopers, Imperial storm commandos (essentially black scout troopers), medics, surgeons, snipers, and grenadiers.

The game also contained a wide variety of new, rare, and unusual dark troopers. These included numerous types, such as Black Hole; Exogen-class; heavily armored, Glory-class; Opressor-7; Opressor-9; Triumphant-class; and Victory-class.

On August 19, 2008, Sony Online Entertainment launched the *Star Wars* Galaxies Trading Card Game, available online to subscribers of the MMORPG game. It featured cards for a variety of stormtroopers, including dark troopers and shadow stormtroopers.

THE CLONE ADVENTURES

Despite the anticipation generated by the film's name, *Attack of the Clones* did not show the clones in battle until the very end of the movie. The next film, *Star Wars: Revenge of the Sith* (2005), only featured the tail end of the Clone War. This left a gaping three-year hole in *Star Wars* history, comprising nearly the entire Clone War. How to fill that void became the question.

"Hasbro was instrumental in providing impetus to make the micro series happen," says Derryl DePriest, Hasbro's global brand marketing director. "We asked Lucasfilm whether there could be created some form of entertainment to engage audiences in between movies. Through Transformer, we had a good relationship with Sam Register at Cartoon Network. Sam worked with Genndy [Tartakovsky] on *Samurai Jack*, and it was felt that his style could work well for a new *Star Wars* series. We brought Sam and Genndy together with Lucasfilm to present concepts."

George Lucas hired animator Genndy Tartakovsky to create *Star Wars: Clone Wars*, a hand-drawn 2D animated series (with the exception of ship animations, which were 3D CGI creations), which aired on Cartoon Network over the course of three years. The first season of ten, three-minute "chapters" (mini-episodes) aired November 7–20, 2003. Season two ran in the same format from March 26 through April 8, 2004. Season three was comprised of five, twelve-minute episodes, airing March 21–25, 2005. The series' storyline began at the close of *Attack of the Clones* and ended right where *Revenge of the Sith* picked up.

The series centered on a military-led war, with large-scale battles on land, sea, air, and space between clone troopers (all voiced by André José Sogliuzzo) and Separatist battle droids.

"We did a lot of research with all the hand signals to make sure that they were accurate. So you'll see a lot of the guys using hand signals and not so much dialogue," Tartakovsky says in his DVD commentary. "We initially thought they would all be clone troopers. But Lucas wanted to show a little bit more ranking, so they had some normal troopers along with a few special ARC troopers."

The series featured a group of ARC troopers (Advanced Recon Commandos) under the command of General Kenobi, and led by ARC-77 (also known as Alpha, Alpha-77, or Captain Fordo) on the Banking Clan's world of Muunilinst. Though ARC troopers were introduced earlier in Dark Horse Comics' *Star Wars: Republic #50: "The Defense of Kamino"* (February 26, 2003), fans first saw them in motion in the

ABOVE: A final frame from *Star Wars: Clone Wars* (2005) depicting Phase II clones. The series' influence on the aesthetics, character designs, and storytelling in *The Clone Wars* (2008–2014) was significant.

second episode of season one of *Star Wars: Clone Wars*. With Hasbro's early involvement, their team was influential in creating a look for these troopers. "Our team designed a lot of the things seen in the series," says DePriest, "characters, vehicles . . . and the ARC troopers."

Clone Wars also introduced clone scuba troopers for the first time, wearing twin jetpacks and scuba fins. They were led into battle by Kit Fisto in the seas of Mon Calamari—a scenario that would be re-created in the Dave Filoni–helmed *The Clone Wars* TV show.

Clone Trooper Phase II armor made its television debut (in advance of *Revenge of the Sith*) during season three (chapter twenty-two) of *Clone Wars*, worn by Commander Cody. It first appeared in Dark Horse Comics' *Star Wars: Republic #68: "Armor"* (August 25, 2004), as worn by clone Commander Bly, illustrated by artist Jan Duursema. Cody had just been introduced a few months earlier in author James Luceno's *Labyrinth of Evil* (January 25, 2005). His appearance in *Clone Wars* provided context for his relationship with Obi-Wan in the upcoming *Revenge of the Sith*. The introduction of these troopers across so many different tie-ins, prior to *Revenge of the Sith*, demonstrated the strong integration of *Star Wars* media during the era of the Expanded Universe.

Cloning Toys

Despite its brief combined run time, *Clone Wars* inspired a remarkable amount of merchandise, particularly action figures. From 2003 to 2005, Hasbro produced both a realistic line of figures as well as an animation-style line.

The initial series of realistic figures included an ARC trooper in three variants and Army of the Republic: Clone Trooper Army 3-packs, with troopers in various striped colors locked in standing, kneeling, or lying positions. Entertainment Earth also sold four Clone Trooper Troop Builder 4-packs with super-articulated clones in various ranks, with and without battle damage.

The animated line included a Phase I Clone Trooper, Clone Trooper Captain, Clone Trooper Commander, and Clone Trooper Lieutenant. A Phase II Commander Cody and clone trooper were also sold, each part of separate commemorative DVD collections, exclusive to Walmart in 2005.

Gentle Giant, a company that produces detailed and collectible figures and statues, released a number of pieces for the *Clone Wars* series, including a *Star Wars Clone Wars* Bust-Up Clone Trooper (each with one of three possible mini-bust variants), ARC Trooper Captain mini-busts, and an ARC Trooper Captain maquette. The series animation style inspired later pieces that didn't actually appear in the show, such as their whimsical *Star Wars* Animated Sandtrooper on Dewback Limited Edition Maquette, released in 2013.

ABOVE: The animation-style figure sculpts from *Star Wars: Clone Wars* looked great though their articulation was limited to a ball-joint head, swivel arms, and a swivel waist. The elbows and legs did not move. **LEFT:** Clone Trooper (Hasbro, 2004). **CENTER:** Clone Trooper (Hasbro, 2005). **RIGHT:** ARC Trooper (Hasbro, 2005). The ARC Trooper was also available in a commemorative DVD collection.

PAYING HOMAGE

On September 20, 2004, the original trilogy was released on DVD for the first time. There were a number of well-known changes made, including an alteration to a famous shot on the Death Star in *A New Hope*. In the scene, a stormtrooper bumps his head on a door frame on his way to investigate the office where R2-D2 and C-3PO are hiding. Rather than removing this vintage "mistake" for the DVD release, Lucas decided to capitalize on the humor of it and add an audible "bump" sound effect when the stormtrooper hits his head.

Interestingly, Lucas had already paid homage to the scene in *Attack of the Clones* by having Jango Fett bump his head as he enters his ship, *Slave I*, on Kamino. Speaking on the *Attack of the Clones* DVD commentary, Lucas said, "In *Star Wars*, one of the stormtroopers bumps his head on the door as they leave the control room on the Death Star and I thought, *Wouldn't it be funny if that's a trait that Jango has?* When he puts his helmet on and everything, he can't really see that well, and so he's constantly bumping his head. That trait gets cloned into all the stormtroopers, and that's why they keep bumping their heads."

WRAPPING THE PREQUELS

Star Wars: Revenge of the Sith premiered May 19, 2005, with a new array of clones in battle—fighting in their prime—across the galaxy. As a backdrop to the story of Anakin, Padmé, and Obi-Wan, we see the clone troopers' betrayal of their Jedi generals, and what was envisioned by George Lucas at the time as their transition from heroes of the Republic to the villainous stormtroopers of the Empire.

The design of the clones' Phase II armor, as it appears in the movie, represents a visual transition between the soldiers of *Attack of the Clones* and the stormtroopers of the original trilogy, with recognizable deviations toward specialized troops such as sandtroopers, biker scouts, and pilots. From Lucasfilm's first art department meeting in April 2002, George Lucas made it clear that he wanted these new clones to have individualized designs. This would help hide the fact that all of the helmeted clones were digital copies. But it would also lend each clone more personality and a sense of realism because soldiers in real wars

ABOVE: Examples of specialized troopers from *Revenge of the Sith*. **TOP to BOTTOM:** Shock clone troopers in the Senate arena on Coruscant; clone Commander Gree (CC-1004) and a clone scout trooper receive their orders to terminate Yoda; Commander Cody (CC-2224) was one of Obi-Wan's most trusted men, before Order 66; a 501st trooper takes aim at Bail Organa on Coruscant.

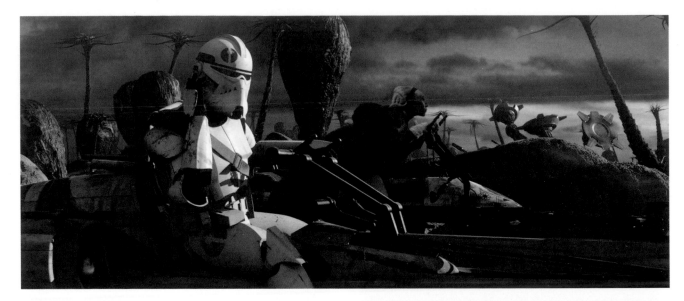

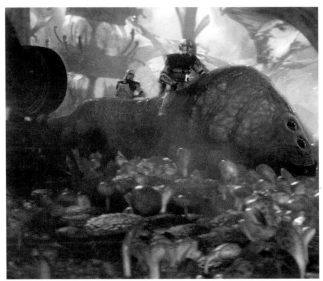

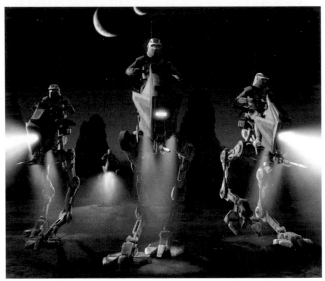

may customize their gear. Rob Coleman's team referenced films like *Black Hawk Down* (2001) to create a grittier, commando visual style. At this point in the *Star Wars* timeline, the colored stripes and patterns on clone armor no longer signified rank, but rather legion affiliation. Their unique looks were also dictated by the demanding environments on the worlds where they battled, especially in the lush jungles of Kashyyyk, where clone armor was camouflaged. Some, like the ARC troopers created by Alex Jaeger, were based on clones from Tartakovsky's *Clone Wars*. Others, like the purple Mygeeto clone troopers, closely resemble snowtroopers from *The Empire Strikes Back* (though their face masks would protect them from falling ash, rather than the icy cold of Hoth).

In a callback (or rather, a call-forward) to the reptilian dewbacks ridden by sandtroopers in *A New Hope*, George Lucas had the art department design a new creature for the clones to ride through the fungal forests of Felucia. Several concepts were created before Lucas settled on the giant translucent green gelagrubs—the larvae of Felucian ground beetles. Clones also rode mechanized mounts. Though first introduced in *Star Wars: Clone Wars* chapter twenty-two, the AT-RT, designed by T. J. Frame, made its film debut at the Battle of Kashyyyk. Rob Coleman's animation team closely studied the scout walkers from the original trilogy to match their quirky hand-animated motions for these new "proto chicken-walkers." There were still other clone vehicles. On Felucia, Commander Bly's 327th Star Corps drove

TOP: Clone Commander Neyo of the 91st Recon Corps receives the order to terminate Jedi Stass Allie on Saleucami, *Revenge of the Sith*. **BOTTOM LEFT:** A clone in the Galactic Marines rides a gelagrub on Felucia. **BOTTOM RIGHT:** The 41st Elite Corps ride AT-RTs, scouring Kashyyyk for Master Yoda.

eight-legged All Terrain Open Transport (AT-OT) walkers resembling giant mechanized beetles. Commander Neyo and his men from the 91st Mobile Reconnaissance Corps drove more elegant BARC speeders on Saleucami—a vehicle that would be seen often in *The Clone Wars*.

RUMINATIONS ON CLONES

The focal point for clones in *Revenge of the Sith* was of course their treachery toward the Jedi. As Anakin and his 501st Legion storm the Jedi Temple on Coruscant to wipe out the Jedi there, Palpatine finally executes the final stage of his diabolical plan and issues "Order 66." Across the galaxy, the clone army instantly turns against their Jedi commanders. We see Jedi Ki-Adi-Mundi, Aayla Secura, Plo Koon, and Stass Allie all perish in rapid succession. Cody's instant, though unsuccessful, betrayal of Kenobi on Utapau gained even greater emotional impact once their relationship was developed in Lucasfilm's animated television series, *The Clone Wars*.

Palpatine justified Order 66, telling the Senate that the Jedi have turned against the Republic, declaring "the attempt on my life has left me scarred and deformed, but I assure you, my resolve has never been stronger!" What exactly caused the once-loyal clones to brutally murder their Jedi comrades-in-arms? Were they merely obeying orders? This

mystery would remain unexplained until the final season of *The Clone Wars*. The clones' vicious betrayal and lack of any impulse to question Palpatine's orders established the tone of what Obi-Wan later referred to as "the dark times." It also more fully informed the ruthless mythos of the Imperial stormtroopers seen in the original trilogy.

George Lucas worried the violence might be too graphic in *Revenge of the Sith*—particularly the scene where Obi-Wan and Yoda storm the Jedi Temple and retake it from the clone troopers. As told by J. W. Rinzler in the bonus chapter of *The Making of Star Wars: Revenge of the Sith*, animation director Rob Coleman asked Lucas what he thought about the test footage where Yoda impales a clone. George Lucas hesitated. "It's good, but is it appropriate?" Lucas likewise worried that throwing a lightsaber was very "un-Jedi." He mused, "A good Jedi does not let go of his sword."

The scene did make the final cut of course, as did another scene where Yoda decapitates clone Commander Gree and another trooper after they receive Order 66 and try to kill him on Kashyyyk.

When it came to marketing the film, the clones caused a few road bumps. The Motion Picture Association of America (MPAA) objected to shots where clone troopers aimed blasters at people, and initially rejected the trailer.

At the end of the movie, fans were left wondering about the transition between clone troopers and stormtroopers. Are

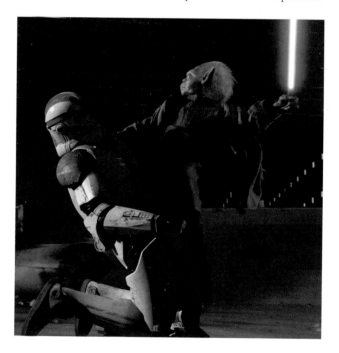

LEFT: Commander Cody receives Order 66 from Palpatine, *Revenge of the Sith*. He and the 212th Attack Battalion then turn against Obi-Wan on Utapau. **RIGHT:** The scene in which Yoda retrieves his lightsaber from the chest of a 501st clone after the clones have taken control of the Jedi Temple in *Revenge of the Sith*.

LEGENDS

ON THE BATTLEFRONT

Star Wars: Battlefront, a first-person shooter, galactic conquest game created by Pandemic Studios and LucasArts, was released on September 20, 2004. The game marked a new era of success for LucasArts. It was marketed together with the original trilogy DVD (which included an Xbox game demo) and went on to be LucasArts' best-selling game at the time. Battlefront allowed players to take control of either side in both the prequel and original trilogy eras—although prequel-era content ended at the Battle of Kashyyyk.

Players could play as one of five classes in each faction (basic infantryman, sniper, pilot, heavy, and special). The Republic forces included clone troopers, clone sharpshooters, clone pilots, ARC troopers, and jet troopers. The Empire ranks featured stormtroopers, snowtroopers, and scout troopers; AT-ATs, AT-STs, and TIE pilots; shock troopers equipped with mines and rocket launchers; and dark troopers fitted with jetpacks.

The vastly expanded sequel *Star Wars*: Battlefront II, which went on sale October 31, 2005, included locations and characters from *Revenge of the Sith* as well as new space battles that allowed players to board ships at will. The game featured similar unit classes as before (now in Phase II armor, except where clones appear on Geonosis), with extra weapons and abilities, as well as three new classes: engineers, marines, and special officers. Clone sharpshooters (snipers) now appeared as clone scout troopers on Kashyyyk, Felucia, and Mustafar. ARC troopers were also swapped for "clone heavy troopers," resembling Commander Bacara from *Revenge of the Sith*.

Temuera Morrison voiced the clones in the original game and returned to voice Jango and Boba Fett, as well as a

ABOVE: A promotional image for *Star Wars:* Battlefront (2004).

The official tie-in to the exciting new *Star Wars* video game!

STAR WARS
REPUBLIC COMMANDO
HARD CONTACT

KAREN TRAVISS

STAR WARS
AN IMPERIAL COMMANDO NOVEL
501ST

They were the Republic's right hand. Now they're the Empire's iron fist.

KAREN TRAVISS
#1 *NEW YORK TIMES* BESTSELLING AUTHOR

retired clone character in the sequel. The rest of the clones in the sequel were voiced by David Boat and the stormtroopers by Lex Lang. The game was full of "Easter eggs," such as clones who humorously yell out, "Look out! It's Major Malevolent, uh, General Grievous!" and "Hey Jango! Can I have your autograph?"

Star Wars: Battlefront Renegade Squadron, released exclusively for the Sony PlayStation Portable system (PSP), was another big hit when it was released on October 9, 2007. Unlike the previous games, it had no class system. Instead, players could customize the abilities and appearance of their character on the fly. Traits could be assimilated from new forces, such as elite dark troopers, dark trooper commanders, MEC troopers, and clone paratroopers. The troopers of both eras were voiced by Andrew Chaikin.

On October 26, 2004, Del Rey released the first in a five-book series. *Republic Commando: Hard Contact*, a Karen Traviss novel, tied in to the new game, Republic Commando. The game itself launched on February 28, 2005, and was a success, though not as big as LucasArts would have liked. The gritty first-person shooter followed Delta-squad, a group

of elite clone commandos, on a series of three missions taking place during the Clone Wars. Players assumed the role of "Boss" (RC-1138), who wore an orange and white version of the distinctive new commando armor. A planned game sequel, Imperial Commando, never went beyond the concept stage; however, the last book in the novel series used the name *Imperial Commando: 501st*, and a mobile phone game Republic Commando: Order 66 was produced by THQ Wireless. Boss and Delta-squad would later be inducted into the official canon via an appearance in *The Clone Wars* episode "Witches in the Mist" (season three, episode 314).

Both the Battlefront games and Republic Commando would spawn a variety of Hasbro action figures. Gentle Giant also released a series of Republic Commando Clone Mini Busts. LucasArts created a maquette of all four commandos, colored in bronze (four hundred pieces), and gifted it to the team members who created the game. StarWarsShop.com commissioned 513 copies repainted to match the game character colors, titled the *Star Wars* Republic Commando Limited Edition Full Color Maquette, and offered them for sale online.

ABOVE: Covers to *Republic Commando: Hard Contact* (Del Rey, 2004) and *An Imperial Commando Novel: 501st* (Del Rey, 2009). These were the first and last titles in the novel series tied to the Battlefront games (LucasArts).

stormtroopers clones too? Rinzler provided some insight into Lucas' thinking at the time:

"Acting upon the orders of Palpatine, they have betrayed the Jedi and the Republic, becoming the stormtroopers of *A New Hope*." Indeed, by the end of the shooting script for *Revenge of the Sith*, George Lucas was regularly referring to the clones as "stormtroopers." In fact, earlier, in May 2004, Pablo Hidalgo explained in *Star Wars Insider #76* that "During the production of Episode III, Lucas told crewmembers that the stormtroopers seen in Episode IV are—in the story world—made from multiple sources. That is, they're not all Jango clones. By that time in the saga, other clone hosts have been selected." Elaborating further, "Lucas intimated that the selection process has become more political than strategic in some cases—a highly placed officer's cousin might be selected over a more capable specimen, for example. The politicization results in less-than-ideal candidates, which could explain some of the embarrassing marksmanship witnessed in the original trilogy." These statements pull directly from George Lucas' own words as they appeared in the Hyperspace fan website "Set Diary" for August 13, 2003: "Well, they start to turn to different sources when they need [soldiers], that's why

you get the differences," offers Lucas as an explanation. "We get a model that isn't the Jango version, that doesn't bump his head on doors. But then we get versions that can't shoot straight," he laughs. "I can see the corruption in the Empire: someone says to the Emperor, my cousin would like to fight in the wars, but he doesn't want to do any of the actual fighting. Can you clone him? Well, can he shoot? Ah, yeah. Sure he can."

However, the *Star Wars* Expanded Universe and reference material would leave a lot of wiggle room. Hidalgo added in 2004, "In addition to multiple clone hosts, stormtrooper ranks also include conscripted soldiers and academy graduates, as has been chronicled in the Expanded Universe for many years now." The varying statements would result in a variety of interpretations regarding who the individuals actually are that were under those stormtrooper helmets!

Lucas demonstrated that his ideas were indeed evolving in May 2005, when he told MTV, "The idea is that over time, there were new clone strains introduced, and then they even conscripted guys to be stormtroopers. So it's not just purely clones; it started out as clones, but then it got diluted over the years as they found out they could shanghai guys [more cheaply] than they could build clones."

ABOVE: Emperor Palpatine comes to the aid of Anakin on Mustafar, accompanied by two shock troopers, in *Revenge of the Sith*. The red and white shock troopers would often be seen in *The Clone Wars*, and an Imperial stormtrooper version would be created for *Star Wars: Battlefront* (EA, 2015).

REVENGE IN THE STORES

As with *Attack of the Clones*, toys pertaining to *Revenge of the Sith* first went on sale at "Midnight Madness" events on April 2, 2005. Hasbro had a number of single-carded clone action figures in their initial product lineup. These included three different Clone Trooper variants (a plain white trooper, a red-and-white shock trooper, and a "super articulation" clone trooper), a Tactical Ops Trooper (actually a 501st Legion), two Clone Pilot variants (gray and black), two generic Clone Commander variants (red and green) and Commander Bacara, Commander Bly, and Commander Gree. There were also exclusive clone troopers available via Target and StarWarsShop.com.

Once again, Hasbro also released a series of 3-packs, now with Phase II clone troopers locked in standing, kneeling, or lying positions. There were also sets of figures with collectible plastic cups (reminiscent of the 1980s' Burger King cups), and a Walmart exclusive Commemorative Episode III DVD Collection 3-pack of unique clone troopers. With the saga now complete, Hasbro began producing "Evolutions: Clone Trooper to Stormtrooper" packs, including variants of an EPII Clone Trooper, an EPIII Clone Trooper, and an EPIV Sandtrooper.

LEGO produced its first Phase II Clone Trooper in 2005, as part of the Clone Turbotank (set 7261). A flurry of fourteen *Revenge of the Sith* sets were released in 2005, but fans didn't see many more until another cache of thirteen sets were released in 2014.

LEFT: A Phase II Clone Trooper minifigure that was included in the LEGO Clone Turbotank (set 7261), 2005. **RIGHT:** A Tactical Ops Trooper from *Revenge of the Sith* (top) and figure in its packaging (bottom). A sticker on the right denotes it as "Vader's Legion," though it falls short of calling it a 501st Legion trooper, because the official connection in canon had not yet been made.

THE CLONE WARS CONTINUE

On April 21, 2005, at Celebration III, George Lucas announced plans for another animated TV series, *Star Wars: The Clone Wars*, which would be launched with a feature film on August 15, 2008. Dave Filoni would be the supervising director of what Lucas referred to as "a 3D continuation of the pilot series that was on the Cartoon Network." In actuality, this second series would overwrite the story laid out by the Tartakovsky rendition of the *Clone Wars*, but his designs and story details did influence some of the material in the new show. Dee Bradley Baker would voice all of the clones in the 2008 series; his other credits include sounds and voices for *Star Tours: The Adventures Continue* (2011), *The Box Trolls* (2014), *The Hobbit: The Battle of Five Armies* (2014), and Jon Favreau's *The Jungle Book* (2016), just to name a few.

"I had pretty well established myself as a voice actor, for a little over ten years in Los Angeles, and I had already worked with Dave Filoni, who had directed on the first season of *Avatar: The Last Airbender* on Nickelodeon," recalls Baker. "So he knew me, as did Andrea Romano, casting director extraordinaire, who was involved with the initial casting process of *The Clone Wars*. So they called me in to audition. They didn't really tell us what it was, but eventually it became clear that they wanted someone to sound like the clones in the prequels. So I looked through those and there was precious little dialogue there, so I gave my best shot at it, and they liked what I did, and they liked working with me, and so they hired me, I guess, much to my surprise!"

While hiding stormtroopers and clones inside generic suits of armor minimize the consequences of violence in the films, George Lucas made audiences care about his soldiers for the first time by removing their helmets and humanizing them in *The Clone Wars*. Lucas insisted on individual personalities for the clones. Their differentiations were apparent in their peculiar nicknames, haircuts, tattoos, the designs and customizations of their armor, and even their distinct mannerisms and speech patterns.

This made Baker's task daunting. "The challenge of it was to make these guys seem different and give them an individual humanity. It wasn't real clear up front that that's what the mission was. But that really was what the trick was—to make these guys individuals, because they are very much the heart of the regular human side of the story of *The*

TOP: Movie poster for the cinematic release of *Star Wars: The Clone Wars* (2008). **BOTTOM:** Echo—seen with a signature blue handprint on his chest—roams the clone facilities on Kamino with Fives, where they meet their old friend, 99, just prior to the Separatist invasion in "ARC Troopers" (Season 3, Episode 302).

Clone Wars, I think. Which really wasn't fleshed out much in the prequels." For the first time on screen, fans would see soldiers with a moral compass; soldiers who talked about duty, honor, and loyalty, both to the Republic and each other. These were troopers with integrity and heart.

Kilian Plunkett, the design lead on the show, knew that convincing photo-realism was elusive, so the design team created stylized characters instead. "Our whole goal, from very early on in [The] Clone Wars, and it's a mentality that carried through to [Star Wars] Rebels, was it's better off that it feels true rather than it looks real. That's been something of a mantra . . . because the audience will sort of go along with your story and invest in these characters more if everything seems like it's a singular world and it's convincing and it's consistent."

That being said, Plunkett was thankful that the art department had real-world references to work from. "During [The] Clone Wars, the 501st were actually good enough to show up in their clone armor and go through a series of poses and exercises with the episodic directors, to sort of show them what poses were possible and which ones were very difficult, and where the armor would restrict you, and compromises you would have to make to move."

THE ORDER OF THINGS

Throughout *The Clone Wars*' six seasons (and the later, unfinished episodes), viewers met a seemingly endless list of individual clone troopers, all of whom became legendary *Star Wars* characters in their own right. Some of the most important clones, like Captain Rex (who was originally to be named "Alpha," after the Dark Horse Comics' ARC trooper), Commander Cody, Fives, Wolffe, and Echo, had story lines that spanned the entire series. Other well-defined, unforgettable characters, like Dogma, Cut Lawquane, Waxer, Gregor, and 99, appeared in no more than a few episodes.

Seasons one through three of the Emmy Award–winning show established character roles and outlined their career paths within the Grand Army of the Republic. The first episode, "Ambush," airing on Cartoon Network on October 3, 2008, began with Yoda affirming the value and uniqueness of each clone. "Deceive you, eyes can. In the Force very different, each one of you are. Clones you may be, but the Force resides in all life forms."

"Rookies" (Season 1, Episode 105), which actually picked up where season three's premiere episode "Clone Cadets" (Season 3, Episode 301) left off, followed clones Hevy, Echo, Fives, Droidbait, and Cutup on their first mission to the Rishi

ABOVE: Renderings of three clone commandos from Delta-squad (left to right): Fixer, Sev, and Boss. Their cameo in *The Clone Wars* was a nod to the fans after the much-loved characters debuted in LucasArts' Republic Commando, and appeared in five popular novels.

Moon, where Droidbait and Cutup ultimately lost their lives. In "Clone Cadets," audiences got to see the aforementioned soldiers as they trained at the facilities on Kamino.

"Innocents of Ryloth" (Season 1, Episode 120) followed Ghost Company's Waxer and Boil as they rescued little Numa, a young Twi'lek girl on Ryloth. Their story demonstrated that clones were more than soldiers, and their actions had a lasting impact on others.

In "The Deserter" (Season 2, Episode 210), Rex met Cut Lawquane, a clone who abandoned his post and started a family. The encounter planted seeds in Rex's mind that a full life is possible beyond military service.

"I really loved Cut Lawquane," says Baker. "He was just a one-off, but I find it so fascinating that he was a clone with a

family. I'm a dad with two kids, and he was too. I just found that a really interesting, pivotal episode—a moment for Rex, where he could have turned the guy in at the end because he was typically more by the book. But I think he saw the valor and the honor and the sense of the decisions that Cut had made, especially to protect his family."

In "ARC Troopers" (Season 3, Episode 302), Fives and Echo returned to Kamino to fend off a Separatist invasion. The sacrifice of their friend, a maintenance trooper named 99, taught the life lesson that every person, no matter how marginalized, has value.

Baker was particularly proud to help create 99's story. "He was only in two episodes, and is just this sort of outsider bad-batch clone that still had great resolve and a great humanity

TOP LEFT: Yoda discusses the situation on Rugosa with his troops in season one's "Ambush" (Season 1, Episode 101). **TOP RIGHT:** Domino Squad trains on Kamino in season three's "Clone Cadets" (Season 3, Episode 301). **BOTTOM:** Captain Rex with Cut Lawquane and his family on Saleucami in season two's "The Deserter" (Season 2, Episode 210).

and a great moral sense in him. And he was ultimately very heroic in how he helps out. I think it's great to have characters in the grand mythology that are not all 'superheroes' with 'super powers.' Some are just normal people or people that are challenged in some way."

In Seasons Four through Six, the clones began to wonder about the Jedi's intentions, as well as their own place in the Republic's military machine. Season Four's "Darkness on Umbara" (Season 4, Episode 407), "The General" (Season 4, Episode 408), "Plan of Dissent" (Season 4, Episode 409), and "Carnage of Krell" (Season 4, Episode 410) detail a clone mutiny against the rogue Jedi General Krell, who had fallen to the dark side. The story arc lent support to the eventual claim by Palpatine that the Jedi were working against the Republic and set a precedent for clones turning against the Jedi. The arc featured many clones, including Rex, Appo, Dogma, Fives, Jess, Kix, Tup—and the death of Waxer.

"Missing in Action" (Season 5, Episode 512) was a character story about Gregor, a clone commando stranded on Abafar with amnesia. His sacrifice allowed D-squad to complete their mission for the Republic. Like Rex and Wolffe, however, his story continued in *Star Wars Rebels*.

The series' run ended on Cartoon Network in March 2013, with the conclusion of Season Five. The Sixth and final season premiered on Netflix in 2014. During that time, a four-episode story arc told within "The Unknown" (Season 6, Episode 601), "Conspiracy" (Season 6, Episode 602), "Fugitive" (Season 6, Episode 603), and "Orders" (Season 4, Episode 604) provided one of the series' biggest

payoffs. It explained that the Sith instructed the Kaminoans to implant the clone brains with a biochip to control their behavior—which was the secret instrument that made the clones' unquestioned obedience of Palpatine's Order 66 all possible. "The Lost One" (Season 6, Episode 610) finally revealed the story of Sifo-Dyas, the Jedi who foresaw the coming war and ordered the creation of the Clone Army. The Jedi learn that the Sith were behind his disappearance and arrive at the startling realization that Dooku guided the creation of the clones from the beginning. Yoda's own surprisingly dark response to "cover up this discovery, we must" directly led to the destruction of the Jedi Order.

The unfinished four-episode "Bad Batch" arc premiered at *Star Wars* Celebration Anaheim and was later made available on StarWars.com in 2015. Those episodes followed a group of commando clones who had each been genetically modified to produce uniquely advantageous traits (an evolution of Lucas' earlier ideas that eventually clones belonged to different genetic lines). Their mission was to rescue Echo, originally thought killed at the Citadel, and now a cyborg prisoner of the Techno Union.

Season Six of *The Clone Wars* had been a parting gift from George Lucas to *Star Wars* fans. It was his last chance to wrap up several lingering mysteries in his saga. However, the answer to two important questions would remain: What happened to the clones? And are stormtroopers really clones too? The answers to these questions had evolved and changed as Lucas crafted his saga, but they would only be addressed canonically for fans, after Lucas' departure from the company.

LEFT: 99 helps Domino Squad fend off a Separatist invasion of Kamino in "ARC Troopers" (Season 3, Episode 302). **RIGHT:** Fives is injected with a sedative by Kaminoan scientist Nala Se in "Orders" (Season 6, Episode 604). Fives' final episode was an emotional one for fans, who had followed his journey since the fifth episode of Season One.

LEGENDS

THE FORCE UNLEASHED

On September 16, 2008, LucasArts released *Star Wars*: The Force Unleashed, which incorporated both the voice and likeness of actor Sam Witwer as the main character and secret apprentice of Darth Vader: Galen Marek, a.k.a. Starkiller. Both in promotional art and the game itself, stormtroopers were the fodder for Starkiller's aggressive, over-the-top abilities with the Force. In an effort to bring some variety to the game, the developer included all of the original trilogy troopers and invented several new types by blending elements from prequel clones with classic stormtroopers. These included jump troopers wearing jetpacks; EVO (environmental) troopers equipped to survive hostile environments; incinerator troopers armed with plasma weapons; shadow troopers with cloaking devices; Navy commandos; and brutish cyborg dark troopers.

His first professional entry into *Star Wars* wasn't just a job for actor Sam Witwer—stormtroopers have long been part of his own fan obsession. "I must have fallen down the trooper rabbit hole when I was about eleven or twelve," admits Witwer. "I was an avid player of the West End Games' *Star Wars*

role-playing game. One of the most addictive things about that game were their sourcebooks, which were these treasure troves of *Star Wars* lore that I devoured hungrily. Those sourcebooks are not only responsible for making me the fanatic that I've become, but they are the true birthplace of the *Star Wars* Expanded Universe. Timothy Zahn's *Thrawn* trilogy drew heavily from those books."

But it wasn't just books for Witwer, either. "When I was a kid, the first *Star Wars* action figure my dad ever brought home for me was a stormtrooper." Witwer's collection has grown to include more than a few helmets. "I have a Clone Mk I, Clone Mk II, *A New Hope* edition of the standard stormtrooper helmet (complete with some bumps near the bottom edge of the right eye), and a stormtrooper commander helmet from The Force Unleashed. It should be noted, the clone armor and the stormtrooper commander helmets are symmetrical. The standard stormtrooper helmet is not. Not even a little bit. Just shows you that Palpatine was saving money on cheap equipment for the rank-and-file stormies. Palpatine is also notorious for budget cutbacks on railings and other safety measures."

Witwer's fascination with troopers isn't just about their armor either—it is philosophical. "I loved that stormtroopers were 'fanatically loyal' and could not be 'bribed or seduced.' I was fascinated by the idea that there was this force that was separate from the Army and the Navy who were loyal only and directly to the Emperor. There was something frightening about all of that."

The new stormtroopers introduced in The Force Unleashed were an appealing part of his experience with the game. "I thought the EVO trooper was fascinating. Almost a rougher, more primitive design. They had those rattlesnake-sounding electrical rifles. I wanted to know more about them. Oh, and I do love those flametroopers. Great chaps! Glad their children made it into *The Force Awakens*."

The sequel, *Star Wars*: The Force Unleashed II, was released on October 26, 2010, and focused on what some thought to be a clone of Starkiller. New troopers were again added into the mix, including nightmarish terror troopers, energy-saber-wielding riot troopers, and Force-sensitive saber guards. Despite their violent gameplay, LucasArts games have always minimized blood and gore. Nonetheless, The Force Unleashed II received clearance from the Entertainment Software Rating

ABOVE: Box art for *Star Wars*: The Force Unleashed (LucasArts, 2008), featuring Starkiller, Darth Vader's secret apprentice, and the likeness of Sam Witwer.

Board (ESRB) to include stormtrooper decapitations and still retain a Teen rating.

Actors Roger Jackson, Lex Lang, Steve Blum, and Fred Tatasciore all provided voices for various Imperial troopers in the series. Dee Bradley Baker appeared in the sequel also, but this time voicing Boba Fett, Baron Tarko, and a rebel soldier.

The Force Unleashed franchise spawned a pair of novels, a comic book series, numerous Hasbro action figures, and LEGO sets (including an unbranded 2015 Shadow Trooper set, #75079). Gentle Giant released several collectibles related to The Force Unleashed, including mini-busts of the Shadow Guard and Stormtrooper Commander in 2010. Sideshow also released a Stormtrooper Commander Premium Format Figure in 2013.

ABOVE: *Force Repulse* by concept artist Greg Knight. The image was used heavily to promote the game, and for the cover of *The Art and Making of Star Wars: The Force Unleashed* (Insight Editions, 2008). The image emphasized the revolutionary ability for players to interact with the game environment and rupture surfaces.

CLONES FOR SALE

Hasbro produced animation-styled *The Clone Wars* action figures from 2008 to 2013. With nearly a hundred different packaged clone figures, there were many different characters featured and a trooper for every situation. Some of the most remarkable include 2009's Captain Rex (Cold Assault Gear), which resembled a forerunner to the snowtroopers of *The Empire Strikes Back*; 2010's Flamethrower Clone Trooper was an interesting parallel to future flametroopers of *The Force Awakens*; 2011's Clone Trooper Hevy in Training Armor and 2012's Clone Trooper Cutup (also in training gear); 2011's Riot Control Clone Trooper included a shield and baton, again echoing the stormtroopers of *The*

Force Awakens; 2012's Cad Bane in Denal's clone armor was included in the Cad Bane's Escape set; 2012's Republic Commando Boss was inspired by the video-game character; and 2012's Clone Scuba Trooper was ultimately based on the Tartakovsky trooper.

LEGO began producing *The Clone Wars* sets in 2008, with peak production in 2009. LEGO developed a unique style for the faces of *The Clone Wars* minifigures, to match the aesthetic of the TV series. Dozens of unique figures were produced, although the majority of clone troopers were Phase I. After the series was canceled, LEGO began producing occasional *The Clone Wars* minifigures with more conventional LEGO-styled faces.

LEFT: Hasbro's Captain Rex (Cold Assault Gear) is based on the character as he appears in *The Clone Wars* "Trespass" (episode 115). **RIGHT TOP:** LEGO Phase I Clone Trooper minifigure (2008). **RIGHT BOTTOM:** LEGO minifigure Commander Fox (left) and Phase I Clone Pilot (both 2008).

LEGENDS

DEATH TROOPERS

On October 13, 2009, Del Rey published the first adult horror novel set in the *Star Wars* universe: *Death Troopers* by Joe Schreiber. The story followed an Imperial prison barge that encountered a derelict Star Destroyer. An experimental virus unleashed aboard the Star Destroyer converted the crew into zombies, and now the remaining survivors, including Han Solo and Chewbacca, must escape. The novel introduced the now-popular, gruesome concept of flesh-eating stormtrooper zombies. A related concept had already been introduced in *The Clone Wars* earlier that year, when clone soldiers were infected and controlled by the Geonosian queen via brain worms. The novel inspired an expansion in *Star Wars* Galaxies, and a prequel novel, *Red Harvest*, released December 28, 2010. Gentle Giant also got in on the stormtrooper zombie-fest with the gruesome Death Trooper Deluxe Collectible Mini Bust (2010) and Death Trooper Deluxe Statue (2013).

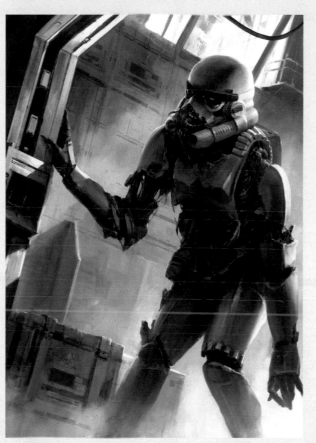

LEFT: Cover of *Death Troopers* by Joe Schreiber (Del Rey, 2009). A series of nine messages were posted on seven different fan websites to promote the then upcoming book on September 10, 2009. They were titled *Death Troopers: Recovered Messages from Purge*. **TOP RIGHT:** *Stormtrooper Reanimated* artwork by Kai Lim was created as part of the Agents of Deception expansion pack for the *Star Wars* Galaxies Trading Card Game (LucasArts and Sony Entertainment, 2009). **BOTTOM RIGHT:** An exploded stormtrooper helmet created as part of the London Film and ComicCon in London, 2013.

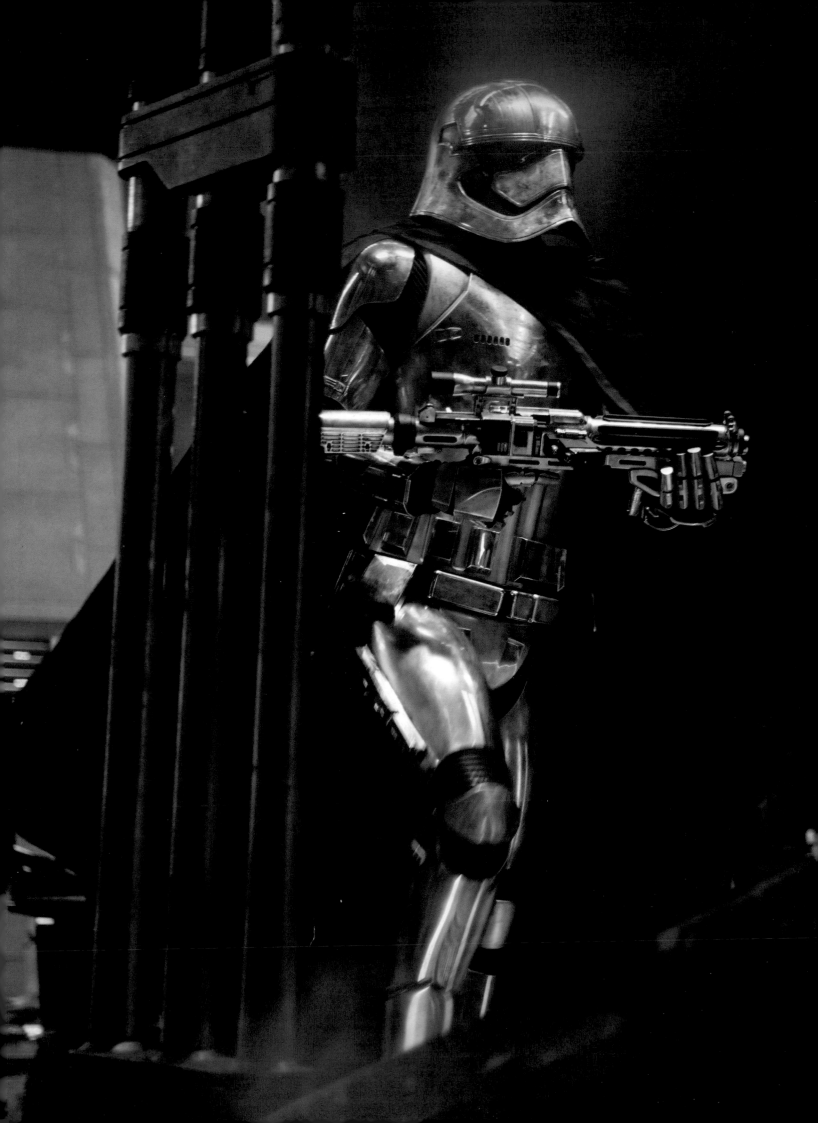

NEW REGIMES

"My dad had a stormtrooper helmet he would put on and chase us around the house with it. The people on the dark side were more interesting to me. You can't beat their aesthetic!" —Adam Driver, *Rolling Stone* magazine, December 2, 2015

Tremendous changes came to *Star Wars* when George Lucas sold his company to Disney in late 2012. Along with the initial announcement came the exciting news that Disney would be making *Star Wars* movies again! There were a number of other changes too, marking the end of a decades-long era. Lucasfilm shut down LucasArts video game development in April 2013 and turned to Electronic Arts for all future *Star Wars* console and computer gaming. On April 24, 2014, Lucasfilm announced that the *Star Wars* Expanded Universe would be rebranded "Legends" and a new *Star Wars* canon would be crafted for future publishing and games. That canon would be overseen by a new Lucasfilm team known as the Story Group. At the end of 2015, the comic-book license would also transfer from Dark Horse Comics back to Marvel, another Disney property. All of these changes resulted in a clean slate, and a renewed focus on the era of the Empire and its progeny, the First Order. Fans were about to witness an explosion of new content, merchandise ... and many more incarnations of their beloved stormtroopers!

THE REBELLION BEGINS

Soon after the Disney acquisition, it was announced that *The Clone Wars* would come to an end. Fans were devastated, but had hope

OPPOSITE: A scene from *The Force Awakens*. Captain Phasma boards an Atmospheric Assault Lander (AAL), otherwise known as a First Order Transporter, used to move stormtroopers.

MAY THE FOURTH BE WITH YOU

The play on the phrase "May the Force be with you" turned the date May 4th into the international "Star Wars Day." The grassroots fan-driven day of celebration was embraced by Lucasfilm and spurred numerous themed events, activities, and promotions.

On May 4, 2014, Lucasfilm teamed up with Neff to celebrate Star Wars Day in a unique way. They presented three hundred artists—including employees of Lucasfilm, ILM, Pixar, Marvel, celebrities, and street artists—each with a six-inch vinyl replica of a stormtrooper helmet based on the actual models used in Star Wars Rebels. Their task was to transform the helmets in any way they liked as part of Star Wars Legion, an exhibit that debuted at the Robert Vargas Gallery in Los Angeles. Some were also displayed at D23 (August 14–16, 2015), where eight of the helmets were reproduced and sold as blind box collectibles. The imaginative results of the project inspired the product Star Wars: Design a Vinyl Stormtrooper, which was sold on Force Friday, September 4, 2015, by Tara Toy Corporation, and allowed fans to create custom mini-helmets of their own.

when Lucasfilm Animation announced that it was working on a new series: Star Wars Rebels. Dave Filoni and his team moved more than fifteen years ahead in the Star Wars timeline to tell the story of the birth of the Rebellion. Because the events of the show would occur close to those of A New Hope, it meant getting back to the fundamental aesthetics of the original Star Wars.

"We've really tried to keep to the classic trilogy era for this," says Filoni. "I am definitely a person that loves the prequels, especially what they bring visually to the table. So, I'm never neglecting of the prequel era, it's just that I have to weight this show more toward the classic era, especially to make it different from what [The] Clone Wars was. So our artistic references are definitely leaning a lot more toward 'Joe [Johnston]-Ralph [McQuarrie] era' than it is the 'Doug Chiang or [Erik] Tiemens era.' But I love the work that all those guys do."

Though the show's artists looked to McQuarrie for the foundation of their stormtrooper redesign, that aesthetic was just one of many factors. "Knowing that our human characters were going to be stylized, it made sense then to stylize everything else," explains Star Wars Rebels art director Kilian Plunkett. "Because if you didn't, what you would end up with would be sort of very realistic, photo-accurate stormtroopers, living beside Kanan, Ezra, Hera, and Sabine. Those characters wouldn't necessarily play off of each other well, so it was a given that we were going to have to do something to the stormtrooper armor to create a visual continuity.

"Because we keyed off the work of [Hayao] Miyazaki and Studio Ghibli—in general in terms of the amount of detail on each character—it made sense for us to sort of explore ways to simplify down what the stormtrooper armor is and find ways to either combine shapes or to pair things down to a simpler form than you would see in the movies."

After The Clone Wars ended, processes at the smaller Lucasfilm Animation had to be streamlined and optimized. Simplicity was key. "When it came to designing all our characters, we sort of approached it as if this was going to be a 2D show," recalls Plunkett. "In other words, whatever your design was, the amount of visual information on it couldn't be so much that it would take some hapless artist who had to draw this as a piece of 2D cell animation days on end to do each frame . . . That more than anything else

LEFT: A selection of helmets from the Star Wars Legion art exhibit. (clockwise from top left) "Imperial Racing" by Alex Jaeger; "Untitled" by Steve Purcell; "Kitbash Head" by James Clyne.

is why the troopers got to be much, much simpler in terms of the frequency of stuff that's happening on their armor."

The design team went for shorter stormtroopers, with more realistic proportions, reminiscent of McQuarrie's art. "On [The] Clone Wars, when you look at the clones, they are very tall, they are very thin, extremely spindly; they have very attenuated sort of joints and limbs," Plunkett points out. "They are certainly dynamic and they are interesting looking, but they aren't proportions that would necessarily be reflected in real life. So we kind of went in the opposite direction, to a degree, with the troopers on Rebels, where they are a little more rounded, they have a lot more bulk to them—their hands are much bigger relative to their overall scale."

Nonetheless, Plunkett notes that the need for dynamic, animated action in Rebels demanded alterations not found in live-action stormtroopers. "If you were to compare a

photo of the live-action stormtrooper armor to a Rebels trooper, you'll see the gaps between the armor are bigger in Rebels than they would be on a 501st costume. That's because we need that sort of space so the troopers can hit pretty deep poses and stances without the pieces of armor penetrating into each other. So you'll see there's a little more clearance around the armpits than there would be in the live-action versions, and there's a much bigger gap around the hips—and even the gaps at the knees are a little bigger too."

According to Plunkett, the stormtroopers actually set the style guidelines used to design other seemingly unlikely characters for the show, like R2-D2, C-3PO, and even Ketsu Onyo. "The troopers and the TIE pilots were some of the first designs that we addressed for Rebels," says Plunkett, "because it was set during the Imperial Era, so we

TOP LEFT: In "The Call," Rebels Season Two, Kanan wears a stormtrooper helmet that Sabine decorated to look like a Loth-cat. The concept image was illustrated by artist Chris Glenn. BOTTOM LEFT: Star Wars Rebels Season One (2014) debuted stylized stormtroopers. ABOVE RIGHT: Two Imperial combat drivers walk the red carpet at the Star Wars Rebels premiere in Century City, California, September 27, 2014.

knew that we were going to see these characters a bunch . . . We were able to sort of use our stormtrooper design and the thinking behind it as something of a compass for how we would approach other very complex, visually dense characters."

The first episode of *Star Wars Rebels* aired on Disney XD on October 3, 2014. Besides classic stormtroopers (wearing a lot more shoulder pauldrons)—and pilots flying white TIE fighters with short wings based on McQuarrie concepts—there were also a few new troopers. These included Imperial combat drivers (based on McQuarrie concept art) manning AT-DPs and speeder bikes (both vehicles based on Joe Johnston concept art from the original trilogy), and Imperial troop transports (based on the vintage Kenner toy). Season two also introduced a new, taller AT-AT model and classic AT-AT drivers. Perhaps more exciting, however, was the return of a trio of much-loved soldiers from the previous era . . .

THE CLONES ARE BACK!

Season two welcomed back clone troopers Rex, Gregor, and Wolffe. Voice actor Dee Bradley Baker was pleased to be reunited with an old friend. "I love Rex because he's ultimately flexible of mind, and smart, and he endures. He's the kind of guy you'd want to have in any kind of a situation. I really like his arc of development from being more by the book in the very beginning, to gradually, as *The Clone Wars* unfolds, a more flexible and nuanced view of who he is."

The return of the three clones was not without surprises. Baker came to a quick realization about Gregor. "He's kind of nuts. He's had a personality shift. But the last that we saw him, when he sort of heroically assumed the mantle of clone commando, I believe, and saved the others who were escaping, there was a huge explosion where it looked like he might have died. I mean, it was really bad! It was after the fan reaction, as I remember, that they said that they loved Gregor so much that [Filoni] decided to let him live. And so, the trauma of that event—I think it kind of rattled his personality a little bit. So he's a little bit of a wacky old man! [Though] he still retains the fundamental competency of a really well-trained fighter."

TOP: Promotional poster for Season One of *Star Wars Rebels* (2014). **MIDDLE:** (left to right) Captain Rex, Gregor, and Wolffe return in *Rebel's* Season Two, Episode 3 "The Lost Commanders" and Episode 4 "Relics of the Old Republic." Though Rex joins the rebels, the other two continue their retirement. **BOTTOM:** Captain Rex and Wolffe in Season Two of *Star Wars Rebels*.

NEW AND OLD TROOPERS

Season Three of *Star Wars Rebels* brought together some old favorites as well as a new riff on a previous stormtrooper design. Not only were AT-AT drivers seen again, but biker scouts made their *Star Wars Rebels* debut on the planet Ryloth in "Hera's Heroes," while in "Imperial Super Commandos," fans were treated with a nod to the original "super storm-troopers" conceived by Ralph McQuarrie. In the episode, Mandalorians working for the Empire wore virtually all-white armor based on original McQuarrie concept designs from *The Empire Strikes Back*—designs that eventually evolved into the look for bounty hunter Boba Fett.

The rebels also faced off against Imperial security droids in "The Wynkanthu Job": droids new and yet very familiar to fans of classic LucasArts games. "Filoni is a big fan of Dark Forces," says Kilian Plunkett. "We are always trying to find ways—is there anything that we could do that would justify the appearance of—if it's not called a dark trooper—some kind of Imperial weapon that is very dark trooper–like."

Late in Season Three, flying stormtroopers with jetpacks were introduced. These skytroopers first appeared in Disney's Star Tours: The Adventures Continue (which opened May 20, 2011). Death troopers, first seen accompanying Director Krennic in *Rogue One*, were also seen escorting Admiral Thrawn. New toys for this season included Hasbro's Kanan Jarrus action figure wearing a stormtrooper disguise, and the Imperial Speeder, which included an Imperial combat driver.

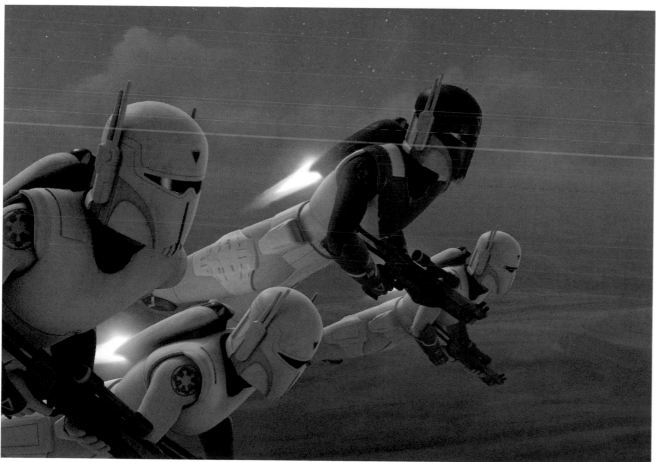

TOP: In *Rebels* "Through Imperial Eyes" (Season 3, Episode 317), Admiral Thrawn spars with an Imperial security droid—a design based on dark troopers from Legends. **BELOW:** Gar Saxon, the Imperial Viceroy of Mandalore (in red), leads his Imperial super commandos on Concord Dawn, where they have destroyed the Journeyman Protectors in Fenn Rau's absence, *Rebels* "Legacy of Mandalore" (Season 3, Episode 316)

REBELS IN PRINT

On September 2, 2014, John Jackson Miller's *Star Wars Rebels* prequel novel, *A New Dawn*, kicked off Lucasfilm's new publishing canon, including references to a female stormtrooper. He also created a female Imperial officer—Rae Sloane—whose story would be rapidly woven throughout novels and Marvel comics. It was immediately apparent that within the new publishing canon, women would have a larger role in the Empire.

Jason Fry's *Servants of the Empire* was a four-book series following the adventures of Zare Leonis, a young Imperial cadet who befriends Ezra Bridger in the first season of *Rebels*. In the final volume, *The Secret Academy*, Zare arrives on Arkanis, searching for his missing sister, Dhara. In the process, he uncovers a secret Imperial program to raise brainwashed children as future stormtroopers. The program was run by none other than Commandant Hux, the father of General Hux in *The Force Awakens*.

"During *The Clone Wars*, the elder Hux served alongside Jedi Knights and clones, two groups that trained warriors from birth," explains Fry. "Hux saw the deficiencies of the Empire's conscript and volunteer stormtroopers and imagined a radical reimaging of what the Jedi and clones had done. That program began in secret and was fulfilled by his son for the hermetic, fanatical First Order."

A NEW WAVE OF MERCHANDISE

Packaging for the new *Star Wars Rebels*–centric toy line featured a stylized stormtrooper helmet vandalized with Sabine Wren's signature orange starbird—a symbol of the rebels. The initial toys released included a new line of figures from Hasbro—a Stormtrooper and TIE Pilot (available separately or in a 2-pack), a Stormtrooper Commander (packaged with Hera Syndulla), and an AT-DP Driver. The vehicles included an AT-DP (available with or without a driver) and an Imperial Troop Transport—the first available since Kenner's vintage original. Season Three brought a Kanan Jarrus (Stormtrooper Disguise) as well.

After *The Clone Wars*, LEGO discontinued stylized faces on their minifigures; thus minifigures released with *Rebels* were reminiscent of those from the movies. However, while the stormtroopers and TIE fighter pilots feature the same

TOP LEFT: The cover to Jason Fry's *Star Wars Rebels: Servants of the Empire: Edge of the Galaxy* (first in the series, 2014). **BOTTOM LEFT:** The cover to John Jackson Miller's novel *A New Dawn* (Del Rey, 2014).

helmet molds as movie figures, the printed details on their armor were altered to match the stylized *Rebels* versions. White AT-DP drivers and gray Imperial combat drivers were an entirely new addition to LEGO *Star Wars*.

FROM THE BATTLEFRONT

The highly anticipated video game *Star Wars* Battlefront was released by Electronic Arts (EA) on November 17, 2015. The game developers at DICE (an EA subsidiary based in Stockholm, Sweden) were given special access to archive props at the Lucas Cultural Arts Museum, and visited the original film locations—all to create the most realistic gaming experience possible.

The game features battlegrounds and dogfights on Hoth, Endor, Jakku, Tatooine, Sullust, Cloud City, Scarif, as well as the Death Star and in space. While the battle locations spanned the movies, the stormtroopers in the game were limited to the original trilogy era and included all the classic types—stormtroopers, sandtroopers, snowtroopers, and biker scouts—as well as shadow troopers and shock troopers.

They were playable with and without their helmets and featured both male and female characters. This feature was later removed in the Death Star digital expansion after fans continually posted online that stormtroopers without helmets were neither intimidating in battle nor authentic to *Star Wars*. Characters could be equipped with backpacks and a large variety of weapons; drive speeder bikes and AT-STs, and fire a number a number of stationary cannons. An add-on to the games, released December 2016, allowed players to assemble the roles of death troopers and shoretroopers from *Rogue One*.

Associated merchandise was light, but fans of the game were treated to a Walmart-exclusive six-inch Black Series Imperial Shock Trooper and a LEGO Galactic Empire Battle Pack (set 75134). Aside from toys, there were a few cross-content books released as well. Del Rey published *Star Wars Battlefront: Twilight Company*, by Alexander Freed, on November 3, 2015, just before the game's release. The tie-in novel followed the story of Hazram Namir and the Rebel Alliance's 61st Mobile Infantry. It also wove a parallel story about Thara Nyende (SP-475), a female stormtrooper stationed on Sullust, whose story intersected with Namir's.

ABOVE: Promotional art for *Star Wars:* Battlefront (2015), as seen in The Forest Moon of Endor level.

THE FORCE AWAKENS

Ten years after the release of *Revenge of the Sith*, fans were rewarded with the first movie in the new *Star Wars* trilogy. Arguably the most anticipated film of the year, *The Force Awakens* opened in theaters December 18, 2015. It ushered in a return to the fundamentals of filmmaking and those of the original trilogy, with a renewed focus on practical effects, real-world filming locations, and stormtroopers played by real actors in costumes.

Within the *Star Wars* story, the Republic's clones were impressive soldiers; however, they were expensive to produce and had tendencies toward individuality that were both surprising and worrisome for a dictator like Palpatine. The troopers that became the Empire's stormtroopers had their own faults, too. The best stormtroopers were driven by patriotism and ambition, but their overall performance was variable at best, and at times rather disappointing.

The First Order's stormtroopers, however, marked a different breed of soldier altogether. "Stormtroopers are formidable now," comments actor Oscar Isaac (who played Poe Dameron). "They have all sorts of new weaponry, they have a new way of fighting, and they're vicious—and quite scary, when you see them on the set, running out of those transport vehicles. It's frightening." Under the First Order,

stormtroopers were stripped of their individuality and reared to be unquestioning warriors. Stormtroopers like FN-2187, a.k.a. Finn (played by John Boyega), weren't even given their own names—just ID numbers—like the clones of the old Republic.

CONCEPTS AND COSTUMES

The Lucasfilm design team convened in January 2013 to begin preproduction work on *The Force Awakens*. Concept artists Christian Alzmann and Iain McCaig began brainstorming initial designs of angular stormtroopers with sharp lines and edges. Their ideas were developed over numerous meetings, then further refined by costume concept artist Glyn Dillon. The costuming department met several times a week, collaborating between the artists, costume designer Michael Kaplan, and director J. J. Abrams.

The Imperial TIE pilots of the original trilogy had odd proportions. Their helmets were a little too big in comparison to their bodies. So Dillon and the team shrank the First Order pilot helmets and used the same basic shape for the snowtroopers and flametroopers as well. This strengthened the design continuity with a synthesis of common elements across much of the First Order military.

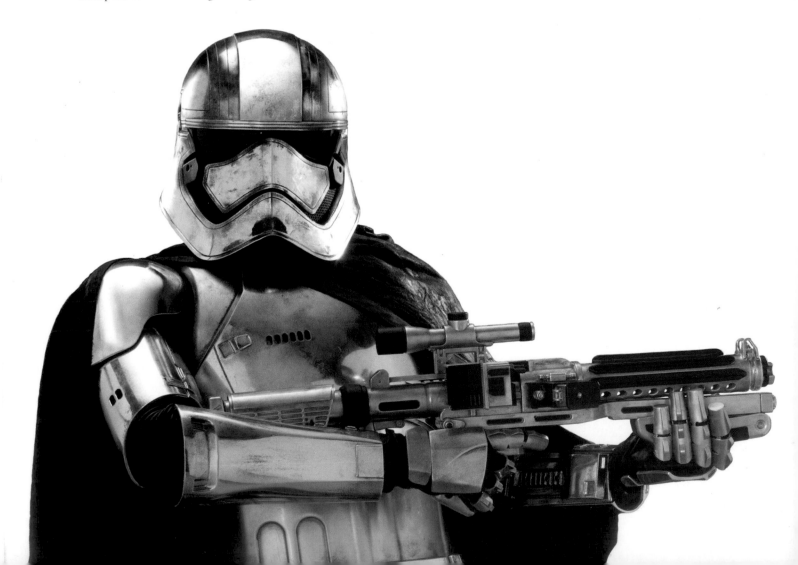

Despite their goal to illustrate a thirty-year progression in stormtrooper armor since the original trilogy, some details in First Order armor were even closer to McQuarrie's designs than the original Imperial costumes. There was subtle detailing around stormtrooper ears, for example, taken directly from Ralph McQuarrie's sketches. Similarly, First Order riot control troopers carried a shield in their left hands, much like McQuarrie's troopers—though they swapped their white lightsabers for batons. First Order snowtroopers also had overhanging helmet rims and a pair of chin nozzles that more closely resembled McQuarrie's designs than the original trilogy snowtroopers.

Michael Kaplan considered the original stormtroopers to be some of the most iconic costumes in the franchise. He spent a day at Lucas' archives in California to absorb the aesthetic of *Star Wars*, sifting through sketches and props for inspiration. None of the actual costumes could be reused. The old Vacuformed armor was too brittle and much of it had cracked and fallen apart. The new costumes Kaplan designed would be much heavier and more durable.

In a *Vanity Fair* behind-the-scenes article Kaplan said that he looked to contemporary inspiration, because "with the stormtroopers it was more of a simplification, almost like,

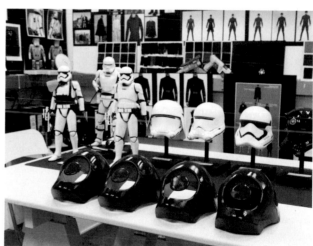

'What would Apple do?' J. J. wanted them to look like stormtroopers at a glance but also be different enough to kind of 'wow' people and get them excited about the new design."

In an interview with *Tyranny of Style*, Kaplan noted, "The new script was calling for a lot of action and stunt work that would require tougher armor. The suits were molded out of polyurethane, much stronger and in 'certain areas' more flexible for comfort. They look and perform a lot more solidly, which was important for today's more sophisticated moviegoers."

TOP: (left to right) HOD SFX costume modeler Pierre Bohanna and costume department members—Mike Smart, John Moss, Antonio Levetti—discuss the First Order flametroopers, 2014. BOTTOM: Models of First Order stormtroopers and flametroopers on display along with a snowtrooper helmet, flametrooper helmet, stormtrooper helmet, TIE pilot helmet, and Guavian Death Gang helmets in the costume shop, 2015. OPPOSITE: Captain Phasma. While Phasma had limited screen time in *The Force Awakens*, Lucasfilm president Kathleen Kennedy assured fans that Phasma would return in *Star Wars: The Last Jedi* (2017).

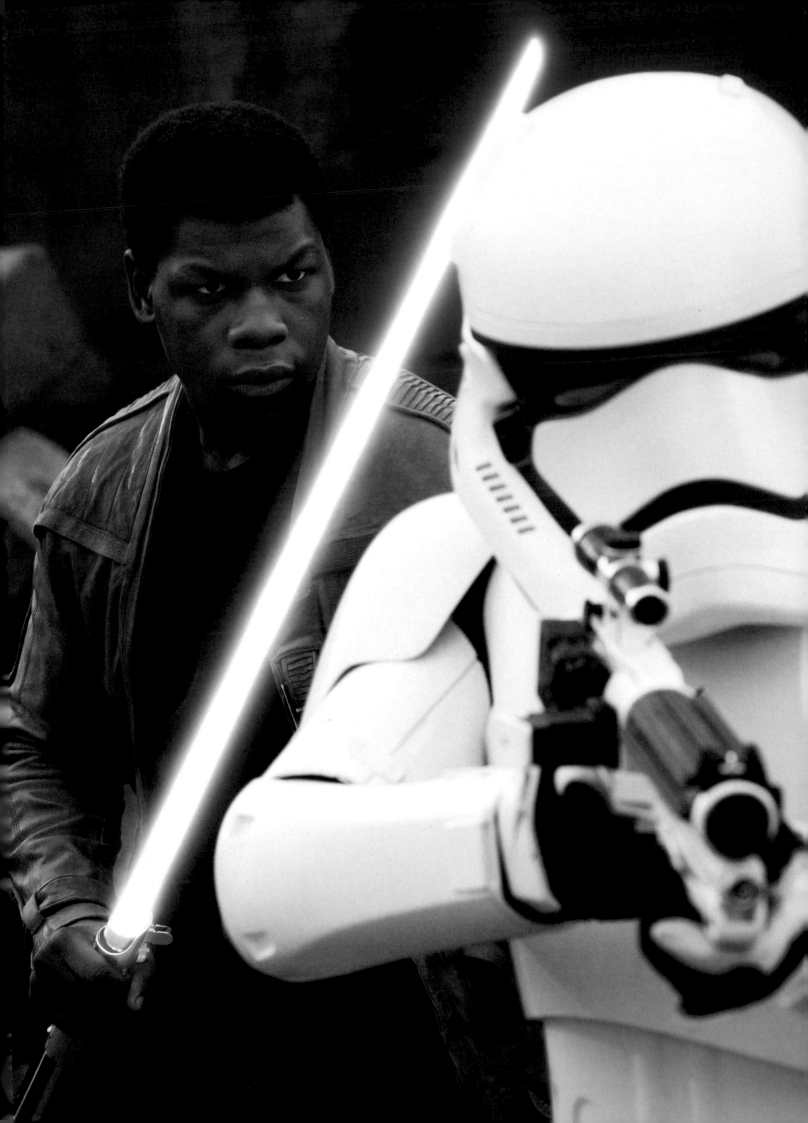

FN-2187

Writer Larry Kasdan (who also wrote the screenplays for *The Empire Strikes Back*, *Return of the Jedi*, and the young Han Solo movie) came up with the idea that one of the heroes would be a faceless stormtrooper who has a crisis of conscience and defects from the First Order. The role of Finn was played by John Boyega, a relatively unknown who appeared in *Attack the Block* (2011) and *24: Live Another Day* (2014). The teaser trailer for *The Force Awakens* debuted Boyega, a black twenty-something British actor, popping his head into camera view from below. He appeared among golden sand dunes, wearing stormtrooper armor and sweating desperately to get away from some unseen threat.

The images generated almost immediate discussion. What does a stormtrooper look like? This is the first time *Star Wars* fans had seen an authentic stormtrooper take off their helmet (apart from a disguised Han and Luke in *A New Hope*). Suddenly stormtroopers were no longer faceless soldier drones. Some fans were rightly confused, assuming that stormtroopers were still clones, as George Lucas had suggested in the past. Shouldn't they look like Maori New Zealanders? Others correctly understood that by the time of the First Order, the status quo of the galaxy had changed and stormtroopers were recruited or conscripted into service and could look like anyone. Public reaction to this new reality was varied, but the majority of fan reaction was overwhelmingly positive. Even before the film's debut, John Boyega won fans over with his endearing personality, charisma, and genuine enthusiasm for *Star Wars*. His sincerity and talent stole audience's hearts when the film finally premiered.

Finn was no ordinary stormtrooper. His choice to step away from the First Order was monumental. It was the first time we saw a stormtrooper thinking and acting independently. At first all of his actions were self-serving. He uses Poe and then Rey to propel himself away from the First Order, largely driven by fear. He had no interest in the cause of the Resistance. Yet unintentionally, he forms bonds of friendship, which pull him into Rey's orbit. His feelings and sense of love for Rey lead him to sacrifice himself to save her. Finn has finally found a purpose—for the first time in his life—in something other than the First Order.

OPPOSITE: Finn's lightsaber scene on Takodana in *The Force Awakens* was designed to show stormtroopers have melee weapons combat training, and thus justify his duel with Kylo Ren later. **ABOVE:** During the opening scenes of *The Force Awakens*, Finn's helmet is distinguished with blood streaks, allowing the audience to follow him in the chaos on Jakku (neither the opposite nor above frame actually appears in the film, however).

CASTING AND PRODUCTION

Other than John Boyega as Finn, only three actors received credits in the film as stormtroopers. These were Lead Stormtrooper, played by Pip Andersen, a practitioner of parkour; FN-9330, played by record producer Nigel Godrich of Radiohead fame; and FN-3181, played by composer Michael Giacchino, who has a long history of working with director J. J. Abrams.

Released the same day as the film, Greg Rucka's novel *Before the Awakening* told the backstory of Pip Andersen's character. FN-2003, also known as "Slip," was a friend and team member of FN-2187, a.k.a. Finn. In the film, he is shot by Poe Dameron and then reaches up, marking Finn's stormtrooper helmet with blood, just before he dies. While the act results in an easy way to identify Finn amidst the other helmeted stormtroopers on screen, it also uncovers the uncomfortable "reality" that stormtroopers are humans who bleed and die when they are shot. George Lucas had intentionally hidden stormtroopers in armor to gloss over the consequences of violence, and move on with the storytelling. Now audiences were suddenly seeing the story from the viewpoint of a stormtrooper, and witnessing the soldiers' humanity.

Another character introduced in Rucka's novel was FN-2199, a.k.a. "Nines." Played by veteran stuntman Liang Yang, and voiced by Skywalker Sound editor David Acord (both uncredited for the role), the redheaded shock trooper appeared in the film at Maz's castle, where he confronts Finn with a Z6 baton and shouts, "Traitor!"

Also uncredited in the film was one of the movie's worst-kept secrets: actor Daniel Craig, who played a stormtrooper who succumbs to Rey's Force-powered "mind trick." Craig, of course best known for his role as James Bond, appropriately received the stormtrooper ID "JB-007."

First Order stormtrooper extras were required to be between five feet ten inches and six feet ten inches tall to fit properly into the armor. There were nearly a hundred prospective stormtroopers sent by talent agencies; the vast majority were young men in their early twenties. The actors underwent a few days of "stormtrooper boot camp" at Pinewood Studios, where they were assessed on their appearance in costume, their abilities to walk up and down stairs in full armor, march in formation, follow instructions, and handle weapons. Much like classic stormtrooper armor, the new First Order costumes were uncomfortable, difficult to move around in, and the helmets provided poor visibility. The extras were constantly stumbling.

These stormtroopers were split into three groups; the small core group worked close to the camera and included actors Aaron Ayamah, Amy Hargreaves, Charlie Akin, David M. Santana, Marc Rolfe, Mark Alec Rutter, Samantha Alleyne, Sandeep Mohan, Neil Bishop, and Jason Nicholls-Carrer. It was common for these stormtrooper actors to play multiple types of stormtroopers and TIE pilots—and even Resistance fighters.

The two core female stormtroopers—Samantha Alleyne and Amy Hargreaves—both arrived later on the set and didn't have the benefit of the same boot camp the men

ABOVE: A stormtrooper (played by actor Daniel Craig) is controlled by Rey—after the two make eye contact—to carry out her commands to set her free in *The Force Awakens*.

went through though. The women brought some equality to the First Order troops as *Star Wars*' first on-screen female stormtroopers. They wore the same costumes as the men, with only a few minor adjustments. Their own voices were not heard in the film as the stormtroopers' voices were later dubbed by two female voice actors.

The first stormtrooper scenes filmed for *The Force Awakens* were for the attack on Jakku's Tuanul Village. Starting in May 2014, the stormtroopers spent around two weeks filming these night scenes in the village. There was a lot of tumbling down the shuttle ramp and stumbling in the uneven sand.

In addition to casting numerous stormtrooper extras, Lucasfilm wanted to honor the fan commitment and the charity work of the 501st Legion, so in July 2014, six members of the U.K. Garrison were invited for a day of shooting at Pinewood. The six gentlemen were John Maul (TK-256), Steve Buckley (TK-1902), Ross Walmsley (TK-5509), Rob Ledsom (TK-5968), Steve Hill (TK-7058), and U.K. Garrison commanding officer Gary Hailes.

They joined a group of around sixty stormtroopers for a very long, thirteen hour day of filming a group scene (much of it outdoors), which included Hux's speech on Starkiller Base.

ADDING VOICES

Back at Skywalker Sound, additional stormtrooper voices were provided in postproduction by actors Sam Witwer, David Acord, David Collins, Devon Libran, Fred Tatasciore, James Arnold Taylor, Kat Sheridan, Kevin Smith, Matt Lanter, Matthew Wood, Michael Donovan, and Verona Blue—creating a great continuity as many of them had done voice work for *The Clone Wars* and *Star Wars Rebels*.

One of the most significant bits of background dialogue was performed by former LucasArts lead sound designer and voice director David W. Collins, and actor Sam Witwer (best known for voicing Starkiller in The Force Unleashed and the animated version of Darth Maul). "Some of it was scripted by Matthew Wood and others, but a lot of it was

ABOVE: Crew members help First Order troopers rehearse with blasters, 2014.

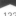

improv," recalls Witwer. "The conversation between the two troopers Rey sneaks by on Starkiller Base (voiced by David Collins and myself) concerning the T-17s was both. What happened was that Matthew wanted us to talk about the 'new T-17s.' That was the guideline, and David and I just ran with it. I thought it would be funny to have two troopers complaining to each other about the substandard nature of some of their equipment. David says, 'I hear they're a great improvement' and I say something like, 'That's what they say, but believe me, they don't hold up.' This is, of course, in stark contrast to the two troopers that Obi-Wan sneaks by in *A New Hope* who were sharing their enthusiasm over 'the new VT-16 which were, apparently, 'quite a thing to see.' If you want to know our exact dialogue, turn the subtitles on next time you watch *The Force Awakens*."

Voicing stormtroopers in the movie was not at all like voicing characters on *Star Wars Rebels*, which were animated later to match the performance. For the movie, Witwer notes, "We always recorded to picture. Stormtroopers, aliens, Resistance . . . We saw quite a bit of the movie. We made a lot of noise . . . Except when Harrison Ford showed up

on the screen. Then we were quiet." This wasn't the only difference. "I think the trick to doing a trooper rather than Maul or Starkiller is that these troopers were not bred for big personality. You have to give them an everyday-Joe quality whereas Maul looms larger than life."

As a group effort in creating lots of dialogue, it became hard to keep track of who was who later on. "Matt Wood kind of auditioned us on the spot for various moments and it seemed pretty clear who should be in those spots, but there was a lot of material," explains Witwer. "What was less clear was later when he was trying to map out who said what. He'd send me a clip of a stormtrooper shouting battle orders. He'd ask if it was me. I'd listen and say—'Nah, I think that's David Collins.' Then I'd record myself trying to mimic the particular stormtrooper voice into my phone. Play it back . . . Then contact Matt and inform him, 'My bad. That was me.' We were all disguising our voices and saying funny space things." Witwer's anecdote also shines a light on why it was so hard to conclusively identify actors who played notable stormtroopers from the original trilogy.

ABOVE: A production photo from *The Force Awakens* of the skirmish in Jakku's Tuanul Village. Running around the sand in stormtrooper armor was difficult for the actors—especially in low light—leading to frequent stumbles.

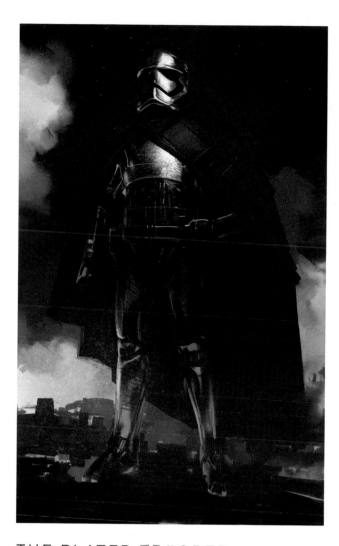

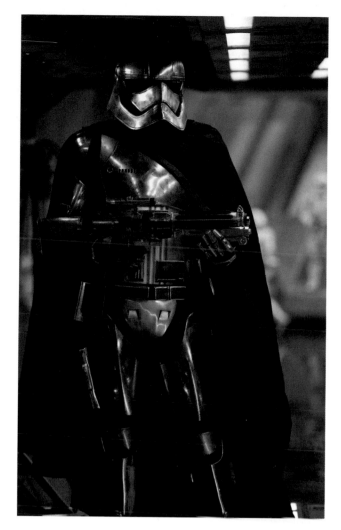

THE PLATED TROOPER

Fans fell in love with Captain Phasma the moment they saw her in the movie trailer—before many even knew that the flashy new character was a woman.

"Captain Phasma is the first [live-action] female *Star Wars* villain," actress Gwendoline Christie proudly states. "I find it very heartening that a franchise like *Star Wars* made a progressive character—a modern character. A new relationship with a female character, which isn't about her being sexualized, it's about us responding to the choices that she makes."

Initially, costume designer Michael Kaplan was taken with the idea of Kylo Ren as "Lord of the Stormtroopers." Inspired by frequent visits to local London museums such as the Wallace Collection, he had a vision of a silver suit of armor, guided by stormtrooper forms. He described his vision to concept artist Dermot Power and asked him to render it.

"They did these beautiful illustrations of Kylo Ren in silver. J. J. said, 'I don't see Kylo Ren that way, but I love the idea,'" recalls Kaplan. "Weeks went by and Kathy [Kennedy] came in and she said, 'What is that?' pointing at the knight in shining armor. She said, 'That's amazing. That has to be in the movie.' So, that's how Captain Phasma came to be."

Abrams immediately cast Gwendoline Christie, who was famous for her knightly character Brienne of Tarth, on HBO's *Game of Thrones*. Christie recalled giggling in delight when she first put on her shiny, silver-plated costume. "I thought it was great that they had not feminized the armor. I thought that was fantastic. But I thought it's good to know there's a woman in there. So, maybe subtly I can let that come across in the way that she stands, in the way that she holds her body. It isn't sexualized, but there is something occasionally of a femininity, to give this character a little bit more of an identity."

ABOVE LEFT: An illustration by Dermot Power depicting an early concept for Kylo Ren as the *Lord of the Stormtroopers*. **ABOVE RIGHT:** A production still of Captain Phasma when she confronts Finn, back on the First Order Star Destroyer, the *Finalizer*. Phasma never removes her helmet in the film, leading to a great deal of mystery and fan speculation about the character's physical appearance beneath the armor.

THE 501st AT THE PREMIERE

Clint Randall, a member of the Dune Sea Garrison, was one of the first in the 501st Legion to own First Order stormtrooper armor, affording him a once-in-a-lifetime opportunity.

"It was late October 2015," recalls Randall, "and my garrison CO, Joe LaFortune, let me know that Lucasfilm was asking for submissions for a special opportunity related to the world premiere of *The Force Awakens*.

"I submitted my pics in armor to the appropriate parties, and then the waiting game began. . . . On December 11, just three days before the premiere, we finally got an email from Pete Vilmur, fan relations rep for Lucasfilm, that blew us away."

The note read, "CONGRATULATIONS! You're going to the WORLD PREMIERE of *Star Wars: The Force Awakens*!!"

Lucasfilm, once again, wanted to honor 501st members for their charity work and fan devotion by inviting them to participate—in full stormtrooper armor—along with the cast and crew. A day and a half later, Randall landed in Hollywood from Arizona. "We arrived at the destination, which was a building on Hollywood Boulevard, a couple blocks from the entrance to the huge tent that was erected for the world premiere event. All the rebels got dressed first and headed out, and then all of us stormtroopers and villains got suited up."

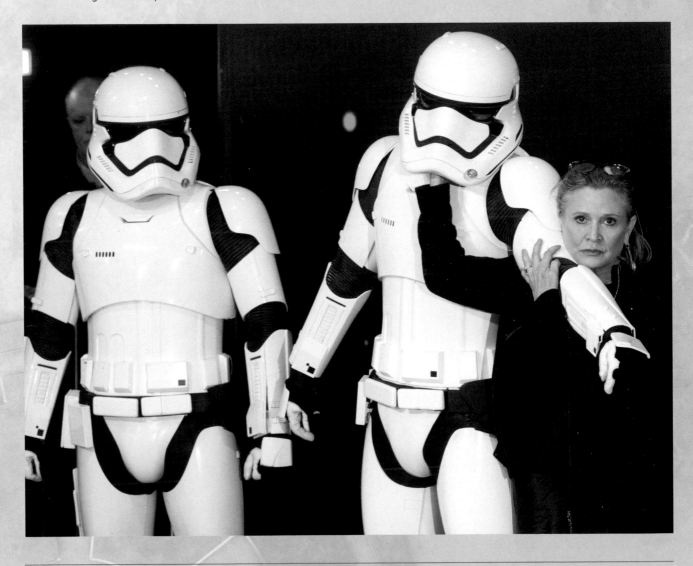

ABOVE: Carrie Fisher at the European premiere of *The Force Awakens* in Leicester Square, London, on December 16, 2015. Much-loved, Fisher was known for having fun with her appearances, hamming it up for the camera and lavishing fans with jokes.

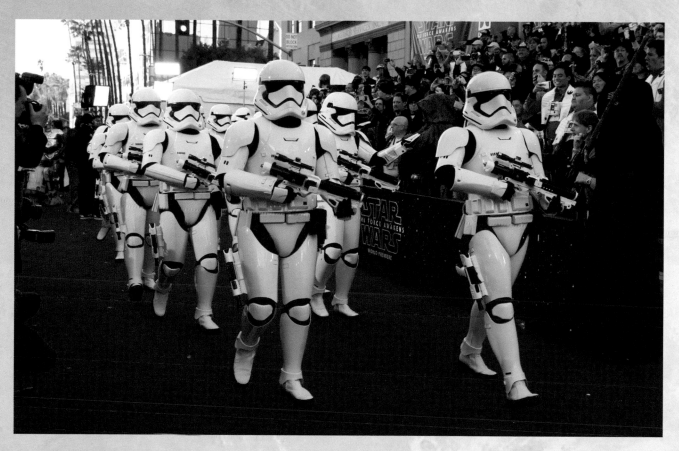

Randall and the troops marched out toward the carpet. "As we approached, the screams from the crowd steadily rose until we turned the corner in front of the tent entrance and onto the red carpet. At this point everyone was screaming, there were reporters everywhere, and it was obvious this was going to be one of the coolest events of our lives!

"Over the next two hours, literally every major *Star Wars* celebrity came out onto the red carpet, right in front of all of us, and took photos, gave interviews, and strolled around. Many of them came right over to us . . . It was amazing!"

Randall and the other 501st members were then welcomed into the theater to watch *The Force Awakens* with the cast, crew, and celebrity guests. As they waited for the movie to begin, things only got more exciting. "Little did I know they were going to proceed to also bring out Kathleen Kennedy as well, who was then going to give a big thanks to George Lucas—who was sitting in our theater, towards the back, next to Steven Spielberg! Over the next ten minutes, they bring out J. J. Abrams and the entire cast and suddenly there on the stage, maybe twenty or thirty feet away, is everyone significantly involved with *The Force Awakens*."

The ending was just as amazing as the beginning. "I turned around and realized George Lucas was standing directly behind me! I shook his hand and thanked him for *Star Wars* and then stepped back as Mark Hamill walked over and he and Lucas chatted for a while. It was amazing. So then before exiting, I decide to say hi to a few others seated nearby, including Adam Driver [Kylo Ren] and Gwendoline Christie [Captain Phasma]."

Randall would also run into director J. J. Abrams and actors Domhnall Gleeson, Sam Witwer, Greg Grunberg, and others. "The next two hours, we strolled around this epic four-block tent full of *Star Wars* memorabilia, free food and drink, and lots of fun. By midnight, it was all over. . . . I'm eternally grateful to Kathleen Kennedy for inviting us to this special event and for Pete Vilmur for arranging it."

ABOVE: Stormtroopers walk the red carpet at the premiere of *Star Wars: The Force Awakens* at the Dolby Theatre in Hollywood, California, December 14, 2015.

THE FORCE AWAKENS INVASION

Like the excitement for the movie release, the variety and multitude of merchandise available surrounding the movie was unprecedented. Sneak peek First Order stormtrooper toys debuted at San Diego Comic-Con (July 9–12, 2015) in the form of a Black Series six-inch First Order Stormtrooper figure in elegant, exclusive packaging, and a Mattel Hot Wheels First Order Stomrtooper car, also in variant packaging.

Products from *The Force Awakens* were made available to the general public at special "Midnight Madness" events on September 4, dubbed "Force Friday." Hasbro, LEGO, Jakks Pacific, and Funko led the way with rolling out a plethora of merchandise.

Hasbro produced 3¾-inch figures for nearly every conceivable First Order trooper variation, including sets that didn't appear in the movie at all, such as a black stormtrooper packed with an Elite Speeder Bike and stormtroopers of varying ranks packed with *The Clone Wars*–styled assault walkers. Amazon's exclusive First Order Legion troop builder 7-figure pack included two figures available nowhere else: a First Order riot control stormtrooper and a heavy artillery stormtrooper.

Nearly every trooper variation was also available in Hasbro's six-inch Black Series line. Other exclusives included Amazon's Stormtrooper 4-pack with a First Order Stormtrooper Officer; Toys "R" Us offered a First Order Snowtrooper Officer; and Target featured a 2-pack with

Poe Dameron and a First Order Riot Control Stormtrooper. There was also the impressive First Order Special Forces TIE Fighter, which came packed with an exclusive First Order TIE Fighter Pilot Elite, sporting a pair of red stripes on the helmet.

LEGO fed the fan frenzy with several new sets, which came with a wide selection of First Order stormtroopers, flametroopers, officers, technicians, and crew, as well as Kylo Ren, General Hux, and Captain Phasma. On "May the 4th," 2016, LEGO stores also offered an exclusive "First Order Stormtrooper" (set 30602) with a variant torso print and added backpack.

Jakks Pacific continued their line of jumbo action figures with First Order stormtroopers available in eighteen-inch, thirty-one-inch, and forty-eight-inch sizes. The largest, a First Order Stormtrooper Battle Buddy, includes a motion sensor that triggered several phrases and blaster-fire sound effects. All of the talking stormtrooper toys produced for the movie were voiced by Lucasfilm supervising sound editor Matthew Wood.

Funko continued their wildly popular line of vinyl POP! *Star Wars* bobblehead figures. Highly sought-after POP! figurines included Captain Phasma (Chrome), Finn as a stormtrooper, First Order Stormtrooper with heavy artillery, First Order Stormtrooper with riot gear, FN-2187, and a TIE Fighter Pilot with and without Special Forces stripes.

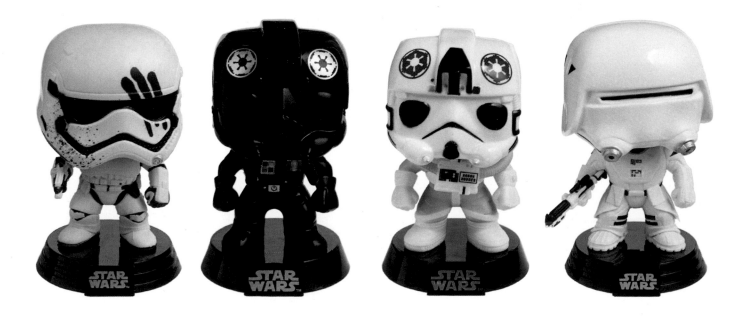

ABOVE: Funko POP! *Star Wars* bobbleheads with removable display bases. (Left to right) FN-2187 (#100) was exclusive to Target in the U.S., TIE Fighter Pilot (#51), the AT-AT Driver (#92) was a U.S. Walgreens exclusive, and a First Order Stormtrooper (#67).

BEHIND THE HELMET

Marvel's flagship *Star Wars* series used the medium of comic books to explore stormtroopers in an entirely new way. "The main thing I wanted to do was give more of a face to some of the stormtroopers," writer Jason Aaron told StarWars.com's Amy Ratcliffe. "We've seen lots of them in the series, but they've all been pretty interchangeable, faceless bad guys. We haven't gotten to know them. That was one of my favorite parts of *The Force Awakens*: getting to see and getting to know a real character who was a stormtrooper and somebody who, of course, has a conscience and changed his ways and joined up with the good guys. This is the opposite of that. It's us peering inside the heads of somebody who is very gung-ho for the Empire and then the question, of course, is 'Why? Why would you sign up to fight for the Empire?'"

The Marvel series first introduced the character of Sergeant Kreel (Agent 5241) in Marvel's *Star Wars* #9: "Showdown on the Smuggler's Moon, Part II" (September 15, 2015). Kreel grew up as a gladiator in the fight pits of

Chagar IX. When the Empire arrived on his world, they brought peace, closed the pits, and gave his people a new sense of purpose. Kreel was enthralled by the Empire's stormtroopers and joined the academy to become one himself. There he befriended a ranger named Izak Anzio. When Anzio is killed by rebels, Kreel is determined to slay every rebel that he can.

In issue #9, Kreel appears undercover as the "Gamemaster" in Grakkus the Hutt's arena on Nar Shaddaa, and shows surprising skill with a lightsaber. In *Star Wars* #19: "Rebel Jail, Part IV," Kreel appears again, as the commander of a Special Commando Advanced Recon (SCAR) squad known as Task Force 99, though his true identity as Kreel wouldn't be confirmed until later. Task Force 99 was named for the previously mentioned Clone Force 99, also known as the "Bad Batch." Like them, the members of Task Force 99 each have their own specialization with customized armor and gear—offering a degree of distinctiveness not afforded to standard stormtroopers. The cover of *Star Wars* #21: "The Last Flight of the Harbinger, Part I" featured stormtroopers and focused entirely on Task Force 99. The original members of the squad were designed by artist Jorge Molina and include Aero (Pilot), Cav (Scout), Kreel (Sarge), Mic (Tech), Misty (Sniper), Shrap (Demolitions) and Zuke (Bazooka).

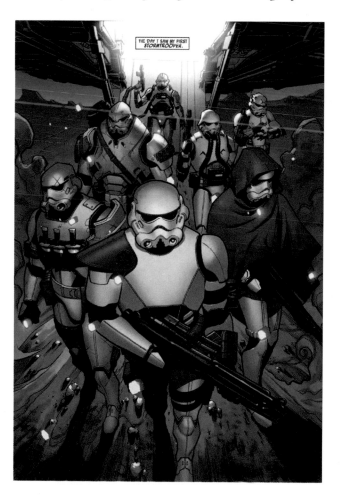

ABOVE LEFT: A frame from Marvel's *Star Wars* #21 (July 20, 2016) featuring Task Force 99, with Kreel leading at the front. **ABOVE RIGHT:** Concept art for Zuke by Marvel artist Jorge Molina. Zuke's tank-like design is meant to facilitate his role as a living battering ram.

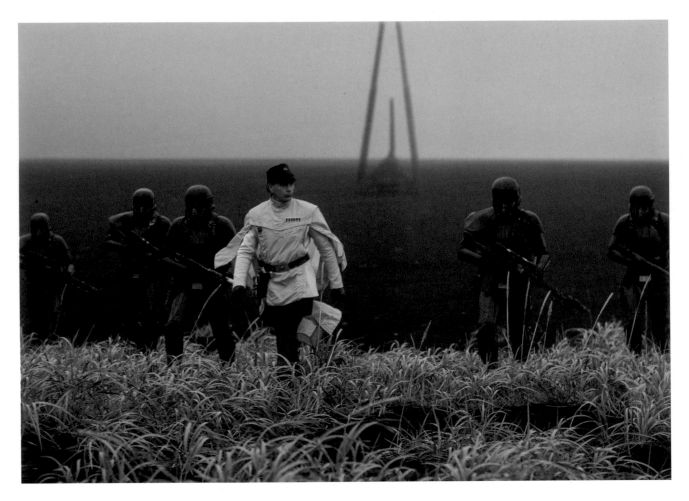

A NEW KIND OF *STAR WARS* STORY

The public premiere of *Rogue One: A Star Wars Story* occurred on December 16, 2016. The first of Disney's *Star Wars* stand-alone films told the story of how the rebels steal the Death Star plans that end up in the hands of Princess Leia in the original film, *A New Hope*. Each film in the *Star Wars* saga introduced new troopers, and *Rogue One* was no different. In fact, if all of the new ranks, specializations, and gear are taken into account, *Rogue One* arguably introduced more new variations of stormtroopers than the entire original trilogy. New troop variants included death troopers, tank drivers, shoretroopers, AT-ACT drivers, Imperial landing crew with truncated helmets, Imperial technicians in tan uniforms (both costumes based on Death Star gunners), and sandtroopers with new gear. *Rogue One* also featured returning troops such as Imperial Royal Guard, navy troopers (Death Star troopers), Death Star gunners, and of course the classic stormtrooper.

DEATH TROOPERS

While the opening shots of *Rogue One* offer the audience a little bit of the familiar—blue milk and moisture vaporators—there is also a sense of the unknown as the shot focused on a tiny ship passing immense planetary rings followed by the appearance of unfamiliar, black-clad stormtroopers.

"Our goal was to introduce something different at the beginning of *Rogue One*, to create a sense of fear of what might happen," says co-costume designer David Crossman, speaking of the terrifying death troopers in the opening scene.

Death troopers were conceived as elite units assigned by Imperial Intelligence to act as bodyguards for key military officials. As the person overseeing the Death Star construction, Director Orson Krennic certainly qualifies. His white uniform, flanked by black trooper armor, was an intentional inversion of Darth Vader with his white stormtroopers in *A New Hope*.

"They're much taller and skinnier, and the costumes much tighter than the regular stormtrooper," says Glyn

ABOVE: Orson Krennic, flanked by Imperial death troopers, marches across a field on Lah'mu in seach of Galen Erso in the opening scenes of *Rogue One*. **OPPOSITE:** Concept art for death trooper (version 1) by co-costume designer Glyn Dillon.

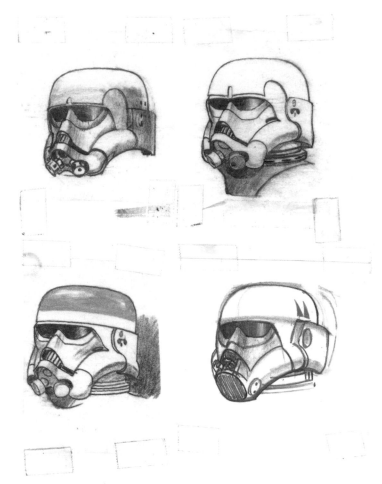

Dillon of the death troopers. "Gareth [Edwards] wanted them to have a real sense of fear and as they are entirely black, their silhouette really is intimidating." The name "death trooper" was intended to capitalize on rumors of a secret Imperial research program to reanimate the dead—though the troopers are indeed alive—reportedly. Their speech is unintelligible—a droid-like chatter—a trait that makes them seem all the less human and more menacing.

Though the death troopers were new, their designs were steeped in the aesthetics of vintage *Star Wars*. "There was a sketch of an early stormtrooper that Ralph McQuarrie did for one of the production paintings of the Death Star," Doug Chiang, Lucasfilm VP creative director and co-production designer, told Dan Brooks for StarWars.com. "It was a really sleek interpretation of a stormtrooper, because Ralph had this amazing ability to stylize figures. His figures were always very elegant and very tall and very thin, and Gareth just loved that, and I love that, as well. Gareth wanted to cast very thin athletes, and he thought the thinner they are the more

menacing they'll be, because they're just super athletes and they just look very lean. Part of the early explorations that we did for the death troopers was that maybe we can cross that line, so that it confuses the audiences a little bit. Are they robotic or are they human? So we made them a little taller, a little thinner. But early on we actually explored the idea that maybe they are actually robotic." This was in fact the same question early audiences had about Darth Vader until he was revealed as Luke's father. The uncertainty over whether Vader was human was part of what made him so frightening as well.

Speaking of Gareth Edwards, concept artist Christian Alzmann elaborates, "He was initially thinking there could be a middle version, something between a soldier and a droid—a special detachment belonging to Krennic that was a mix of organic and mechanical. He wanted to make it clear through the design—to show that the brain was gone by giving them helmets that no human could actually wear. Red lights under the dome. They'd be like Lobot from Cloud City and could be controlled."

ABOVE: The stylized look of the death troopers in *Rogue One* was inspired by original concept paintings and sketches created by Ralph McQuarrie for *A New Hope*. (left) Detail from a McQuarrie concept painting featuring tall, stylized stormtroopers. (right) Sketches by McQuarrie showing stormtrooper helmet variations.

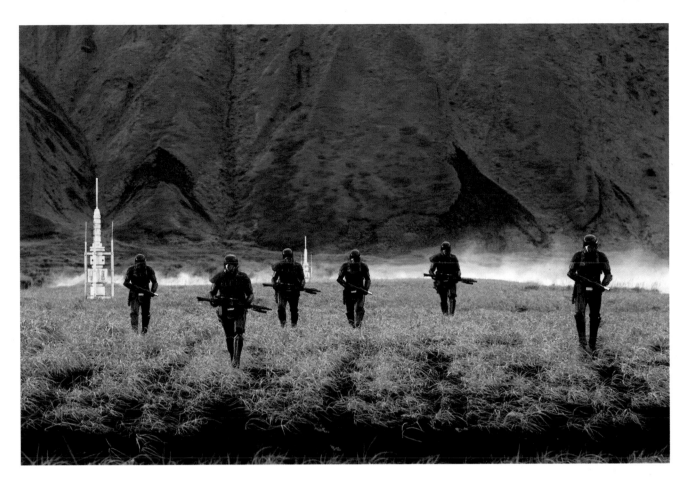

"Ultimately, we decided they would be more menacing if they were human, but we kept the really thin, elegant proportions," concludes Chiang. The death troopers, played by actors over six feet tall, were finally envisioned as humans, but augmented with classified surgical enhancements.

Death trooper gear is more advanced than that of a typical stormtrooper. According to *Star Wars* canon, death troopers not only have increased sensory capabilities, but their armor is coated to deflect enemy sensors for stealth movement. Death troopers are armed with a BlasTech E-11D rifle, C-25 fragmentation grenades, and BlasTech SE-14r light repeating blaster pistols.

While black-and-white stormtrooper weaponry in *The Force Awakens* was 3D-printed and futuristic-looking, the trooper blasters in *Rogue One* were more like the weapons seen in the original trilogy—which resembled real-world firearms because they were made from salvaged weapon parts. "We've come full circle, stripping down and fixing airsoft guns in our shop, because they've got some heft and a mechanism inside that gives them a bit of a recoil, but

they're a lot lighter than what they would have used before," explains prop master Jamie Wilkinson. Blasters, such as the death troopers' E-11D rifles and the shoretroopers' double-barreled E-22 blaster rifles, have flashlights and make sounds when the trigger is pulled.

RETURN OF CLASSIC STORMTROOPERS

Since the events in *Rogue One* occur just prior to the events of *A New Hope*, the design team made a considerable effort to match the details of the original stormtrooper helmets and armor, rather than those used in the later movies. As close as the armor looks, there are significant differences.

"The *Rogue One* stormtrooper armor has been updated in a number of ways," says *Star Wars* author and 501st Legion member Cole Horton. "While it still captures the essence and nuances of the original suits from *A New Hope*, many details have been refined or changed for the modern film.

ABOVE: Death troopers cross the field outside the Erso home on Lah'mu in *Rogue One*.

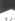
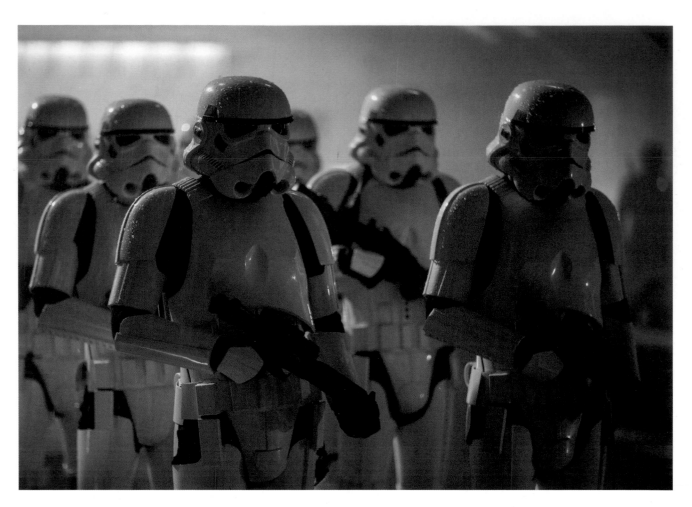

"The helmet is a perfect example. Where the *A New Hope* helmets had simple blue decals along the cheeks, the *Rogue One* helmets have clean-cut recessed details. The ear pieces now seamlessly align to the rest of the helmet and feature more sharply detailed greeblies [cobbled elements added to a costume for authenticity]. The chin now features more intricate tubing, replacing the molded-in and hand-painted details on the 1977 originals.

"The body armor has also been subtly updated in *Rogue One*. The belts—canvas in *A New Hope*—are now plastic. The ab plate now features sharper and refined details. How the ab armor and lower back fit together has been updated as well. Even the shoulder armor is more symmetrical than the vintage armor.

"All of these details will likely go unnoticed by most, but all add up to make a suit of armor that is undoubtedly authentic to *Star Wars*, yet can also hold up to the high fidelity of modern filmmaking."

The asymmetrical nature of film-used stormtrooper helmets has always been a bit controversial. A lot of merchandise has used a mirrored, symmetrical reinterpretation, but purists tend to want helmets just the way they appear on film. "When we redid the stormtrooper helmet, we made and sculpted it in a computer, but based on a scan of the original," co-costume designer Glyn Dillon explains. "We noticed the [scans of the original] helmet had quite a big squint because originally they were made out of clay and you're not going to get it perfectly symmetrical. So we tidied it up a bit on the computer, but still kept that slight squint as we wanted to honor that organic feel."

A new quirk in the armor was added as well. An Easter egg during the skirmish in Jedha City revealed that the stormtroopers have black circles on the bottom of their feet—an homage to classic Kenner action figures.

Star Wars artists Chris Reiff and Chris Trevas (501st Legion member and honorary member, respectively) are among fans who have begun deconstructing the *Rogue One* stormtrooper gear to identify what real-world parts were

ABOVE: A production photo from *Rogue One* of stormtroopers on Scarif that bridged the look of the stormtrooper armor with those in *A New Hope*.

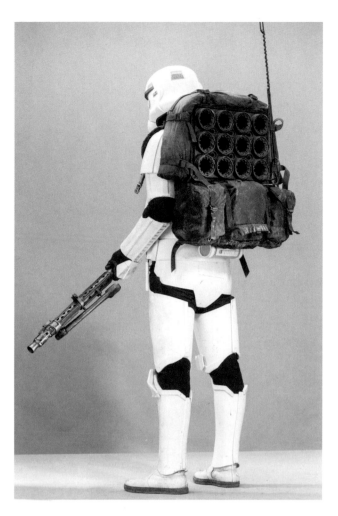

used in constructing the costume. "We've been doing this exercise for decades," says Reiff. "Trevas and I started 'Parts of *Star Wars*' over twenty years ago to act as a repository for the data we were collecting, so we are used to looking at props and details in a very analytical way. It is a science, a type of archaeology.

"For the 'crystal patrol duty pack' it was a group effort from folks all over the world working to ID the components used in making these new stormtrooper packs and then to reverse engineer how they were constructed. The team is still working to identify every tiny detail of the pack and has been sharing the info openly online with costuming and fan groups throughout the process.

"The main frame is an M75 Swedish military backpack. The backpack's upper half [the honeycombed kyber crystal storage area] is part of a Norwegian army grenade carrying case. The soft pack parts at the bottom are from a Large LC-II USGI ALICE pack. The antenna is made from surgical tubing and an Avanti Precision X twelve-foot Float Rod. The shoulder straps are USGI ALICE backpack quick release LC2 shoulder straps, dyed black and detailed with Royal Air Force pilot gear hooks. The fabric roll at the top is held on with webbing straps and cam-lock buckles."

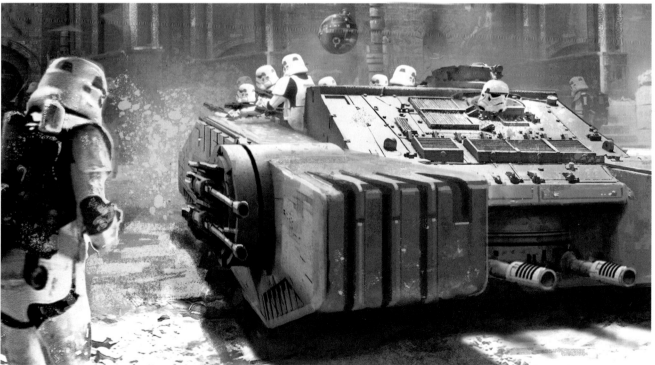

TOP: Costume reference photo of the "crystal patrol duty pack" worn by the stormtroopers on Jedha. **BOTTOM:** Concept painting *Imperial Hovercraft, version 24D*, by concept artist Vincent Jenkins. The tank was conceived of as a hovercraft, but it appeared as a treaded vehicle in the final film. Early merchandise released for these vehicles still referred to them as hovertanks.

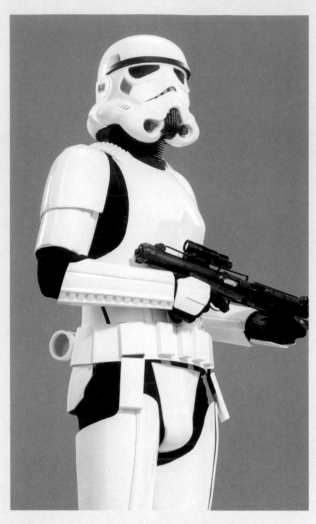

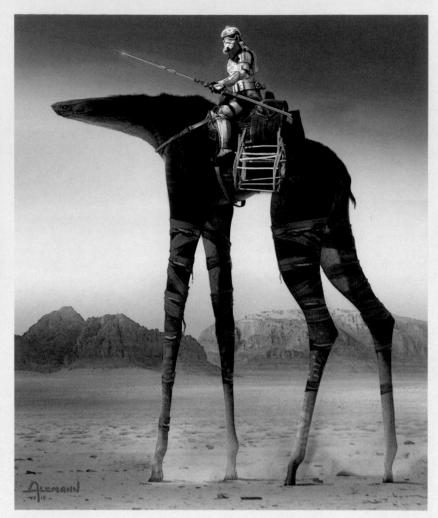

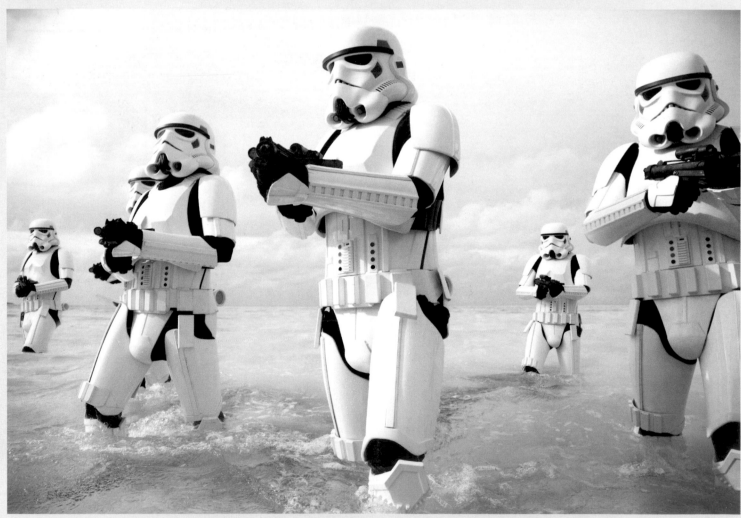

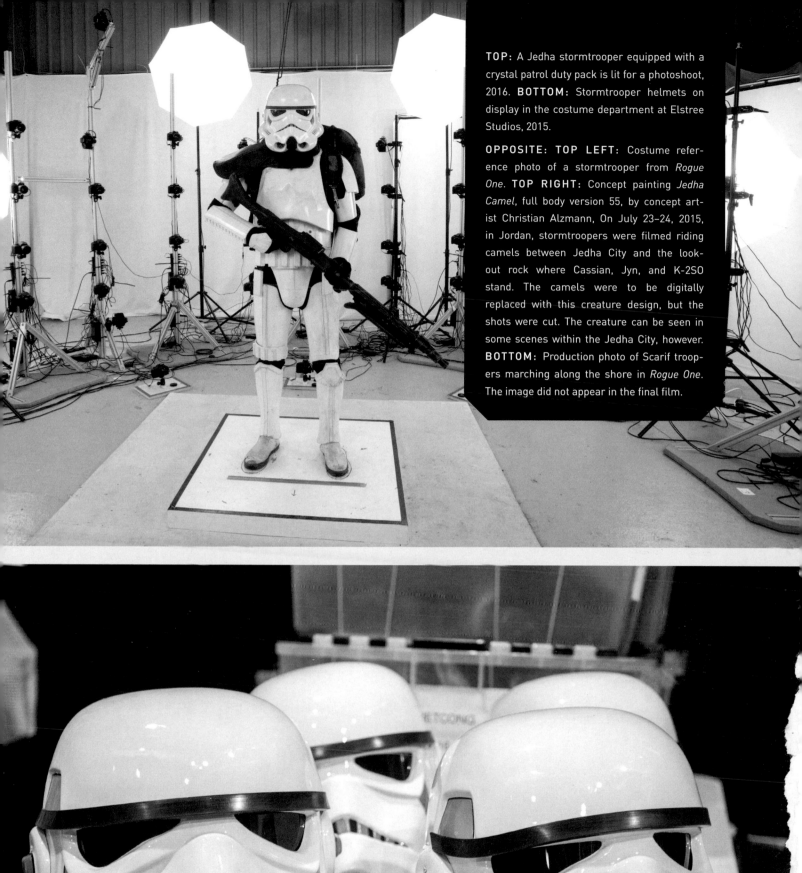

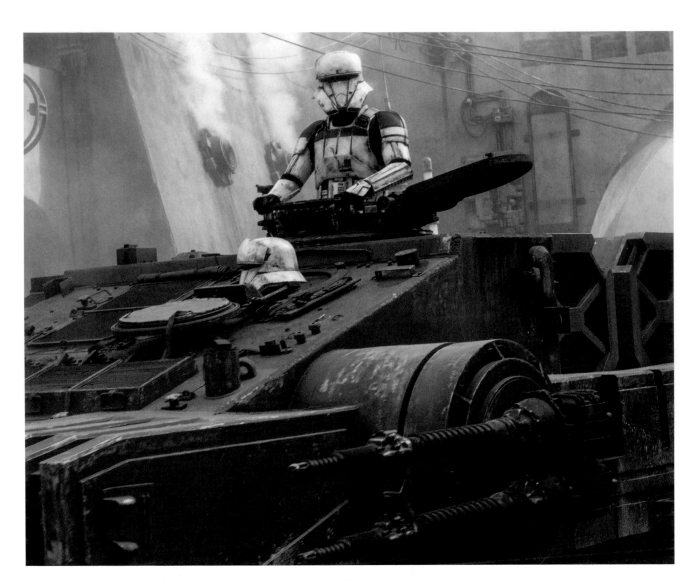

TANK DRIVERS

At the suggestion of George Lucas himself, director Gareth Edwards gave his tank drivers a unique look. Their costumes were a modified white version of the Scarif troopers, but with a helmet that was entirely unique. Their loose trousers allowed them more flexibility to sit inside the cramped tanks. These new Imperial combat drivers (also called Imperial tank troopers or just tank drivers) drive Rothana Heavy Engineering's TX-225 "Occupier" combat assault tanks (for the film, the tanks have a fiberglass and biscuit-foam body built around a tractor tank), as seen on Jedha. The tanks were designed for a crew of three: a commander, a gunner, and a driver. Commanders are distinguished by gray painted markings on their shoulders and breastplate.

SCARIF TROOPERS

Coastal defender stormtroopers, known as shoretroopers, were not intended to be a common class of stormtrooper. Their light armor and trousers allow them greater mobility in the coastal zone environment. "We thought, 'Why couldn't we have a stormtrooper version that's specific to Scarif, that could be on the sand and in the water,'" says Chiang. "Gareth always really loved the scout trooper, as did myself. Some of the early ideas that Glyn Dillon explored was to take the scout trooper helmet, in terms of that biker look, and merge it with a regular stormtrooper. And then we also thought, 'Well, because this film happens before Episode IV, there's maybe an opportunity to bridge a little bit of the clone troopers in here, as well.' So we brought those elements into this.

ABOVE: A final frame of a tank driver on Jedha in *Rogue One*.

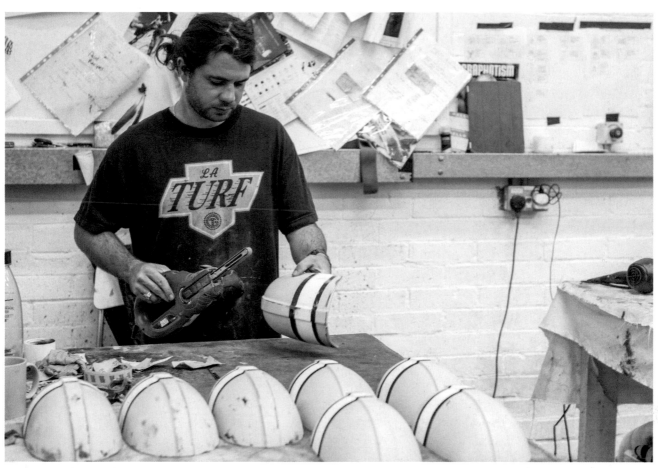

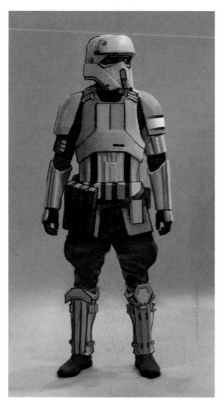
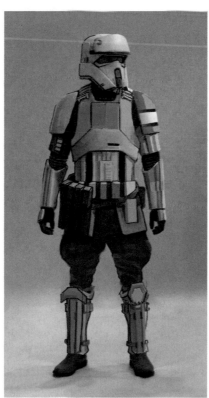
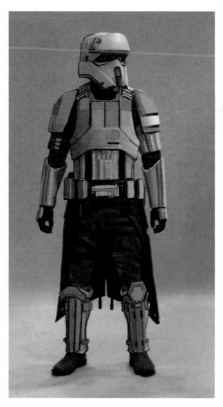

TOP: Member of the *Rogue One* crew at work on the pauldrons for the shoretroopers seen on Scarif, 2014. BOTTOM: Sketches of the Scarif shoretrooper costume and marking variations by co-costume designer Glyn Dillon, *Rogue One*.

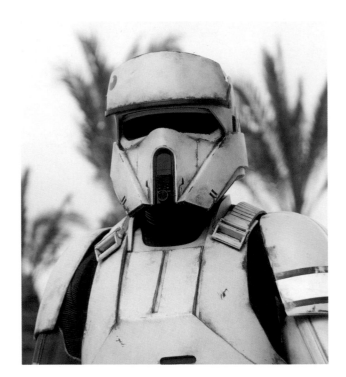

"Gareth wanted a stormtrooper that was kind of warm-toned, kind of sand-colored, to make it make sense why they were on Scarif with the sand," continues Chiang. "But then Glyn modeled the color scheme on the [WWII fighter] Messerschmitt, where the base color was sort of tannish, but then it had patches of this blue and orange that were so elegant."

Shoretrooper rank is distinguished by the color markings on their armor. All soldiers have a red stripe with yellow dots on their right arm, and a white stripe on their left shoulder (although costuming anomalies do exist). The standard uniforms have no blue on their armor. Squad leaders have blue upper shoulders and a blue stripe across their chest. They also wear a kama on their waist instead of the armor skirt and ammo pouch (an actual Yugoslavian M49-M56 submachine gun ammo pouch) worn by other shoretroopers. The captains have much more blue on their torso, and blue and yellow stripes on their lower left arm. Most shoretroopers hold the rank of sergeant, allowing them to command regular stormtroopers. A white version of shoretrooper armor, marked with a red Imperial logo on the right of the visor, was worn by the crew of AT-ACTs—a variant of the four-legged AT-AT, seen on Scarif. Comfortable shoes are important for shoretroopers; their costumes all feature actual Orca Bay Brecon Chelsea boots.

LENDING A VOICE

Rogue One continued a conversation that stormtroopers have been having since the beginning of the franchise. "I have to say, the T-15 in *Rogue One* was my fault initially!" says David W. Collins, whose voice is featured as various stormtroopers, rebels, creatures, and resistance fighters in the new *Star Wars* movies. A voice actor, composer, and sound designer living in Los Angeles, Collins worked on dozens of *Star Wars* video games at LucasArts before transitioning into animation and film. Collins has played clone troopers in Republic Commando, as well as stormtroopers in games series such as The Force Unleashed, Battlefront, and LEGO *Star Wars*. The lines about T-15s refer to this exchange between two stormtroopers on a landing pad in *Rogue One*:

"Hey did you hear the rumor?"

"Yeah, the T-15s have been marked obsolete."

"Oh boy, it's about time for that."

"In order to understand how these things come about," Collins continues, "it's helpful to know that actors in Hollywood are often members of 'loop groups,' which specialize in background dialogue for TV and film. A lot of these dialogue moments are unscripted, so it requires being comfortable with improvisation as an actor. This means that a working knowledge of your show's subject is really important: if you're on a medical show, it helps to know something about working in a hospital; on a crime drama, knowing police jargon is handy. For *Star Wars*, Sam Witwer and I are two actors and great friends who talk about *Star Wars* literally every day, and this knowledge has been extremely helpful on the recording stage when thinking on your feet has been required. Some actors even show up with copious *Star Wars* notes and phrases to help them improvise!

"So, about a week before the session, I got to thinking about what we'd possibly see in the rough cut of *Rogue One*. I called Sam one afternoon to catch up, and at one point I half-jokingly pitched him a far-fetched idea: what if these *Rogue One* stormtroopers set up the VT-16 conversation in *A New Hope* by mentioning that the old model was going away? He laughed, and we both thought that even having an appropriate opportunity during the cut of the movie wasn't going to be likely.

ABOVE: A final frame of shoretroopers on patrol on Scarif, *Rogue One*.

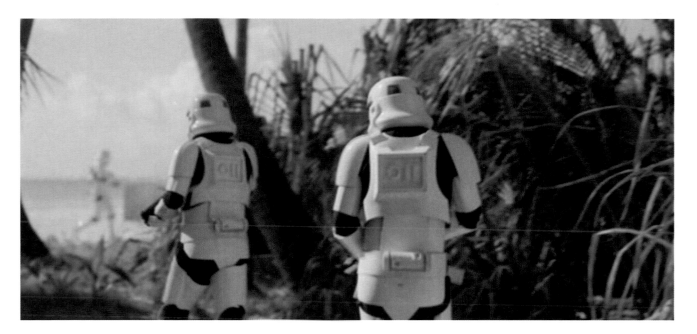

"Our first day on *Rogue* was in mid–October 2016, and it involved a whopping crowd of twenty-five actors on the stage. It was like *Star Wars* theater camp: everyone worked hard, cheered each other on, had plenty of laughs, and brought an immense amount of talent and creativity to the table. Just like on *The Force Awakens*, it was inspiring to watch! We covered all of the big crowd scenes that first day: the big battles, creatures, background walla [or sound effects created to mimic the murmur of a crowd], and a few individual lines of dialogue here and there.

"Occasionally we just read multiple lines off of a script page to be synced up later, but I'd say ninety-five percent of the time we were recording to picture. Sometimes a handful of actors would all read the same lines, so that the editors had options to choose from. This often leads to us not knowing whose take will land in the final picture. There were only a few cases where we knew it would be us, because we were the only ones that covered the line. Actually, even then you're not always certain.

"But the stormtrooper magic really happened the following week. Six of us were brought back in for another full day of recording, and we worked through the majority of the stormtrooper and rebel dialogue. Then at one point, supervising sound editor Matthew Wood cued up a scene with the two stormtroopers on the beach at Scarif. We watched the scene, and immediately reacted to how empty it was: literally nothing going on but two stormtroopers walking along, silently, for almost five seconds. What happened next is destined to be one of my personal favorite *Star Wars* behind-the-scenes memories.

"Without saying a word, without being called upon, and without even looking at each other, Sam and I stood up from our chairs and walked up to the array of microphones in front of the movie screen. Matthew said, 'Okay, we need some kind of stormtrooper dialogue here, guys . . . oh, looks like you're ready, let's go for it.'

"Sam spoke first, and I spoke second, delivering the line about T-15s being made obsolete. He reacted in that great trooper monotone, and then we both performed a vocal for being taken down by rebels. The room laughed. We did a second take, and that was it. The whole thing went down in less than two minutes.

"You never know what's going to make it into the final movie. *Star Wars* movies are over-recorded for coverage, and sometimes things change or get muted during the final mix. But Matthew Wood loved it! He thought it was important to show that the Imperials on Scarif were not ready for an attack in the slightest, and he liked the comedic beat."

The small bit of dialogue was more than audio filler; it connected the stormtroopers on Scarif to the greater Imperial army and, like the subsequent conversation in *A New Hope*, it gave the audience a sense that the men beneath the helmets are interested in the technology they are using and have a sense of camaraderie.

ABOVE: Final frame of two stormtroopers having a conversation about the obsolete T-15. The exchange was intended to set up the conversation overheard during *A New Hope* regarding the new VT-16. However, the *Rogue One* conversation identifies the previous model as a T-15, incorrectly calling out the letters as that would link the two references.

FAR FROM THE LAST

As *Star Wars* stories and history evolves so to do the look and types of troopers found in the galaxy. *Star Wars: The Last Jedi*, premiere on December 16, 2017, continued where the story left off in *The Force Awakens*. And like the films before it, *The Last Jedi* introduced audiences to new classes of ruthless soldiers. Joining the First Order stormtroopers, snowtroopers, and flametroopers seen in *The Force Awakens*, two new troopers made their debut—the Elite Praetorian Guard and stormtrooper executioners.

Like the iconic Imperial Royal Guard that flanked the Emperor in the early movies, Supreme Commander Snoke is protected by his own faceless guardians. Obscured behind crimson robes, ornate plated torso armor, and face masks, these stoic sentinels are not merely status symbols but highly -trained martial artists ready to take on intruders in melee combat. They carry an assortment of deadly single- and double-bladed polearms, whip-staffs and throwing weapons. While they harken back to the Imperial Guard, the members of the Praetorian Guard have specialties within their own ranks, denoted by the slight differences in their helmets and weapons.

Like the Praetorian Guard, the Stormtrooper Executioners are another specialized soldier. The First Order demands absolute loyalty from its members. If a member of the First Order military is found guilty of a treasonous act, these judicials and Stormtrooper Executioners, led by Captain Phasma, dispense brutal judgement within the regime. They are clad in standard stormtrooper armor, but are marked with black shoulder plates and a black stripe on the right side of the cranial plate of their helmet. In place of a blaster, these troopers wield a terrifying double-bladed laser axe—with design similarities to the Z6 Riot Control Baton seen in *The Force Awakens*. When ignited, this axe has two hemispheres of blue lasers able to deliver swift and final justice.

Following the success of Force Friday midnight release of product for *The Force Awakens*, the toys released as part of Force Friday II, held on September 1, 2017, offered a sneak-peek of new characters, ships, and much more. Among the toys released were Hasbro action figures, LEGO sets and Funko POP! figurines—including those of the Elite Praetorian Guard and Stormtrooper Executioners.

ABOVE: Hasbro Black Series figures of the First Order Stormtrooper Executioner (left) and the Elite Praetorian Guard (right). These figures were released September 1, 2017 as part of Force Friday II. **OPPOSITE LEFT:** A studio photograph of an Elite Praetorian Guard holding a single-bladed polearm, *The Last Jedi*. **OPPOSITE RIGHT:** A studio photograph of the First Order stormtrooper executioner or judicial wielding a laser axe, *The Last Jedi*.

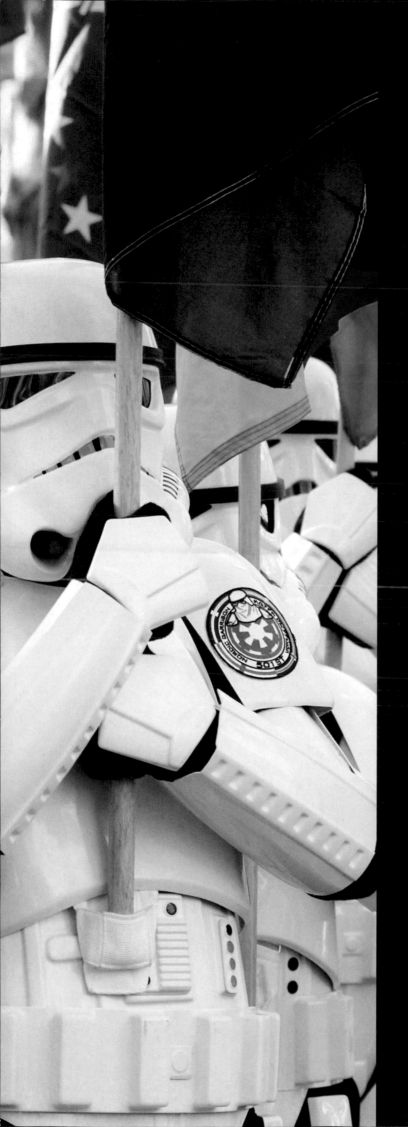

STORMTROOPERS FOREVER!

Stormtroopers are not merely people in cool costumes from an old sci-fi movie. They have permeated popular culture: appearing in magazines, television specials, and commercials, and they are featured at community events. Their presence goes beyond the toy aisle, and they have become something more than the villainous characters of the original movies. Quite often stormtroopers are real-world heroes, when members of the 501st Legion dressed in costume visit children's hospitals and raise money for charity.

Dave Filoni's Wolfpack, the 104th Battalion led by Jedi General Plo Koon, was a bit of a personal symbol for the supervising director. But it also became an emblem for fans to show their love of *The Clone Wars* and their appreciation for Filoni's contributions. The symbol found its way into not only costumes, but tattoos, fan art, and *Star Wars* fan associations—all as a way to connect with *Star Wars* and bring it into the real world.

"It's fascinating how fans will really latch onto a particular clone or a particular episode that really resonated with them," says Dee Bradley Baker. "It's like that [character] is a living hero to them, or their children or the family. It's always fascinating to me how much these clones matter to people. It's really the most gratifying thing—that there's a reality and a meaning to these good soldiers that really connect with people and that really make these stories live, along with everything else."

With each new iteration of *Star Wars*, fans eagerly anticipate a new evolution in clone armor and trooper specialization, all of

OPPOSITE: 501st Legion members from around the world march at the Tournament of Roses Parade, 2007. Each member wore a special event patch on their right shoulder pauldron and the patch of their regional chapter on their left pauldron.

which still ultimately finds its roots in the original designs of the beloved artist Ralph McQuarrie, and the mind of the creator of *Star Wars*, George Lucas.

HONORING THE MAKER

Without George Lucas, there would be no stormtroopers, so it is only right that stormtroopers would be part of any show of appreciation for him. On June 9, 2005, seated between Steven Spielberg and Harrison Ford, George Lucas received the American Film Institute's 23rd annual Lifetime Achievement Award. The evening's festivities opened with a parody of "My Way," sung by William Shatner, who was backed by a group of ten dancing stormtroopers. Dancing is always a challenging task for stormtroopers, given the limited field of vision and movement-restricting armor. Nonetheless, their range of motion proved even more versatile than Shatner's vocal range.

George Lucas has been immortalized in Hasbro plastic several times. In May 2006, Hasbro offered a free mail-in action figure of George Lucas (in Stormtrooper Disguise). The offer was part of the Ultimate Galactic Hunt, requiring fans to send in $4.95 shipping and handling plus

TOP: The George Lucas (in Stormtrooper Disguise) action figure, released by Hasbro, 2006. **BOTTOM:** William Shatner appears for Lucas' Lifetime Achievement Award, 2005. Shatner also appeared at the 2015 Country Music Awards in stormtrooper armor, and before Carrie Fisher's passing in 2016, when asked if he'd like to play a stormtrooper, Shatner replied, "I'm holding out to be the next love interest of General Leia!"

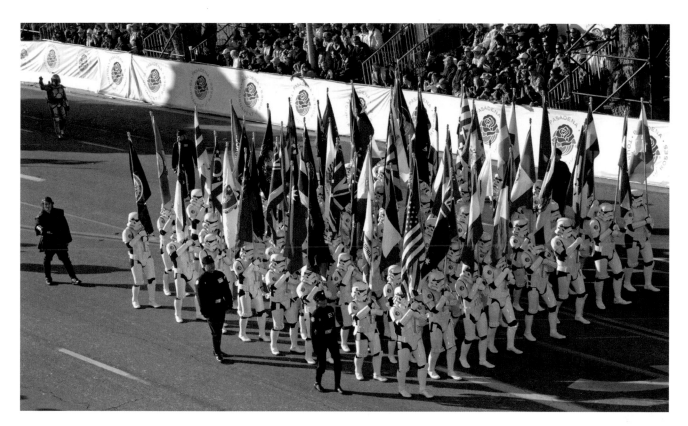

proof-of-purchase stickers from the first five figures in their new classic Kenner-style line, which would evolve into Hasbro's The Vintage Collection of retro-packaged figures in 2010.

Hasbro's marketing director Derryl DePriest called George Lucas "the greatest character in the universe," saying, "We took a cue from when Han Solo and Luke disguised themselves as stormtroopers."

The George Lucas figure featured a removable helmet and blaster, packed on a reproduced 1978 Kenner storm-trooper action figure card. The figure body was repurposed from an early Fan Club exclusive Stormtrooper Troop Builder Set 4-pack in 2002, which were likewise modified versions of 1999's Stormtrooper with Battle Damage and Blaster Rifle Rack in Hasbro's Power of the Force 2 line.

George Lucas is known for shying away from the cameras himself, but on January 1, 2007, he served as the grand marshal of the Tournament of Roses Parade in Pasadena, California, in conjunction with the thirtieth anniversary celebration of Star Wars. More than two hundred costumed members from the 501st Legion, coming from twenty-two states and thirty-six countries, volunteered to participate in the parade, most of them stormtroopers.

Albin Johnson remembered the occasion as one of his most rewarding Star Wars-related experiences. "So for the five days we were gathered in Anaheim, I enjoyed the hard work and fun downtime with two hundred of the finest Star Wars fans from all over our planet. It was such a rewarding time to be there in fellowship with such fine people. The day of our dress rehearsal I was asked to step forward during the group photo and meet George himself. I was stricken with awe at standing next to the man.

"He was very kind, saying, 'Thank you for this' as he gestured at the two hundred stormtroopers at attention behind us, their local unit logos emblazoned on their armor.

"I was taken aback, not knowing what to say. 'But sir,' I said, 'you made Star Wars. I should be thanking you.'

"He answered plainly, 'Yes, but you made this. Thank you.'

"I'll never forget the words, and I cherish them as a validation for what we do."

The procession included two floats, representing Naboo and the Ewok village on Endor, and the Grambling State University Marching Tigers. The experience is documented in Star Warriors, produced by Kevin Burns and Prometheus Entertainment, and featured on the ninth disc of the 2011 Star Wars: The Complete Saga Blu-Ray set.

ABOVE: The 501st Legion marching in the Tournament of Roses Parade, 2007. During their welcome dinner, Lucas told them, "Thanks for volunteering for this special mission. This is a first campaign in our effort to rule the universe." In another spectacle on October 18, 2008, Samuel L. Jackson, flanked by fifty stormtroopers, presented Lucas with the Comic-Con Icon Award at Spike TV's Scream Awards.

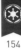

THE 501ST LEGION

The 501st Legion, nicknamed "Vader's Fist," is a volunteer fan organization, which was founded by Albin Johnson in 1997. Since then it has grown to more than 10,000 members from about fifty countries. Their website says, "Some fans are content to collect action figures . . . other fans want to be action figures." Though the 501st is not officially affiliated with Lucasfilm, Disney does grant the organization permission to use *Star Wars* character likenesses for their activities.

According to Johnson, "The 501st Legion is a fan-based *Star Wars* costuming group that specializes in the 'bad guy' costumes and props from the *Star Wars* saga. Its goal is to forge a community of like-minded fans who take pride in costuming as well as community service."

"I think the 501st is amazing," says honorary 501st member and actor Sam Witwer. "Never in the history of modern fandom have we seen an organization like this. The only thing that comes close is *Star Trek* fans, but we have yet to see an army of Klingons or Jem'Hadar march in the Rose Parade. What makes this group of villains truly special is their charity activities. In a stroke of visual irony, these particular baddies truly exemplify and champion the values of *Star Wars'* greatest heroes. They remind all of us of the moral relevance and power of this modern-day myth.

They justify our love of *Star Wars* by proving it's more than just a fairy tale. It can also be a philosophy."

The 501st are renowned for their charity work, particularly concerning children with illnesses. Fans may know Johnson via the story of his daughter, Katie, who was diagnosed with terminal cancer in 2005. The R2 Builders Club made her a pink astromech named R2-KT. Since her passing, Johnson continues to tour the country with the droid to visit sick children and raise public awareness of pediatric illness. R2-KT and the 501st are credited with raising millions for charity, and the little droid has gained further notoriety, and an induction into official *Star Wars* canon, by appearing in *The Clone Wars* and *The Force Awakens*.

"I think the 501st—all of them—are heroic people," says voice actor and honorary member Dee Bradley Baker. "They are the nicest, sweetest people I think I've ever met. All of them are so focused on helping people and making kids happy. I just think they are absolutely terrific. They spread the love of *Star Wars* and the best of all the things that are the *Star Wars* universe's take on who we are and what we should be doing. I think they bring that to reality—in the real world. I think it's marvelous that they are like a living part of the mythology."

ABOVE: During a 2016 visit to Hospital Universitario 12 de Octubre, a pediatric hospital in Madrid, Spain, 501st Legion members surprised a few special *Star Wars* fans. The 501st charter emphasizes service: "The Legion promotes interest in *STAR WARS* and facilitates the use of these costumes for *STAR WARS*–related events as well as contributes to the local community through costumed charity and volunteer work."

The 501st were first included in official *Star Wars* story lines via Timothy Zahn's *Survivor's Quest* and the prequel novella *Fool's Bargain* (which is the only book told completely from the point of view of stormtroopers), both published in 2004. They were subsequently included in the video game Battlefront II, as well as *Revenge of the Sith*, *The Clone Wars*, and many other *Star Wars* stories and merchandise. Their emblem was even featured on one of the flags hanging in the courtyard of Maz's castle in *The Force Awakens*.

After Johnson and his friend Tom Crews first appeared in stormtrooper armor at their local theater in 1997, they went to any event they could use as an excuse to dress up. "I started posting photos of our antics on the newly emerging internet," recalls Johnson. "I created a site called 'Detention Block 2551' and posted our photos as if chronicling the adventures of two misfit stormtroopers who were bored from duty on the Death Star. Before long, I started getting emails from other fans dressing out as stormtroopers. The first was Scott McArthur from Canada. He sent me a photo of himself in armor next to a lake with a sunset behind him. I posted it with the caption that this was one of our trooper buddies on vacation on some tourist planet. It got some laughs, but mostly it generated more photos from more people in armor around the world.

"It got me thinking about the original concept I had, that of seeing all these stormtroopers together. I remembered photos of my dad from his World War II flight school book, all these pilots lined up and looking cocky. It occurred to me that on a website we could do something similar, featuring all these stormtroopers lined up with cool nicknames or identification numbers. And if we did that, we'd look a lot cooler featured as a military unit of some kind. So I did some writing and developed a name for the unit, as well as a backstory and a catchy motto. I thought a large number for the unit would be fitting for something as big as the Empire, so I went with 'five hundred' to fit with a cool motto. I thought 'Fighting 500th,' but added a '1' to give it some flavor. I also gave it the motto 'Vader's Fist' because the image of Vader shaking his fist on Cloud City was just so powerful and lent itself to a military unit."

Within the *Star Wars* universe, the 501st Legion has become the group of stormtroopers commanded by Anakin Skywalker (and then Darth Vader). Notable clone members have included Captain Rex, Fives, and Echo.

RIGHT: A collection of 501st Legion badges from around the world. The custom badges are highly collectible and treasured by members and friends of the 501st Legion.

THE TROOPS ASSEMBLE

"Before long the submissions came in every day, from all over the world," says Johnson. "I put together a loose organizational scheme based on the Roman Empire, both to root it in historical archetypes and to avoid contemporary military unit names. I envisioned that if the group grew worldwide it would make more sense to 'franchise' it to offer members the chance to support their local unit and, by extension, the whole unit."

Regional units became known as "garrisons," local units as "squads," and themed groups within the organization as "detachments." Member ID conventions were based on TK-421, a stormtrooper on the Death Star in *A New Hope*. Each member would retain a unique number, but they would receive a unique prefix for each costume type that they registered (TK for stormtroopers, TS for snowtroopers, TD for desert troopers, and so on).

The majority of the costumes and components are handmade by the members themselves, but in some circumstances costumes or components can be purchased from outside licensed vendors. Clint Randall owns a stunt version of the stormtrooper from *A New Hope* and a First Order stormtrooper. He made both himself, each starting with a purchased kit. "The kits come with Vacuformed ABS plastic armor components that have to be cut, sanded, and mounted or strapped to each other or to the undersuit. There are also

a lot of other components that are often custom made, such as elastic, Velcro, snap attachments, and canvas. At the end of the day it's a lot of work, probably twenty-five hours or so for the classic stormtrooper and upwards of eighty hours for the First Order stormtrooper."

Men and women are drawn to the 501st not just because of the cool costumes, but because of the examples set by its members. "Being involved with the 501st Legion has literally been a life-changer on a couple of fronts," says Clint Randall. "Firstly, the opportunity to make so many people happy with something you love is a really rare thing to find. After seeing stormtroopers on National Adoption Day at the courthouse where I was adopting my first son, the wheels really started spinning. I couldn't believe how happy those guys made me and others around just by their presence! The kids were ecstatic and the adults possibly even more so. Then six months later, there they are again at a foster care picnic my wife and I were attending and again—what joy they were bringing to people! That flipped the switch for me and I had to find out more. That's when I started meeting members of the Dune Sea Garrison and started to realize that this was a great group of people with pretty normal lives who liked making people happy. I'm now friends with stormtroopers, biker scouts, and Imperial officers who are also military veterans, police officers, and teachers. Together we visit kids in the hospital, go to

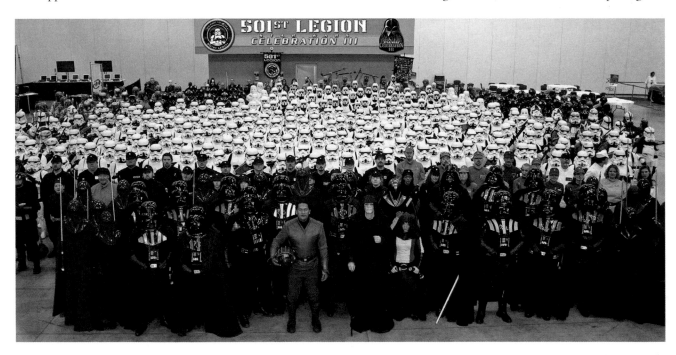

ABOVE: The group photo of the 501st Legion taken at *Star Wars* Celebration III in Indianapolis, Indiana (April 21–24, 2005). The event celebrated the release of *Revenge of the Sith* and featured an appearance by George Lucas to announce intentions for a live-action TV series and a new iteration of Star Tours. Activities included a "Stormtrooper Olympics" and *Clone Wars* panels.

schools, support various fund-raising efforts, and all while having a lot of fun!"

The charities the 501st works with are chosen by the local garrisons individually, but collectively, they work with the Make-A-Wish Foundation most often. "For kids, I imagine it is a dream come true," says Johnson. "They're seeing the characters come to life—greeting them and affirming them. I only imagined such a thing when I was a child back in 1977. We hope that it gives kids the kind of boost they'd want from meeting their heroes. Every kid should be made to feel like a star and to enjoy the power of imagination."

The charity work is ultimately the reason that many like Clint Randall joined the organization. "I have had the opportunity on multiple occasions now to go to Cardon Children's Medical Center in Mesa [Arizona] where a child was celebrating getting to go home after being cleared from cancer. They get to bang a special gong that resonates down the hallways of the hospital and the nurses and staff really celebrate them. It's so incredible to be invited into such a personal moment in people's lives all because of *Star Wars*. Somehow, the magic of the armor allows everyone to drop

their guard and celebrate like a child and forget about a lot of things weighing them down."

There are three things that Johnson would like fans to know. "The 501st is a family, first and foremost. It is rooted in the belief in building a home for fans, and the love and fun of costuming is what makes the club special. . . . Second, it is important to realize how selfless the Legion can be . . . We are dedicated to doing good work to help our communities, spread the magic of *Star Wars*, and have fun. Third, I'd love for the public to know that costuming is a liberating and healthy way to celebrate your fandom and that we work to knock down stereotypes about fans of any genre.

"The Legion is made up of a wide range of professions, of dedicated people, of veterans of military and public safety service, and is very supportive of all races and of women being involved in fandom," says Johnson. "We want to be known as those fans empowering people to express themselves. Folks from every walk of life can live the magic of *Star Wars*. All they need to do is put on a costume and see the look in a child's eyes when they appear, just see the magic from the point of view we see it."

ABOVE: A TIE pilot (Ricky Torres of Palm Springs, from the Florida Garrison of the 501st Legion) holds hands with a four-year-old patient in the pediatric unit of Palms West Hospital in Loxahatchee, Florida, on July 21, 2007.

PREMIUM COLLECTING

With advances in technology, *Star Wars* collectibles have become increasingly detailed and finer in quality. With that comes a larger price tag; premium action figures and statues can cost several hundred dollars each. However, for the fan who has everything, or simply has expensive tastes, there is a broad range of upscale merchandise to meet their demand.

Gentle Giant became famous within the film industry via their production work on *Attack of the Clones* in 2002. They began using their expertise to produce licensed *Star Wars* products that same year. Gentle Giant has subsequently used their cutting-edge 3D scanning technology to capture physical props, actors, large objects, and entire sets for numerous films.

Their early Deluxe Collectible Busts (otherwise known as mini-busts), produced using the very same CGI clone models from the film, included a Clone Trooper, which also came in variants of captains and clone commanders (all released in 2003). Later exclusives included the Clone Trooper Lieutenant variant (2003 summer conventions exclusive), Clone Trooper Pilot (2004 Wizard World Los Angeles exclusive), and Clone Trooper Sergeant variant (2004 StarWarsShop.com exclusive). The statues boasted an unusual feature at the time, which became a genre standard: extra interchangeable heads, arms, and hands holding various accessories, allowing fans to customize a whole army of unique soldiers. Since then their mini-busts and maquettes have covered troopers from each film and animated series. Some of the most imaginative have included a stoic female stormtrooper named Jes Gistang from the Legacy era's "Joker Squad," with an alternate interchangeable head sculpt (Premier Guild 2012 exclusive); a comical Scout Trooper (Ewok Attack) maquette (April 2013 Entertainment Earth exclusive); and a Shadow Trooper bust (2016 Premier Guild Gift), appropriately timed with *Rogue One*. Their First Order Stormtrooper and First Order Flametrooper 1:6 Scale Mini Busts looked like they stepped right off the screen.

In 2010, Gentle Giant began offering jumbo twelve-inch Kenner action figures, scanned from the original vintage figures. The first was a stormtrooper on a special thirtieth anniversary backer card featuring *The Empire Strikes Back* logo, and sold exclusively at San Diego Comic-Con. A standard version was made more widely available

LEFT TOP: A Master Replicas Clone Trooper Helmet from *Revenge of the Sith*. **LEFT BOTTOM:** A Propshop FN-2187 Stormtrooper Helmet. Though marketed for display only, it is wearable. More affordable miniature helmets such as U.K.-based DeAgostini's *Star Wars* Helmet Collection and Hasbro's the Black Series Titanium Series are also produced.

at the end of 2011. A six-foot-tall version was sold for $2,300 in 2014.

Another renowned model making company is the Tokyo-based Kotobukiya, which is well known for their manga and pop-culture-inspired vinyl statues. They began producing licensed *Star Wars* products in 2002. Their first pieces included a series of Clone Trooper maquette variants (trooper, captain, commander, and lieutenant), initially only available in Japan and later imported to the U.S. For *Revenge of the Sith*, Kotobukiya released a large number of new clone troopers, sandtroopers, scout troopers, snowtroopers, and shock troopers in their high-end ArtFX line, beginning in 2005. Their ArtFX statues included decorative bases, and some had extra interchangeable limbs for creating several poses. One of their finest pieces was Commander Cody (Light-Up Version.) holding a light-up Palpatine hologram, released in 2011. That year they also began producing ArtFX+ statues, usually in 2-packs, with even more accessories and magnetic bases. In 2015 they offered an exciting ArtFX+ Stormtrooper Two Pack, and their First Order Stormtrooper Pouch Sandwich Shaper made lunches a lot more fun!

Sideshow Collectibles produced its first clone and stormtrooper products in 2007. Their selection included 1:6 scale figures, premium format figures (quarter-scale maquettes), and "Legendary Scale" busts (half-sized statues). Sideshow produced dozens of 1:6 scale figures from all of the movies and *The Clone Wars*. These premium figures are prized by collectors for their museum-quality likenesses, lifelike articulation, and numerous accessories. Notable releases in their vast Militaries of *Star Wars* line have included their Boil and Waxer with Numa 3-pack (2011), Clone Troopers: Echo and Fives 2-pack (2013), as well as Cad Bane in Denal Disguise (2014). Sideshow has produced only a few premium format troopers. The most impressive was its Speeder Bike and Scout Trooper (2007), featuring several points of articulation. Its Legendary Scale Busts include Captain Rex (2012) from *The Clone Wars* and a *Revenge of the Sith* representation of Commander Cody (2009), holding a holographic Palpatine.

In 2014, Hot Toys began producing a line of *Star Wars* 1:6 scale figures in partnership with Sideshow. Similar to Sideshow's earlier figures, they stand approximately twelve inches tall, include more than thirty points of articulation,

ABOVE: Sideshow Collectibles' Speeder Bike and Scout Trooper (2007) is 35 in (88.9cm) long, 18 in (45.7cm) wide, and 22 in (55.9cm) tall. The 1:4 scale piece is not an action figure, but rather a replica of the stop-motion maquettes used in the making of the speeder chase scene from *Return of the Jedi*.

removable armor and accessories, a stand, and a selection of alternate hands for gesturing and holding weapons. Early offerings included a Stormtrooper, available as a single or as a set with a bonus mouse droid, heavy blaster, and blaster rack. They also produced a Shadowtrooper, Sandtrooper (including a patrol droid and binoculars), and a Luke Skywalker (Stormtrooper Disguise Version).

ALMOST THE REAL THING

Don Post, which had produced quality replica helmets of stormtroopers, TIE pilots, biker scouts, and Imperial Royal Guards since the original films, stopped producing *Star Wars* products around the year 2000. There was a gap in relevant high-end merchandise until Master Replicas began producing full-sized helmets for costuming in 2005. Their helmets included seven variations of clone trooper helmets. They also sold a Stormtrooper Helmet (a "stunt" version made of plastic), a Limited Edition Stormtrooper Helmet (a "hero" version made of fiberglass), and a Shadow Stormtrooper Helmet (2007 Collectors Society exclusive

made of fiberglass). All were modeled from a helmet used in *A New Hope*. The Limited Edition stormtrooper model was asymmetrical like the film-used helmets, while the other two editions were 3D scans of half of a screen-used helmet, which was then mirrored for perfect symmetry. This distinction can be crucial for discerning collectors, who tend to prefer the authenticity of asymmetrical helmets. The clone helmets were created using computer models from *Revenge of the Sith*.

The company eFX took over the *Star Wars* license from Master Replicas in 2008, and eventually produced helmets for stormtroopers, clone troopers, clone captains, shadow troopers, and biker scouts. The stormtrooper helmets were available as both "Hero" fiberglass limited editions, and more affordable, digitally scanned, ABS plastic "Collector's Edition" helmets. More recent helmets have been created with new molds taken from a screen-used helmet.

On June 1, 2015, former licensee Propshop at Pinewood Studios announced it would begin selling an Ultimate Studio Edition of prop replicas from *The Force Awakens*. The high-end props (ranging from $1,250–$3,500) were made by the

ABOVE LEFT: The ANOVOS' *Star Wars: The Force Awakens* First Order TIE Fighter Pilot Helmet Premier Line Accessory included removable and adjustable interior pads to allow for better fitting. **ABOVE RIGHT:** The ANOVOS' *Star Wars* Imperial Shadow Stormtrooper Helmet Accessory featured mirrored silver lenses and decals for the cheek stripes, the rear and temple trapezoids, as well as the ear, frown, and tear details.

same professional artists who created the original pieces used in the movie, using the same materials and techniques. Its FN-2187 Stormtrooper Helmet was complete with a bloody handprint. Their items were considered props and not intended for costuming.

ANOVOS produced their first high-end stormtrooper armor in 2015, with a focus on wearable costuming. The company sells individual helmets and complete costumes, all of which must be preordered in limited runs. They have produced helmets for the First Order stormtrooper, TIE fighter pilot, Captain Phasma, an Imperial shadow stormtrooper, an original trilogy stormtrooper, AT-AT driver, snowtrooper (available glossy or weathered), and TIE fighter pilot (available as basic or Vader wingman version). Their complete costumes have included Imperial, shadow, and First Order stormtroopers, snowtroopers, AT-AT drivers, and TIE pilots. Costumes (which can be ordered ready-to-wear or in unfinished kits) are made using 3D scans and close study of screen-used pieces. In cases like the First Order stormtrooper, they incorporated pieces like gloves and boots supplied by the manufacturer of the film-used costumes.

ENDLESS CELEBRATIONS

In 1999, Lucasfilm began hosting conventions for fans to celebrate the movies, stories, and fandom they had come to share and love. The first celebration was in Denver (April 30–May 2, 1999), and the success of that first convention kicked off subsequent celebrations. Following Denver, the next two Star Wars Celebrations were in Indianapolis (May 3–5, 2003, and April 21–24, 2005). At each of these first three celebrations, fans were introduced to each of the new prequel films as well as a spectacle of props and costumes.

According to Albin Johnson, they also provided the opportunity for the 501st to gain official recognition. "When I caught up to Mary Franklin [former senior events lead for Lucasfilm] at Celebration II, I asked for a meeting. She agreed to meet me for a few minutes before the show opened and I laid out a heartfelt plan for what I wanted the Legion to be for Lucasfilm. All I asked for was the chance to do good work for them, to show them we could be trusted. Their trust in the 501st has been an affirmation of everything I've worked for."

RIGHT TOP: A first class U.K. postage stamp with design by artist Malcolm Tween. RIGHT BOTTOM: A first-class U.S. postage stamp with illustration by artist Drew Struzan, issued May 25, 2007.

STAMPS OF APPROVAL

When governments celebrate a pop-culture phenomenon, it's a matter worthy of history textbooks. Star Wars and its stormtroopers have had such a major impact on the cultures of the U.S. and U.K. that they both immortalized the franchise in the form of postage stamps.

The U.S. Postal Service issued a set of fifteen, forty-one-cent stamps, painted by renowned artist Drew Struzan, to commemorate the thirtieth anniversary of Star Wars. Struzan had already created official posters for Return of the Jedi (known as Revenge of the Jedi at the time), the original trilogy special editions, the prequel trilogy, and would later create a D23 exclusive teaser poster for The Force Awakens. Among the stamp designs was a monochromatic blue stamp featuring a group of stormtroopers.

In 2015, British artist Malcolm Tween (known for his Star Wars Celebration exclusive prints and work on the Revenge of the Sith style guide) created two sets with a total of eighteen stamps, one of which featured a stormtrooper and a smaller inset with a group of stormtroopers led by Darth Vader. The stamp was also monochromatic blue (apart from the lights on Vader's chest plate). The stamps were issued to celebrate the largely British-made new movie, The Force Awakens.

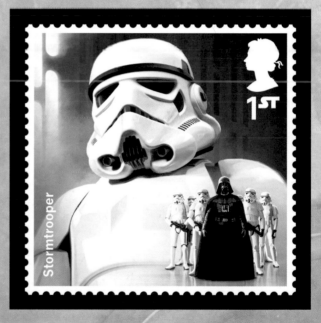

STAR WARS
CELEBRATION VI

Diorama and Photography by Stephen Hayford

/250

As promotions for the upcoming *The Clone Wars* movie and TV series ramped up, Celebration IV, held at the Los Angeles Convention Center (May 24–28, 2007), became a clone-focused frenzy. Footage of *The Clone Wars* was presented by Dave Filoni, and fans were treated to a preview of The Force Unleashed. Celebration IV also honored the thirtieth anniversary of *A New Hope*.

The first *Star Wars* Celebration Europe was held later the same year (July 13–15, 2007) in London, and continued the thirtieth anniversary festivities. To mark the occasion, Ralph McQuarrie had two of his own prints available. They were gradient overlays of paintings on top of original concept sketches from preproduction pieces from *A New Hope*. The first was titled *Armed Stormtroopers on the Floating Prison Planet Alderaan*, with acrylic, gouache, and colored pencil on illustration board. The other was titled *TIE Fighter Attack*, which differed from the original version by putting a Y-wing in the pilot's viewport, instead of the *Millennium Falcon*.

The following year, Japanese fans gathered in Chiba (July 19–21, 2008) to commemorate the thirtieth anniversary of the release of *Star Wars* in Japan. Celebration Japan included sneak peeks of *The Clone Wars* and a buffet of uniquely Japanese *Star Wars* products. Medicom produced a yellow Real Action Hero Clone Trooper Commander. The figures in the series are said to have "the most articulated twelve-inch

figure bodies available, capable of nearly any pose that the human (or superhero) body can achieve." It came in an attractive display box with a blaster and extra pair of hands.

Star Wars Celebration returned to the U.S. a few years later for Celebration V, held in Orlando (August 12-15, 2010). The fifth celebration boasted a "main event" where Jon Stewart, then host of *The Daily Show*, interviewed George Lucas on stage before a live audience. In addition to announcing that *Star Wars* would be released on Blu-Ray the following year, Lucas gifted the comedian with a one-of-a-kind 3¾-inch action figure in Jon Stewart's likeness. The figure appeared on a vintage Kenner card with a stormtrooper outfit, removable helmet, and alternate swappable head, titled Stewart Storm Trooper.

On August 23–26, 2012, fans again met in Orlando for Celebration VI, where they were treated to *The Clone Wars* Season five premiere and a surprise visit by George Lucas. Jay Laga'aia (who played the young adult clones in *Attack of the Clones*) hosted the *Star Wars* Celebrity Contest, a fan talent show. The winner received a life-sized clone trooper statue.

Though it wasn't the only trooper exclusive that year. The official *Star Wars* Celebration store sold four maquettes, with a limited run of three hundred pieces each, one of which was a death trooper. The pieces were of course extremely

ABOVE: A photojournalist of more than twenty years, Stephen Hayford used Hasbro action figures to create a comical depiction of troopers in their employee lounge in his poster *Trooper Break 2*.

rare—and mysteriously, no manufacturer was identified on the statue bases or their packaging.

Sideshow also offered an exclusive red 1:6 scale Clone Commander Granch at the 2012 Celebration. The figure was decked out with numerous accessories, including Phase I and Phase II helmets, as well as a hand-painted head sculpt. It also had thirteen interchangeable hands and two different pairs of boots, and a figure stand to facilitate a variety of poses. Its weapons included a BlasTech DC-15A long-range blaster rifle, BlasTech DC-15S Blaster Carbine, and two BlasTech DC-17 blaster pistols.

For the second Celebration Europe, fans gathered in Essen, Germany, on July 26–28, 2013, and were treated with a first look at *Star Wars Rebels*. Attakus, a French producer of collectible figures, made a bronze painted statue of Commander Cody (Utapau Battle)—only ninety-nine pieces—that stood 15.8 inches and held a DC-15S blaster.

One of the most anticipated *Star Wars* Celebrations was held April 16-19, 2015, in Anaheim, California, where fans were treated to the second teaser trailer for *The Force Awakens*, and the first for the *Rogue One* trailer. Director J. J. Abrams and Lucasfilm President Kathleen Kennedy introduced the cast of *The Force Awakens*, while Dave Filoni premiered *Star Wars Rebels* Season Two and the unfinished "Bad Batch" arc of *The Clone Wars*. Fans also got their first look at the upcoming video game *Star Wars*: Battlefront.

As part of *The Force Awakens* promotion at the Celebration in Anaheim, ANOVOS and Lucasfilm selected a group of 501st Legion members to march as First Order troopers. Clint Randall was one of the few selected for the special opportunity. "In March of 2015, the 501st was contacted about the opportunity and members were invited to sign up for a selection process to be able to buy a prototype First Order stormtrooper kit with the purpose of constructing it prior to Celebration Anaheim to reveal to the world. After submitting names, fifty of us were chosen so we signed nondisclosure agreements, paid for the kit, and then patiently waited for our shipping notifications. Eventually another twenty-five people were added to the pre-Celebration effort, upping the count to seventy-five participants. The whole experience was pretty wild because we only had about two to three weeks to build these suits that no one had ever built before, and we didn't even have

full references of the new stormtrooper because the movie wasn't coming out for eight more months!

"After two grueling weeks of working in the garage late into the night with a secret build crew I assembled from friends in the Dune Sea Garrison," Randall continues, "I finished in time, headed off to California, and had the privilege of trooping around the convention center that weekend in a new *Star Wars* costume that very few had ever seen. It was uncomfortable, a bit stressful, and completely amazing! I think somewhere around thirty of us finished in time for the convention."

Celebration Anaheim also offered several exclusives, including the chance to preorder Hot Toys' Spacetrooper 1:6 Figure (from *A New Hope*). Like other figures in the series, it stood 11.81 inches tall with over thirty points of articulation. It also included five swappable pairs of hands, a heavy blaster, blaster rifle, thermal detonator, and custom figure stand.

ABOVE: Costumed stormtrooper fans take the escalator at *Star Wars* Celebration Anaheim, April 16, 2015. Stairs are a dangerous thing for stormtroopers, as helmets provide a highly restricted field of vision and the armor restricts movement. These wearers wisely opt to take escalators or elevators instead.

CELEBRATING AND EXPLORING THROUGH ART

While each Celebration offers exclusives in merchandising, the events also feature art shows. Over the years, there have been some existent depictions of stormtroopers that offer insight into the characters and particular gaps in storylines.

For Celebration IV, Kilian Plunkett, who served as lead designer in Lucasfilm Animation's art department for *The Clone Wars*, produced an exclusive print that filled in a story gap in *A New Hope*. The print depicted stormtroopers mounted on dewbacks, firing upon the Jawa sandcrawler, which would later be found by Luke and Obi-Wan on Tatooine.

Also for Celebration IV, Dave Dorman created *Lord Vader's Persuasion of the Outer Rim World to Join the Imperial Alliance*. This piece showed Darth Vader leading a ground assault with Crimson Guard, storm-troopers, and backed by AT-ATs, AT-STs, and scout troopers.

Dorman again produced another epic landscape for the 2007 Celebration Europe titled *Incident on the Jundland Wastes, Tatooine*. Much like Plunkett's Celebration IV print, it explored the "missing scene" where the stormtroopers attacked the sandcrawler on Tatooine. Here however, we see the lengths that the stormtroopers went to disguise themselves as Sand People, wearing the Tuskan wraps and head-gear, and dismantling the Jawa's droid cargo.

ABOVE: Artist Marc Wolfe's poster *Legacy of Valor* was created for Celebration V in Orlando, Florida, 2010. His other work includes Imperial propaganda posters such as *Join the Fight!* for Celebration IV (2007) and *Honor. Duty. Empire.* for Celebration VI (2012).
OPPOSITE: Propaganda poster *To Hoth and Back* by Cat Staggs was also created for Celebration V (2010).

"TO HOTH AND BACK"

CHAPTER 7: STORMTROOPERS FOREVER!

Celebration V boasted several stormtrooper-centric pieces. Mark Wolfe's *Legacy of Valor* print captured the history of stormtroopers, beginning with the Battle of Geonosis and ending with the Battle of Endor. He showcased all the major trooper armor variations from the movies in hyperrealistic detail. The Republic and Imperial emblem halves mirror each other and perfectly divide the eras, while details like Jango's helmet and the ships of both governments put the transitions all in further historical context.

To Hoth and Back by Cat Staggs is a great propaganda piece from Celebration V, with the words "Do You Have What It Takes? See Action Now! Apply Nearest Imperial Recruiting Station." Dave Dorman also returned to Celebration V with *A Slight Disturbance in the Force on the Battlefield of Hoth* in which Vader and his Blizzard Force snowtroopers inspect the scene of Luke Skywalker's downed snowspeeder. Once again Dorman floats the theme of Vader fighting right in the trenches with his stormtroopers. From Tsunea Sanda's *Episode V 'To the Cloud City,'* which shows the eleven main characters of the movie moving among a mass of stormtroopers, the heroes are cleverly positioned so they aren't immediately apparent among the troopers (and a hidden snowtrooper). The image drives home the overwhelming numbers of stormtroopers that are faced by the small band of rebels.

Continuing his contributions, artist Dave Dorman's exclusive Celebration VI print, *Breaking Ground: Imperial Base, Moon of Endor*, shows stormtroopers rounding up a group of Ewoks, as Vader gives orders to the Crimson guard and Imperial officers. Meanwhile AT-STs are seen in a creative new light—being used as log haulers. The scout troopers, however, are behaving like playboys, lounging about and showing off on their speeder bikes.

In addition to Dorman's amusing piece, Stephen Hayford's *Trooper Break 2* for Celebration VI took a whimsical look at stormtroopers by presenting them using Hasbro action figures. The scene showed the stormtrooper figures in their employee lounge—on laptops, cell phones, drinking coffee, and retrieving bag lunches.

Presenting alternate views and "offscreen" moments with stormtroopers continued with the art at the second Celebration Europe. *Shade*, a print by artist Drew Baker, provided an uncommon look behind the stormtrooper mask, as two female sandtroopers get out of the heat on Tatooine. Meanwhile, in Chris Trevas' revealing print *Execution Order* (first appearing in 2005's *Vader: The Ultimate Guide* from IDG Entertainment), Darth Vader orders the sandtroopers to end the lives of the Lars couple—his own stepbrother and his wife—in an imagined deleted scene from *A New Hope*.

At *Star Wars* Celebration Anaheim, Chris Trevas, yet again, captured a story with a single image. In *The Folly of TK-421*, Trevas revealed the offscreen moment that Han Solo and Chewbacca kill the inept stormtroopers inside the *Millennium Falcon*, which is docked inside the Death Star in *A New Hope*. The image restores a little of the "scoundrel" persona in Han Solo.

ABOVE: In 2013, artist Drew Baker created *Shade* for Celebration Europe II held in Essen, Germany. **RIGHT:** Artist Chris Trevas' print *The Folly of TK-421* was featured at Celebration Anaheim in 2015. "It's a scene we only hear but never see in *A New Hope*," says Trevas. "Luckily for Luke, TK-421 was well prepared with a belt comlink and grappling hook."

CELEBRATION EUROPE III

The third Celebration Europe met at the ExCel London convention center, July 15–17, 2016. Occurring just four months before the release of *Rogue One*, the convention offered fans the first sneak peek at many of the film's costumes in the *Rogue One* costume exhibit, which among other costumes featured the new shoretroopers, death troopers, stormtroopers, and sandtroopers. Fans were also induced to a panel of the cast of *Rogue One* and treated to a live conversation with them, hosted by Gwendoline Christie. The highlight was no doubt actor Ben Mendelsohn's appearance at the panel, in full costume as Director Orson Krennic, with an escort of death troopers.

Like all *Star Wars* Celebrations, the international gatherings provide *Star Wars* fans from around the world a way to connect with the franchise and other artists both at the shows and through social media. A fan like Russian Ksenia Zelentsova, known for sketching clones, can quickly go from Twitter sensation to Topps sketch card artist.

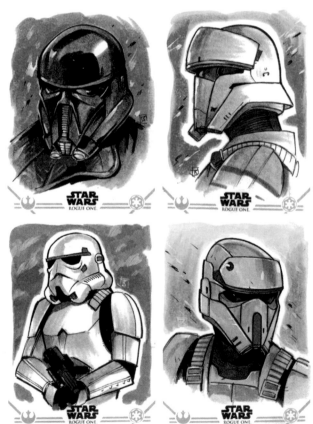

TOP: A stormtrooper stands beneath the Coca-Cola London Eye as part of the promotion for Celebration Europe II, 2016. **BOTTOM:** Topps trading card sketches by Russian artist Ksenia Zelentsova.

A TRIBUTE TO THE MASTER

Ralph McQuarrie's art has been the basis of the look of *Star Wars* from its inception. Even after his passing on March 3, 2012, his designs continue to influence the next generation of *Star Wars* films, and his creativity shines at the heart of the animated series. So many iconic characters, and their collectible merchandise, owe their existence to his imagination and handiwork. His art will always be treasured by fans and creators alike, and it continues to be an inspiration for countless new stories and products.

In 2003, Hasbro released the Ralph McQuarrie Signature Series (also called the Ralph McQuarrie Concept Collection) of action figures based on the artist's original designs. The first was the Concept Stormtrooper (a variant had been released earlier, as the Fans' Choice #4 McQuarrie Concept Stormtrooper). A Concept Snowtrooper followed. In late 2016, Sideshow Collectibles released their Ralph McQuarrie Stormtrooper Statue, the first of three statues in their Concept Art Series, which also includes Darth Vader and Boba Fett. The 1:5 scale statue holds a blue lightsaber and shield, just like the famous McQuarrie painting; however, it also comes with a second helmet design and arm holding a blaster, which can be mixed and matched as desired. It is a testament to McQuarrie's vision and ability to inspire others that new homages to his work are still created—and prized by collectors—nearly forty years later.

Great art often takes on a life of its own—far beyond what the original artist may have intended. Though Ralph McQuarrie may have preferred his own masterful designs over the final results seen in *A New Hope*, fans have grown to cherish the many iterations of stormtroopers. The ever-growing mythologies around the Republic clones, Imperial stormtroopers, and First Order stormtroopers are the result of the collaborative processes of both seasoned and new generations of talented concept artists, prop and costume designers, CGI model-makers, storytellers, and other creative professionals who have all lent their wondrous talents to expand upon the vision of George Lucas and the imaginative designs of Ralph McQuarrie.

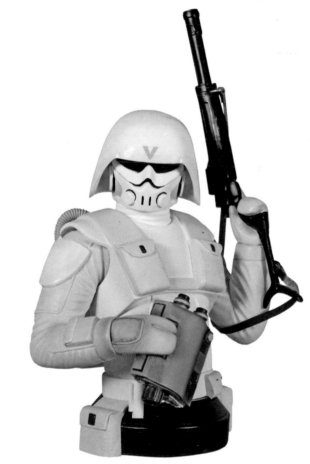

TOP: Two fans wear stormtrooper armor based on Ralph McQuarrie's early design concepts from *A New Hope* preproduction. BOTTOM: Gentle Giant's San Diego Comic-Con Exclusive 2011 *Star Wars* Imperial Snowtrooper (McQuarrie Concept) Collectible Mini Bust. The piece also includes an alternate head. There were 1,800 limited-edition pieces made, originally retailing at $70.

LOOKING BEYOND

Since stormtroopers first burst through the doors of the *Tantive IV* and into the world, they have evolved from faceless and expendable soldiers into complex characters with free will. Within the galaxy, they have been a symbol of oppression while among fans their armor and helmets create a sense of unity. They are a constant within *Star Wars*, linking the story to the fans.

The interplay and development between *Star Wars* comics, novels, video games, toy lines, TV shows, and movies have shaped the way in which stormtroopers are viewed as characters—both within the galaxy as well as in pop culture. The comics and novels brought the first glimpse of the men beneath the helmets, but it was the stories about the Clone Wars that gave them a voice and explored what their lives

were and could be within the galaxy. This evolution was reflected in the toys, types of product, and artwork created by and for fans.

As the stories expanded so did the look and the role of a stormtrooper. Each new location and political faction in the saga brought new specialized troopers. While legions of white-clad soldiers are still a mark of oppression and fear, the classic stormtrooper with poor aim has been joined by snowtroopers and highly skilled death troopers. And with the development of Finn, fans learned that, just as with the 501st Legion and costumed *Star Wars* fans all over the world, a stormtrooper could be a hero.

With the next chapters in *Star Wars* history in development, the stormtrooper is sure to expand even more, both within the *Star Wars* galaxy and as a cultural phenomenon.

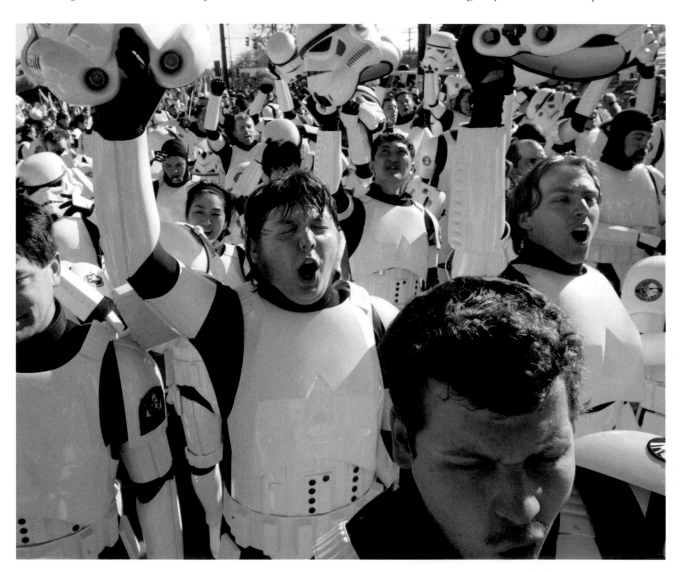

ABOVE: Members of the 501st Legion remove their helmets to celebrate at the end of the Tournament of Roses Parade, 2006.

ACKNOWLEDGMENTS

RYDER WINDHAM

Thanks to Brandon Alinger, Jason Fry, David Hanks, Iane Lowson, Lorne Peterson, and Tim Veekhoven for writing articles and conducting interviews for *Star Wars* magazines, and unintentionally providing valued information for this book. Thanks to Anthony Forrest, Charles Lippincott, Brian Muir, and Randy Stradley for confirming information and sharing their recollections. Thanks also to Hasbro employees—Derryl D. DePriest, vice president, global brand marketing; Mark Boudreaux, senior principal designer, Hasbro Design & Development; Dave Vennemeyer, senior product design manager (sculpting), Hasbro Design & Development; and Brian Parrish, product design manager, Hasbro Design & Development—for answering questions about stormtrooper-related toys.

ADAM BRAY

Thank you to the following people for their assistance—Jonathan Rinzler, who recommended me for this book. 501st Legion founder Albin Johnson and 501st member Clint Randall. Authors Keith Kappel and Cole Horton. Mediocre Jedi Zach Livingston and Thomas Livingston. Artists Chris Reiff, Ksenia Zelentsova, Chris Trevas, and Terryl Whitlatch. Master of sound and voice actor David W. Collins. *TROOPS* director Kevin Rubio. Mary Franklin at ReedPOP. Erich Schoeneweiss at Del Rey. Actors Sam Witwer and Dee Bradley Baker. At Hasbro: Derryl D. DePriest, Mark Boudreaux, Dave Vennemeyer, and Brian Parrish. At Lucasfilm: artist Kilian Plunkett, Pablo Hidalgo, Samantha Holland, Tracy Cannobbio, and Matthew Wood.

ABOUT THE AUTHORS

Ryder Windham has written more than seventy *Star Wars* books, including *The Complete Vader* with coauthor Pete Vilmur, *The Bounty Hunter Code* with Daniel Wallace, and *Millennium Falcon Owner's Manual*. An avid blood donor, he has worked with members of the *Star Wars* costumer clubs—the 501st Legion, Rebel Legion, and Mandalorian Mercs—to help promote voluntary blood donations all over the world.

Adam Bray is the author of guides to *Star Wars Rebels* and a coauthor of numerous books about *Star Wars*, LEGO *Star Wars*, and Marvel. He has written for CNN.com and *National Geographic News*, and contributed to around forty guides to travel in Southeast Asia. His talents have extended to other spheres, including illustration, music, archaeology, spelunking, and working with chimpanzees. Follow Adam Bray on Twitter and Facebook: @AuthorAdamBray, at StarWars.com, and AdamBray.com.

BIBLIOGRAPHY

"Aaron Ayamah Interview." YouTube video, posted by Kishere Film, March 27, 2016. https://www.youtube.com/watch?v=RZ-2h5YPK2A.

Alinger, Brandon. *Star Wars Costumes: The Original Trilogy*. San Francisco: Chronicle Books, 2014.

Associated Press. "'Star Wars' Creator Becomes Storm Trooper." *Washington Post*, May 4, 2006.

Baron, Mike. *Star Wars: Heir to the Empire #6*. Milwaukie, OR: Dark Horse Comics, 1996.

Beecroft, Simon, and Jason Fry. *LEGO: Star Wars: The Visual Dictionary*, updated and expanded. New York: DK Publishing, 2014.

Betancourt, Julian H. "Riddell: A Helmeted Tradition." *Sandtroopers.com*, 2004.

Blackman, W. Haden, and Brett Rector. *The Art and Making of Star Wars: The Force Unleashed*. San Rafael, CA: Insight Editions, 2008.

Bouzereau, Laurent. *Star Wars: The Annotated Screenplays*. New York: Del Rey, 1997.

Brooks, Dan. "'We Set the Bar So High': Doug Chiang on Designing Rogue One." *StarWars.com*, December 22, 2016, www.starwars.com/news/we-set-the-bar-so-high-doug-chiang-on-designing-rogue-one.

Carroll, Larry. "What Happened to Han and Leia? How about Jar Jar? 'Star Wars' Emperor Lucas Speaks." *MTV.com*, May 9, 2005.

Casey, Jo. *Star Wars Character Encyclopedia*. New York: DK Publishing, 2011.

Chernoff, Scott. "Portrait of the Jedi as a Young Man." *Star Wars Insider*, December 1998– January 1999, 56–61.

Cotta Voz, Matt. *The Art of Star Wars: Episode II: Attack of the Clones*. New York: Ballantine Publishing Group, 2002.

Dolan, Hannah, Elizabeth Dowsett, Clare Hibbert, Shari Last, and Victoria Taylor. *LEGO Star Wars: Character Encyclopedia*, updated and expanded. New York: DK Publishing, 2015.

Duncan, Jody. *Star Wars Mythmaking: Behind the Scenes of Attack of the Clones*. New York: Ballantine Books, 2002.

———. "Star Wars Episode II: Attack of the Clones; Love and War." *Cinefex*, July 2002, 60–119.

———. "Star Wars Episode III: Revenge of the Sith." *Cinefex*, July 2005, 60–93, 120–22.

Fine, Deborah, and Aeon Inc. *Star Wars Chronicles*. San Francisco: Chronicle Books, 1997.

Freed, Alexander. *Star Wars Battlefront: Twilight Company*. New York: Del Rey, 2015.

Fry, Jason. *Star Wars: The Clone Wars Episode Guide*. New York: DK Publishing, 2013.

———. *Star Wars Rebels: Servants of the Empire: The Secret Academy*. Glendale, CA: Disney Lucasfilm Press, 2015.

Fry, Jason, John Miller Jackson, James Luceno, and Melissa Scott. *Star Wars: The Rise of the Empire*. New York: Del Rey, 2015.

Handy, Bruce. "How Apple Inspired the Stormtroopers of Star Wars: The Force Awakens." *Vanity Fair* online, May 19, 2015.

Hiatt, Brian. "'Star Wars' Strikes Back: Behind the Scenes of the Biggest Movie of the Year." *Rolling Stone* online, December 2, 2015.

Hidalgo, Pablo. *Star Wars: The Force Awakens: The Visual Dictionary*. New York: DK Publishing, 2015.

———. *Star Wars: Rogue One: The Ultimate Visual Guide*. New York: DK Publishing, 2016.

———. "Star Wars Q&A." *Star Wars Insider*, May 2004, 96–97.

Kucharski, Joe. "Star Wars: The Force Awakens Costume Design." *Tyranny of Style* (blog), December 17, 2015.

Kushins, Josh. *The Art of Rogue One: A Star Wars Story*. New York: Abrams, 2016.

Laverty, Lord Christopher. "Star Wars: Interview with Michael Kaplan." *Clothes on Film* (blog), January 22, 2016.

Lowson, Iane. *Star Wars Magazine UK #7*. Titan Magazines, 1997.

Macnicol, Glynnis. "'The Force Awakens' Costume Designer on What Turned J. J. Abrams into an Obsessive Perfectionist." *Elle* online, November 23, 2015.

Magid, Ron. *Star Wars Magazine UK #53*. Titan Magazines, 2004.

———. "The Old Master." *Star Wars Insider*, May 2004, 50–57.

McQuarrie, Ralph, with Stan Stice and John David Scoleri. *The Art of Ralph McQuarrie*. Modesto, CA: Dreams & Visions Press, 2007.

Muir, Brian. *In the Shadow of Vader*. PPM Group Ltd., 2009.

Parisi, Frank, and Gary Scheppke. *The Art of Star Wars: The Clone Wars*. San Francisco: Chronicle Books, 2009.

Pellegrom, Dennis. "Charlie Akin interview." *StarWarsInterviews.com*, March 2016, http://www.starwarsinterviews.com/sequel-trilogy/episode-vii-the-force-awakens/charlie-akin-first-order-stormtrooper/.

———. "Jamison Jones interview." *StarWarsInterviews.com*, September 2010, http://www.starwarsinterviews.com/various/expanded-universe/jamison-jones-rookie-one/.

———. "Mark Alec Rutter interview." *StarWarsInterviews.com*, January 2016, http://www.starwarsinterviews.com/sequel-trilogy/episode-vii-the-force-awakens/mark-alec-rutter-first-order-stormtrooper/.

Peterson, Lorne. *Sculpting a Galaxy: Inside the Star Wars Model Shop*. San Rafael, CA: Insight Editions, 2006.

Ratcliffe, Amy. "Elite Stormtroopers are coming in *Star Wars #21*—Exclusive!" *StarWars.com*, April 18, 2016, www.starwars.com/news/elite-stormtroopers-are-coming-in-star-wars-21-exclusive.

Rebel Force Radio. "The Force Awakens with Sam Witwer." *RebelForceRadio.com*, April 29, 2016.

Reynolds, David West, and James Luceno. *Star Wars: The Complete Visual Dictionary*. New York: DK Publishing, 2012.

Rinzler, J. W. *The Making of The Empire Strikes Back*. New York: Del Rey, 2010.

———. *The Making of Return of the Jedi*. New York: Del Rey, 2013.

———. *The Making of Star Wars*. New York: Del Rey, 2007.

———. *The Making of Star Wars: Revenge of the Sith*. New York: Del Rey Books, 2005.

———. *Star Wars Storyboards: The Prequel Trilogy*. New York: Abrams, 2013.

Rinzler, J. W., and Ben Burtt. *The Sounds of Star Wars*. San Francisco: Chronicle Books, 2010.

"Samantha Alleyne Interview." YouTube video, posted by Kishere Film, March 27, 2016. https://www.youtube.com/watch?v=RAo7NkSjWQ8.

Sansweet, Stephen J. *Star Wars: From Concept to Screen to Collectible*. San Francisco: Chronicle Books, 1992.

———. *Star Wars: The Ultimate Action Figure Collection*. San Francisco: Chronicle Books, 2012.

Sansweet, Stephen J., and Pablo Hidalgo. *Star Wars Chronicles: The Prequels*. San Francisco: Chronicle Books, 2005.

Smith, Rob. *Rogue Leaders: The Story of LucasArts*. San Francisco: Chronicle Books, 2008.

Szostak, Phil. *The Art of Star Wars: The Force Awakens*. New York: Abrams, 2015

Turl, Tim. "Doom Clone Troopers—The Story Behind Star Wars: Dark Forces." *Game Informer* online, February 27, 2015.

Wagner, John. *Star Wars: Shadows of the Empire #1*. Milwaukie, OR: Dark Horse Comics, 1996.

Wallace, Daniel. "The Fan Club." *Star Wars Insider*, 2000.

Whitlatch, Terryl, and Bob Carrau. *The Wildlife of Star Wars: A Field Guide*. San Francisco: Chronicle Books, 2001.

Windham, Ryder, Daniel Wallace, and Pablo Hidalgo. *Star Wars Year by Year: A Visual Chronicle*. New York: DK Publishing, 2010.

www.JediTempleArchives.com

www.RebelScum.com

www.StarWars.com

www.StarWarsHelmets.com

www.Wookieepedia.com

INDEX

First published in 2017 by
HarperDesign
An Imprint of HarperCollins *Publishers*
195 Broadway
New York, NY 10007
Tel: (212) 207-7000
Fax: (855) 746-6023
harperdesign@harpercollins.com
www.hc.com

This edition distributed throughout the world by:
HarperCollins *Publishers*
195 Broadway
New York, NY 10007

Produced by becker&mayer! an imprint of The Quarto Group

Library of Congress Control Number: 2017932208

ISBN 978-0-06-268117-1

First Printing, 2017

Printed and bound in Shenzhen, China

IMAGE CREDITS

Pages 8-9: © Leon Neal / Getty Images; Page 10: *top left* © ZUMAPRESS.com / Keystone Pictures USA / AGE Fotostock; *middle left* © Paul Marriott / Alamy Stock Photo, *bottom left* © Mark Dunn / Alamy Stock Photo; Page 11: © The Washington Post / Contributor / Getty Images; Page 17: *top* Image Courtesy of Dan Dickenson, *bottom* Image Courtesy of Lindsay Muir; Page 88: *top* © A. Robert Turner / Alamy Stock Photo; Page 92: © PA Images / Alamy Stock Photo; Page 117: *top right* © Kai Lim, *Stormtrooper Reanimated* / Image Courtesy of the Artist, *bottom right* © Dan Dennison / Stringer / Getty Images; Page 134: © Zak Hussein / Contributor / Getty Images; Page 135: © Todd Williamson / Contributor / Getty Images Entertainment; Page 152: *bottom* © Kevin Winter / Staff / Getty Images; Page 154: © Pablo Cuadra / Contributor / Getty Images; Page 157: © ZUMA Press, Inc. / Alamy Stock Photo; Page 159: © Sideshow Collectibles; Page 160: *both top images* © ANOVOS / Image Courtesy of ANOVOS; Page 162: © Stephen Hayford, *Trooper Break II* / Image Courtesy of the Artist; Page 163: © Albert L. Ortega / Contributor / Getty Images; Page 164: © Marc Wolfe, *Legacy of Valor* / Image Courtesy of the Artist; Page 165: © Cat Staggs, *To Hoth and Back* / Image Courtesy of the Artist; Page 166: © Drew Baker, *Shade* / Image Courtesy of the Artist; Page 167: © Chris Trevas, *The Folly of TK-421* / Image Courtesy of the Artist; Page 168: Topps Trading Cards by Ksenia Zelentsova / © Topps / Image Courtesy of the Artist; Page 170: © Annie Wells / Contributor / Getty Images; Page 171: © Brendan Hunter / Getty Images.

From the collection of Gus Lopez: Gatefold between pages 32-33 *vintage merchandise*, Page 54 *bottom right*, Page 57, Page 77, Page 85 *top*, Page 102, Page 136, Page 155, Page 158 *top*.

Photos courtesy of Albin Johnson and the 501st Legion: Pages 86-87.

Photos courtesy of Steve Sansweet: Page 34 *top right*, Page 54 *left and top right*, Page 69, Page 79 *left*, Page 93 *top and bottom right*, Page 109 *left*, Page 116 all minifigures, Page 158 *bottom*, Page 169 *bottom*.